THE BEST OF

Wedding Photojournalism

**TECHNIQUES AND
IMAGES FROM
THE PROS**

Bill Hurter

AMHERST MEDIA, INC. ■ BUFFALO, NY

Copyright © 2004 by Bill Hurter
All rights reserved.

Front cover photo: Joe Buisink © 2004
Back cover photo: Carillo © 2004

Published by:
Amherst Media, Inc.
P.O. Box 586
Buffalo, N.Y. 14226
Fax: 716-874-4508
www.AmherstMedia.com

Publisher: Craig Alesse
Senior Editor/Production Manager: Michelle Perkins
Assistant Editor: Barbara A. Lynch-Johnt

ISBN-13: 978-1-58428-122-1
Library of Congress Control Number: 2003103031

Printed in Korea.
10 9 8 7 6 5 4 3 2 1

Notice of Disclaimer: The information contained in this book is based on the author's experience and opinions. The author and publisher will not be held liable for the use or misuse of the information in this book

Table of Contents

Photograph by Joe Buissink.

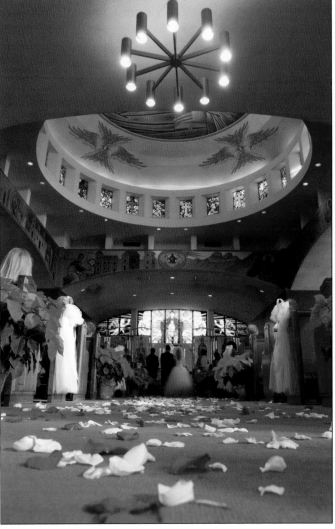

Photograph by David Beckstead.

Landmarks in Wedding Photography

The modern-day wedding photographer is a completely new breed. Not too many years ago, wedding photographers used to be known as "weekend warriors," being wedding photographers only on wedding days and working at another full-time job for the rest of the week. The status of the wedding photographer among other photographers and with the public in general was very low. They were often insufficiently equipped to provide first-rate photographs of the wedding and almost everything was photographed with straight (on-camera) flash. In some cases, not only was their photographic technique suspect, so were their business practices. The phrase "fly by night" often described the struggling weekend warrior.

Of course, there existed the reputable studio photographers who also offered expert wedding coverage, but it was markedly different than the wedding coverage one sees today. These photos—90 percent of them anyway—were posed, and if they weren't posed, the people in the photos were aware of the presence of the photographer and often "mugged" for the camera.

● WPI AND WPPI

In 1981, an organization was formed (coincidentally, an organization I currently work for) to upgrade the techniques and business practices of the wedding photographer. WPI (Wedding Photographers International), as it was known then, brought together these photographers for an annual convention, which provided excellent networking opportunities and speakers from all over the world to educate them on the art and technique of wedding photography. It was an organization that came along at the right time, as it was instantly accepted and gave a home and status never experienced before by the disenfranchised weekend wedding photographers. WPI, and subsequently WPPI (portrait photographers were later added to the organization's fold to create Wedding and Portrait Photographers International), was a turning point in the evolution of wedding photography.

● DENIS REGGIE

Another landmark was the emergence of a former sports photographer named Denis Reggie, who proclaimed himself a "wedding photojournalist." Like WPI, Reggie's words and images were well received by both photographers and brides. He was like a breath of fresh air, instantly giving this brand of photography credibility and salability and gradually enhancing the status of those who practiced this unique brand of documentary photography. Reggie's purpose

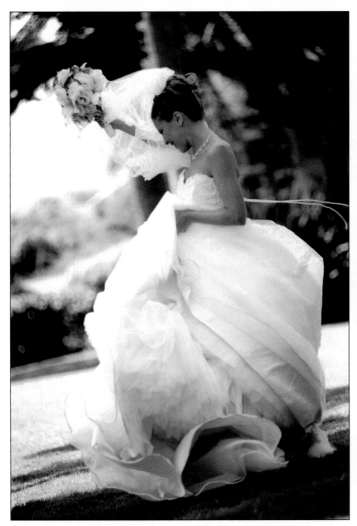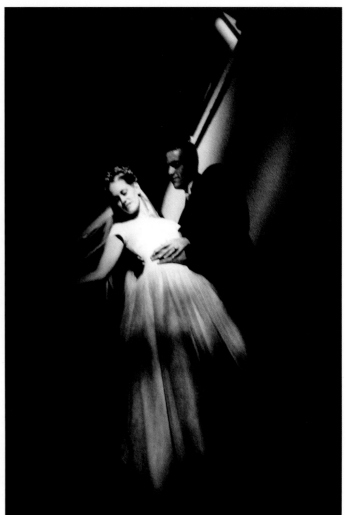

LEFT—The 35mm format has revolutionized wedding photography. In this image by Mike Colón, the eye and reflexes of a sports photographer helped capture this bride in the midst of a joyous moment, dress in full swirl and ribbons flying. This is an image that would be almost impossible to capture without the flexibility of 35mm. **RIGHT**—Today's wedding photojournalism is as much about style and mood as it is about capturing an image with technical perfection. This image by Jerry D might have been deemed unacceptable to the bride and groom only a few years ago. Spotty lighting and slight subject movement only serve to enhance a spur-of-the-moment portrait such as this, which captures eloquently the love between husband and wife.

was and is to provide brides with their own unique and personal story, not a generic version of someone else's wedding.

● **35MM FORMAT AND DIGITAL**

Another important factor that has changed the landscape of wedding photography is the acceptance of the 35mm format by both brides and photographers. Remarkable improvements in the resolution, fidelity, and speed of 35mm films have aided the transition, and the ultrafast 35mm lenses make available-light photography (the staple of the wedding photojournalist) even more pervasive. Now, with the acceptance of digital photography using interchangeable-lens SLRs of remarkable sophistication, much of the wedding photographer's costly "film work" has been supplanted by digital, which affords the opportunity for many more exposures without the additional cost of film or lab charges.

● **ADOBE® PHOTOSHOP®**

Regardless of whether a photographer shoots weddings digitally or with film, Adobe Photoshop has also permanently changed the style of wedding imagery. The photographer, in the comfort of his home or studio, can now routinely accomplish special effects that in years past could only be achieved by a master darkroom technician. Photoshop, and its many plug-ins, has made wedding photography the most creative venue in all of photography—and brides love it. Digital albums, assembled with desktop publishing hardware and software, are quickly becoming the preferred album type, and the style these albums

bring to the wedding experience help to make every bride and groom a celebrity.

Today, many wedding photojournalists have attained a superstar status no one would have dreamed of twenty years ago. Their work is routinely featured in the top magazines around the country and they are in demand fifty-two weeks a year. They have large staffs, a network of like-minded colleagues and, most importantly, today's wedding photojournalist has won over the hearts and minds of brides of every age and ethnicity. Celebrities seek them out to photograph their weddings and parties, and the circle of acceptance grows wider every day.

No location is too remote for these photographers to travel to, and the successful wedding photojournalist may only work in this country half the time. As its acceptance has grown, wedding photojournalism has come to be important enough to encompass other styles of photography. It is now much more than pure documentary photography. You will also see elements of editorial and fashion photography and even a touch of fine art photography in the work of the contemporary wedding photojournalist. You will even see healthy helpings of posed images—although photojournalists regard these moments as choreographed scenes in which the subjects are natural players.

There is no doubt that times have changed, and there is no doubt that they will change again. But for now, wedding photojournalists are among the highest paid and most well respected photographers on earth. And the incredible images these talented photographers are producing have changed the face of wedding photography forever.

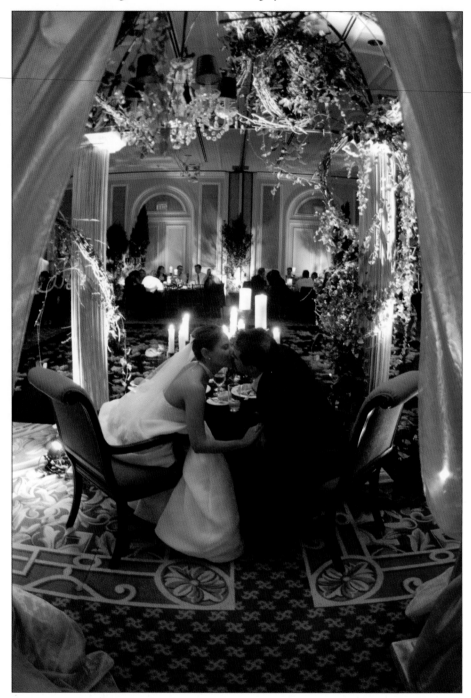

Ultrafast lenses and high film-speed settings allow the contemporary wedding photojournalist to capture priceless moments stolen from time. This winning image by Joe Photo was made with a Nikon D1X and 16mm lens, using a handheld exposure of $^1/_{10}$ second at f/2.8. The wide-angle lens immerses the viewer in this lovely wedding scene lit by spotlights and candles.

Michael J. Ayers (MPA, PPA-Certified, M.Photog. Cr., CPP, PFA, APPO, ALPE, Hon. ALPE)—The 2001–2 International Photographer of the Year (WPPI) and the 2001 United Nations' Leadership Award recipient, Michael J. Ayers is considered one of the best wedding album designers in the world and has developed an album-engineering discipline called Album Architecture. Michael was also one of the first six ANNE Award winners (PPA) and WPPI's 1997 International Portrait Photographer of the Year.

Stuart Bebb—Stuart Bebb is a Craftsman of the Guild of Photographers UK and has been awarded Wedding Photographer of the Year in both 2000 and 2002, with innovative wedding albums. In 2001 Stuart won *Cosmopolitan Bride* Wedding Photographer of the Year, in conjunction with the Master Photographers Association, he was also a finalist for the Fuji Wedding Photographer of the Year. Stuart has been capturing wedding images for over twenty years and works very much as a team with his wife Jan, who creates and designs all the albums.

David Beckstead—David Beckstead has lived in a small town in Arizona for twenty-two years. With help from the Internet, forums, digital cameras, seminars, WPPI, Pictage and his artistic background, his passion has grown into a national and international wedding photography business. He refers to his style of wedding photography as Artistic Photojournalism.

Becker—Becker, who goes by only his last name, is a gregarious, likeable wedding photojournalist who operates a hugely successful studio in Mission Viejo, CA. He has been a featured speaker at WPPI and has also competed and done well in international print competition.

Marcus Bell—Marcus Bell's creative vision, fluid style, and sensitivity have made him one of Australia's most revered photographers. It's this talent combined with his natural ability to make people feel at ease in front of the lens that attracts so many of his clients. His work has been published in numerous magazines in Australia and overseas including *Black White, Capture, Portfolio Bride,* and countless other bridal magazines.

Clay Blackmore—Clay Blackmore is an award-winning photographer from Rockville, MD. He has been honored by the PPA and WPPI and is a featured presenter on the lecture circuit around the United States. He started out as Monte Zucker's assistant.

Joe Buissink—Joe Buissink is an internationally recognized wedding photographer from Beverly Hills, CA. Almost every potential bride who picks up a bridal magazine will have seen Joe

The Photographers

Buissink's photography. He has done many celebrity weddings, including actress Jennifer Lopez's 2002 wedding, and is a multiple Grand Award winner in WPPI print competition.

Bambi Cantrell—Bambi is a highly decorated photographer from the San Francisco Bay area. She is well known for her creative photojournalistic style and is the recent coauthor of a best-selling book on wedding photography, entitled *The Art of Wedding Photography* (Amphoto). Bambi is a highly sought-after speaker at national photographic conventions and schools.

Carrillo—Carrillo is a former associate at Enchanted Memories Studio in Upland, CA, and presently he is assisting for a number of top wedding photographers, including Joe Buissink. He has been a photographer for only a few years, yet has been highly decorated in print competition by WPPI. In 2001, he scored the most honorable mentions in one competition in that organization's history—eleven. His style is photojournalistic and his goal is to create lasting art for his clients.

Anthony Cava (B.A., MPA, APPO)—Born and raised in Ottawa, Ontario, Canada, Anthony Cava owns and operates Photolux Studio with his brother, Frank. Frank and Anthony's parents originally founded Photolux as a Wedding/Portrait Studio, thirty years ago. Anthony joined WPPI and the Professional Photographers of Canada ten years ago. At thirty-three years old, he is the youngest Master of Photographic Arts (MPA) in Canada. One of his accomplishments is that he won WPPI's Grand Award for the year with the first print that he ever entered in competition.

Frank Cava—Frank Cava, brother of Anthony Cava and co-owner of Photolux Studio, is a successful and award-winning wedding and portrait photographer in his own right. Frank is a member of the Professional Photographers of Canada and WPPI. He speaks to professional organizations in the U.S. and Canada along with his brother Anthony.

Robert Cavalli—Robert Cavalli is well known as a master printer. His lab, Still Moving Pictures, in Hollywood, CA, attracts the finest photographers in the country. At the WPPI 2002 print competition, Cavalli had over seventy-five of his prints on display among the award-winning collection. He is also a fine photographer in his own right. He has an associate degree from FIT in New York City, studied at CUNY, also in New York City, and received an MA from the prestigious American Film Institute in Los Angeles.

Michele Celentano—Michele Celentano graduated the Germain School of Photography in 1991. She spent the next four years assisting and photographing weddings for other studios. In 1995, she started her own business photographing only weddings. In 1997 she received her certification from the Professional Photographers of America. She has become a recognized speaker on the art of wedding photography, and has recently relocated her business from New York to Arizona.

Gigi Clark—With four college degrees, Gigi Clark has a varied background including multimedia, instructional design, graphic design, and conceptual art. She brings all of her multidisciplined talents to her upscale photography business located in Oceanside, CA. She has received numerous awards and honors including several First Places in both PPA and WPPI competitions, as well as the first time offered Fujifilm Award for "Setting New Trends."

Mike Colón—Mike Colón is a celebrated wedding photojournalist from the San Diego area. Colón's work reveals his love for people and his passion for life. His natural and fun approach frees his subjects to be themselves, revealing their true personalities and emotions. His images combine inner beauty, joy, life, and love frozen in time forever. He has spoken before national audiences on the art of wedding photography

Jerry D—Jerry D owns and operates Enchanted Memories, a successful portrait and wedding studio in Upland, CA. Jerry has had several careers in his lifetime, from licensed cosmetologist to black belt martial arts instructor. Jerry is a highly decorated photographer by WPPI, and has achieved many national awards since joining the organization.

Deborah Lynn Ferro—A professional photographer since 1996, Deborah Lynn calls upon her background as a watercolor artist. She has studied with master photographers all over the world, including Michael Taylor, Helen Yancy, Monte Zucker, and Tim Kelly. Deborah is currently working toward degrees from WPPI and PPA. In addition to being a fine photographer, she is also an accomplished digital artist. She is the co-author of *Wedding Photography with Adobe Photoshop*, published by Amherst Media.

Tony Florez—For twenty-five years, Tony Florez has been perfecting a unique style of wedding photography he calls "Neo Art Photography." It is a form of fine-art wedding photojournalism that has brought him great success. He owns and operates a successful studio in Laguna Niguel, CA. He is also an

award winner in print competition with WPPI.

Jerry Ghionis—Jerry Ghionis of XSiGHT Photography and Video started his professional career in 1994 and has quickly established himself as one of Australia's leading photographers. His versatility extends to the wedding, portrait, fashion, and corporate fields. Jerry's efforts were recognized by the industry in 1999 when he was honored with the AIPP (Australian Institute of Professional Photography) award for best new talent in Victoria. In 2002 Jerry won the AIPP Victorian Wedding Album of the Year. In 2003 he won Wedding Album of the Year, and won the Grand Award in the Album competition at WPPI.

Jeff and Kathleen Hawkins—Jeff and Kathleen Hawkins operate a fully digital high-end wedding and portrait photography studio in Orlando, FL. They have authored *Professional Marketing & Selling Techniques for Wedding Photographers*, *Professional Techniques for Digital Wedding Photography*, *The Bride's Guide to Wedding Photography*, and *Digital Photography for Children's and Family Portraiture*, all published by Amherst Media. Jeff Hawkins has been a professional photographer for over twenty years. Kathleen Hawkins holds an MA in Business Administration and is a past president of the Wedding Professionals of Central Florida (WPCF) and past affiliate vice president for the National Association of Catering Executives (NACE). They can be reached via their website: www.jeffhawkins.com.

Robert H. Hughes (M. Photog., CR., MEI, AHPA, ASP, PPA Certified MEI & M. Photog.)—Robert Hughes is among the most decorated photographers in the country, having attained WPPI's Accolade of Highest Photographic Achievement as well as PPA's Master of Photography and Master of Electronic Imaging degrees. In addition, he has been the Ohio Photographer of the Year and won numerous awards from Kodak, Fuji, and other prestigious organizations. He has scored perfect 100s in competition three times. He and his wife Elaine own and operate Robert Hughes Photography in Columbus, OH.

Phil Kramer—In 1989, after graduating from the Antonelli Institute of Art and Photography, Phil Kramer opened his own studio, Phil Kramer Photographers, specializing in fashion, commercial, and wedding photography. Today, Phil's studio is one of the most successful in the Philadelphia area and has been recognized by editors as one of the top wedding studios in the country. Recently, he opened offices in Princeton, NJ, New York City, Washington, DC, and West Palm Beach, FL. An award-winning photographer, Phil's images have appeared in numerous magazines and books both here and abroad. He is also a regularly featured speaker on the professional photographers' lecture circuit.

Kevin Kubota—Kevin Kubota formed Kubota Photo-Design in 1990 as a solution to stifled personal creativity. The studio shoots a mixture of wedding, portrait, and commercial photography. Kubota Photo-Design was one of the early pioneering studios of pure digital wedding photography in the late 1990s. He lectures and trains other photographers to make a successful transition from film to digital.

Craig Larsen—Craig Larsen holds a degree in Commercial/Technical Photography. In his fourteen years as a professional photographer, he has worked all over the world photographing weddings and events. He has received numerous awards from WPPI and is a frequent lecturer. He writes a column for WPPI's *Photography Monthly Newsletter*.

Charles and Jennifer Maring—Charles and Jennifer Maring own and operate Maring Photography, Inc. in Wallingford, CT. Charles is a second-generation photographer, his parents having operated a successful studio in New England for many years. His parents now operate Rlab (www.resolutionlab.com), a digital lab that does all of the work for Maring Photography, as well as for other discriminating photographers needing high-end digital work. Charles Maring is the winner of the WPPI 2001 Album of the Year Award.

Malcolm Mathieson—Malcolm Mathieson photographs weddings, a few portraits, and lots of landscapes. He also mounts the occasional exhibition. He's a Master Photographer and a well-known judge, lecturer, and industry supporter. He is a past president of the Australian Institute of Professional Photography, has gained his Associateship of AIPP and the New Zealand Institute of Professional Photography, and was recently elected to the board of the World Council of Professional Photography, the first photographer from the southern hemisphere to gain such a position. He has spoken to many audiences in Australia, New Zealand, Canada, Ireland, Italy, the United Kingdom, and the U.S.

Mercury Megaloudis—Mercury Megaloudis is an award-winning Australian photographer and owner of Megagraphics Photography in Strathmore, Victoria, Australia. The Australian Institute of Professional

Photography awarded him the Master of Photography degree in 1999. He has won awards all over Australia and has recently begun entering and winning print competitions in the U.S.

Dennis Orchard (ABIPP, AMPA, ARPS)—Dennis Orchard is an award-winning photographer from Great Britain. He has been a speaker and an award winner at WPPI conventions and print competitions. He is a member of the British Guild of portrait and wedding photographers.

Joe Photo—Joe Paulcivic III is a second-generation photographer who goes by the name of Joe Photo, his license plate in high school. He is an award-winning wedding photojournalist from San Juan Capistrano, CA. Joe has won numerous first-place awards in WPPI's print competition, and his distinctive style of wedding photography reflects the trends seen in today's bridal magazines.

Stephen Pugh—Stephen Pugh is a wedding photographer from Great Britain. He is a competing member of both WPPI and the British Guild and has won numerous awards in international print competitions.

Patrick Rice (M.Photog. Cr., CPP, AHPA)—Patrick Rice is an award-winning portrait and wedding photographer with over twenty years in the profession. A popular author, lecturer, and judge, he presents programs to photographers across the U.S. and Canada. He has won numerous awards in his distinguished professional career, including the Intenational Photographic Council's International Wedding Photographer of the Year Award, presented at the United Nations. He is the author of *The Photographer's Guide to Success in Print Competition* and coauthor of *Infrared Wedding Photography*, both published by Amherst Media.

Martin Schembri (M.Photog. AIPP)—Martin Schembri has been winning national awards in his native Australia for twenty years. He has achieved a Double Master of Photography with the Australian Institute of Professional Photography. He is an internationally recognized portrait, wedding, and commercial photographer and has conducted seminars on his unique style of creative photography all over the world.

Michael Schuhmann—Michael Schuhmann of Tampa Bay, FL, is a highly acclaimed wedding photojournalist who believes in creating weddings with the style and flair of the fashion and bridal magazines. He says of his weddings, "I document a wedding as a journalist and an artist, reporting what takes place, capturing the essence of the moment." He has recently been the subject of profiles in *Rangefinder* and *Studio Photography and Design*.

Kenneth Sklute—Beginning his wedding photography career at sixteen in Long Island, NY, Kenneth quickly advanced to shooting an average of 150 weddings a year. He purchased his first studio in 1984 and received his masters degree from PPA in 1986. In 1996, he moved to Arizona, where he enjoys a thriving business. Kenneth is much decorated, having been named Long Island Wedding Photographer of the Year fourteen times, PPA Photographer of the Year, and Arizona Professional Photographers Association Wedding Photographer of the Year. He has won these awards numerous times, and has also earned numerous Fuji Masterpiece Awards and Kodak Gallery Awards.

Alisha and Brook Todd—Alisha and Brook Todd's studio in Aptos, CA, is fast becoming known for its elite brand of wedding photojournalism. Both Alisha and Brook photograph the wedding with "one passion and two visions." The Todds are members of both PPA and WPPI and have been honored in WPPI's annual print competition.

David Anthony Williams (M.Photog. FRPS)—David Anthony Williams owns a wedding studio in Ashburton, Victoria, Australia. In 1992 he achieved the distinction of Associateship and Fellowship of the Royal Photographic Society of Great Britain. Via the Australian Professional Photography Awards system, he achieved the level of Master of Photography with Gold Bar—equivalent to a double master. In 2000, Williams was awarded the Accolade of Outstanding Photographic Achievement from WPPI, and has been a Grand Award winner at their annual conventions four times.

Yervant Zanazanian (M. Photog. AIPP, F.AIPP)—Yervant was born in Ethiopia, then lived and studied in Venice prior to settling in Australia twenty-five years ago, where he continued his education at the Photography Studies College in Melbourne. Yervant's passion for photography and the darkroom began at a very young age when he worked in his father's photography business after school and during school holidays. His father was photographer to the Emperor Hailé Silassé of Ethiopia. Yervant owns one of the most prestigious photography studios in Australia and services clients both nationally and internationally. His awards are too numerous to mention, but he has been Australia's Wedding Photographer of the Year three of the past four years.

The Nature of Wedding Photojournalism

One of the reasons wedding photography has achieved such high regard is that it is the permanent record of the most important day in the couple's lives. It is also the end of months of preparation and countless expenses. And it is often the one day when the bride will be her most beautiful and the groom his most handsome. It is a once-in-a-lifetime day.

Traditional weddings feature dozens and dozens of posed pictures culled from a "shot list" passed down by generations of other traditional wedding photographers. There may be as many as seventy-five scripted shots—from cutting the cake, to tossing the garter, to the father of the bride walking his daughter down the aisle. In addition to the scripted moments, traditional photographers fill in the album with "candids," many of which are staged or at least made when the subjects were aware of the camera. A typical candid might be made when the bride and groom are dancing, see the photographer, and turn to the camera while making the appropriate funny faces.

● **NO INTRUSION**

The photojournalistic approach is quite different. The photographer, instead of being a part of every event, moving people around

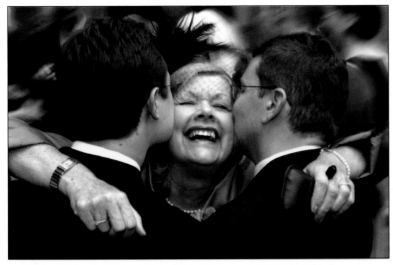

This award-winning image by Dennis Orchard is entitled *My Boys,* and it reveals the pride and love a mother has for her two sons. The image is a wonderful example of a photojournalist at work—the subjects were unaware of the photographer and the emotion of the scene is preserved for all time. Dennis captured the scene at the peak of its action with a relatively slow shutter speed when the subjects were relatively still. Look, however, at the motion in the background.

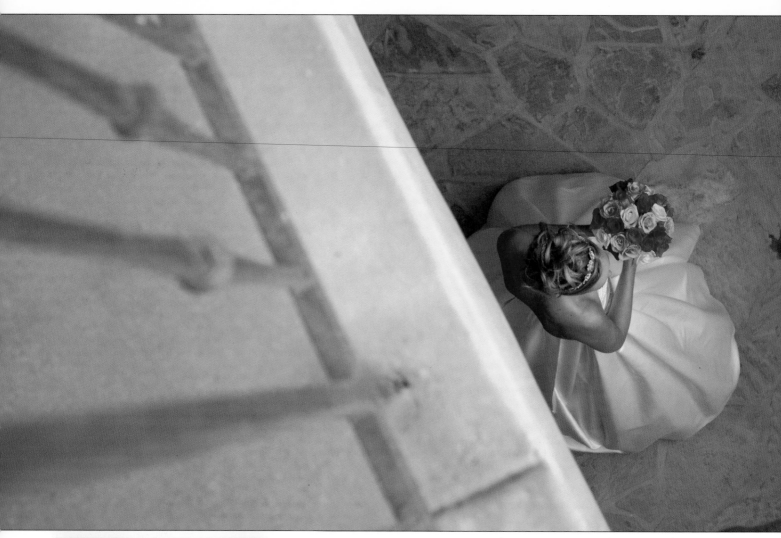

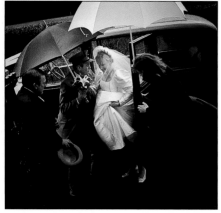

LEFT—The good wedding photojournalist does not manipulate the scene, but rather stays alert to capture the story as it unfolds. This image by Englishman Stephen Pugh reveals the care of the chauffeur, who carefully holds the bride's bouquet and protects her from the raindrops. It is a tiny moment in time, but quite revealing about this wedding story. The image is perfectly framed by umbrellas and heavily sepia-toned in Photoshop to enhance the moment's timelessness. ABOVE—The wedding photojournalist is a keen observer, almost able to predict what will happen next. David Beckstead anticipated the bride's arrival beneath this balcony and prepared by being in the right place at the right time. The result is this unusual and elegant wide-angle image. The image was made with a Nikon D1X, using a 35–70mm lens at the 35mm setting at an exposure of $^1/_{320}$ at f/2.8.

and staging the action, tends to be quietly invisible, choosing to fade into the background so the subjects are not aware of his or her presence. The wedding photojournalist does not intrude on the scene, but records it, documenting it from a distance with the use of longer-than-normal lenses and, usually, without flash.

Because the traditional photographer intrudes on the naturalness of the scene, the coverage is structured and, in the view of many, fictional. While the photojournalist covers the same event, he or she usually does so without interference and intrusion, allowing the scene to unravel with all of the spontaneity and surprises that will occur at such wonderful events.

Because the photographer is working with longer lenses or zoom lenses and is not directing the participants to "move here or over there," he or she is free to move around, working quickly and unobtrusively. The event itself then takes precedence over the directions, and the resulting pictures are more spontaneous and lifelike.

Many wedding photojournalists even photograph groups with this non-intrusive approach, preferring to wait until things "happen."

● **OBSERVATION**

Like any form of photojournalism—whether one is a news photographer, a fashion photographer, or a sports photographer—one of the prerequisites to success in the field is the skill of observation, an intense power to concentrate on the events before you. Through keen observation, a skill that can be enhanced through practice, the photographer begins to develop the knack of predicting what will happen next. This is partially due to knowing the intricacies of the event and the order in which events will occur, and it is partially a result of experience—the more weddings one photographs, the more accustomed one becomes to their rhythm and flow—but the sense of anticipation is also a function of clearly seeing what is transpiring in front of you and reacting to it quickly.

The sports photographer must learn to react to an event by anticipating where and when the exposure must be made. There is an ebb and flow to every action, and like a pole-vaulter, for example, who is ascending at one moment and falling at the next, there is a moment of peak action

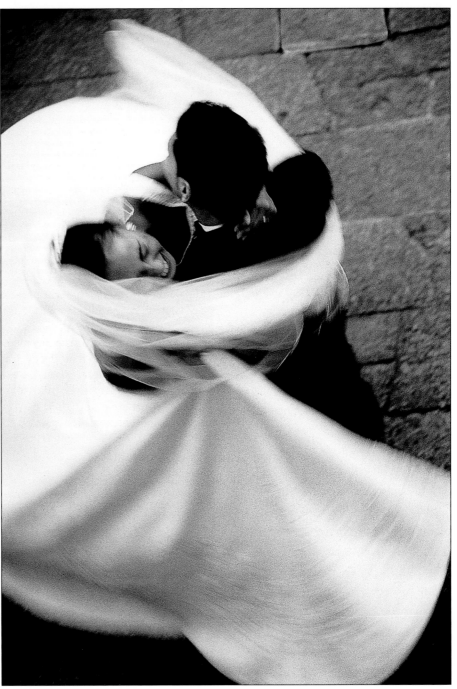

ABOVE—Timing is everything, as you can see here. With Mom in the neighborhood, there was probably only a chance for one take before the fun was halted. Wedding photographer Craig Larsen waited until the child was at the apex of his ascent before pressing the shutter release—at the peak of action. Direct flash helped freeze the action. **RIGHT**—Ken Sklute photographed this perfect wedding image from above. Note that a slightly longer shutter speed was used so that the bride and groom, who were close to the center of the arc of the spin, would remain sharp, while the moving dress is a blur. The expression on this bride's face is pure happiness. This was an award-winning image in WPPI's annual print competition.

that the photographer strives to isolate. Even with motor drives capable of recording six or more frames per second, it is not a question of blanketing a scene with high-speed exposures, it is knowing when to press the shutter release. With a refined sense of timing and good observational skills, you will drastically increase your chances for successful exposures in wedding situations.

Part of one's skills as a polished observer results from being calm and quiet. As a photojournalist, you cannot become part of the spectacle you are covering. Otherwise you will miss the day's most meaningful moments.

● A DIFFERENT MIND SET

Traditional portraiture and traditional wedding photography are, to some, the quest for perfection. The portrait photographer manipulates the pose, lighting, and expression with the goal of idealizing the subject. To be sure, traditional portraiture and traditional wedding coverage are viable, artistically relevant pursuits, but they are not in the mind set of the photojournalist. To the wedding photojournalist, the pursuit of perfection is not the goal. Instead, the ideal is to capture the reality of the situation with as little interference as possible.

The true wedding photojournalist believes that flaws are part of reality and concealing them should be secondary to telling the story truly and capturing the events in an unaltered way. This is not to say that the reality captured by the wedding photojournalist is harsh or otherwise unappealing. To the contrary, the photojournalist's record of the day should be a sensitive portrayal of the events that highlight the emotion elicited.

● THE STORYTELLER

Above all, the skilled wedding photojournalist is an expert storyteller. The wedding day is a collection of short episodes that, when pulled together, tell the story of an entire day. A good wedding photojournalist is aware of the elements of good storytelling—a beginning, middle, and end—as well as the aspects that make a story entertaining to experience—emotion, humor, tension, resolution.

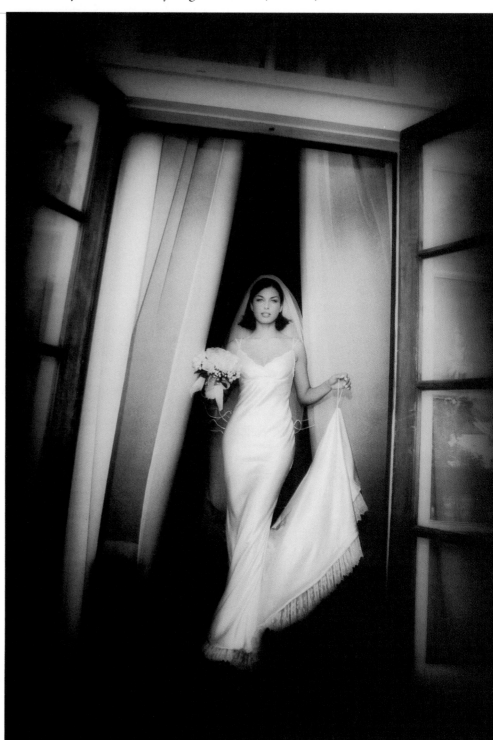

Joe Buissink is a wedding photojournalist in a class by himself and this is one of his signature images. The photograph demonstrates Buissink's perfect fluid timing and innate sense of style. Once you see this image, you never forget it.

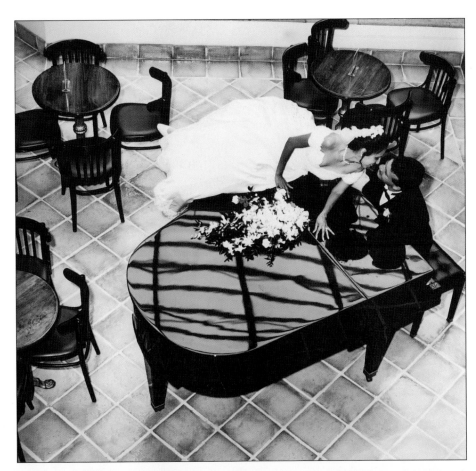

TOP—The good wedding photographer looks for storytelling elements within photos. Here, award-winning wedding and portrait photographer Jerry D used the empty tables to frame and isolate the bride and groom, who seem alone in their own world. The image was made with a Nikon D1X, using an 85mm f/1.4 lens and exposed at $^1/_{60}$ second at f/3.5. Lighting was from an overhead skylight with very slight flash fill. **BOTTOM**—Kevin Kubota looks for the story within the overall story. Here, a long lens reaches out to isolate this tender moment of a bride's tear being wiped away by her new husband. The strong backlighting and shallow depth of field help to isolate the tender scene so that no peripheral elements like the foreground or wrought-iron gate in the background distract from the moment.

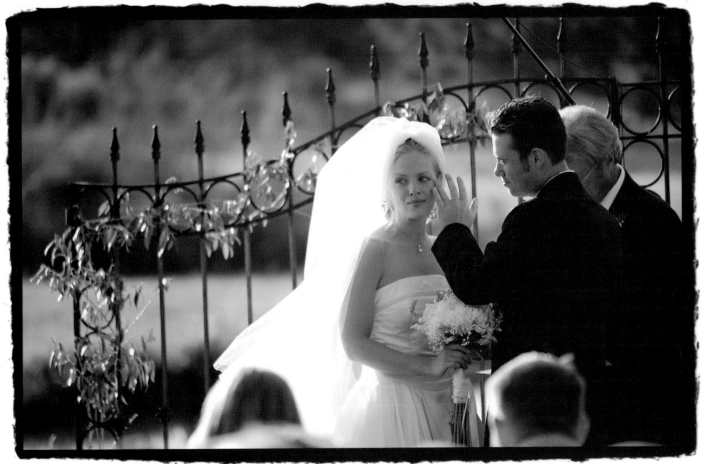

According to wedding photographer Charles Maring, a good story includes many details that go unobserved by most people, even those attending the event. He says, "Studying food and wine magazines, fashion magazines, and various other aspects of editorial images has made me think about the subtle aspects that surround me at a wedding. Chefs are preparing, bartenders are serving, waiters are pouring champagne or wine. My goal is to bring to life the whole story from behind the scenes, to the nature around the day, to the scene setters, to the blatantly obvious. In short, to capture a complete story."

● **POSED SHOTS**

Virtually every wedding—even the most photojournalistic effort—has to include some number of posed images. These are the "formals," the pictures that every bride (and bride's parent) will want. They may include a group portrait of the bride and groom with the groom's family, and one with the bride's family. Also frequently requested is a group portrait of the wedding party, and sometimes the entire wedding assembly—including all the guests. These formal, non-photojournalistic images are a necessary function of recording the day, and may be done with editorial flair or more traditionally, but they are nevertheless part of the wedding photojournalist's pictorial obligation to the couple. Some photographers will make time for the formals before or after the ceremony and may only reserve as little as fifteen minutes to create the shots. Often these images

Joe Buissink captured this wonderful moment by being there and being ready for the unexpected. The image was made with a Nikon D1X and 80–200mm f/2.8 lens. He exposed the image in normal program mode for $1/125$ at f/5.3. When Joe Buissink works a wedding, he is concentrating and observing for seven or eight hours straight—an exercise he finds both exhilarating and exhausting.

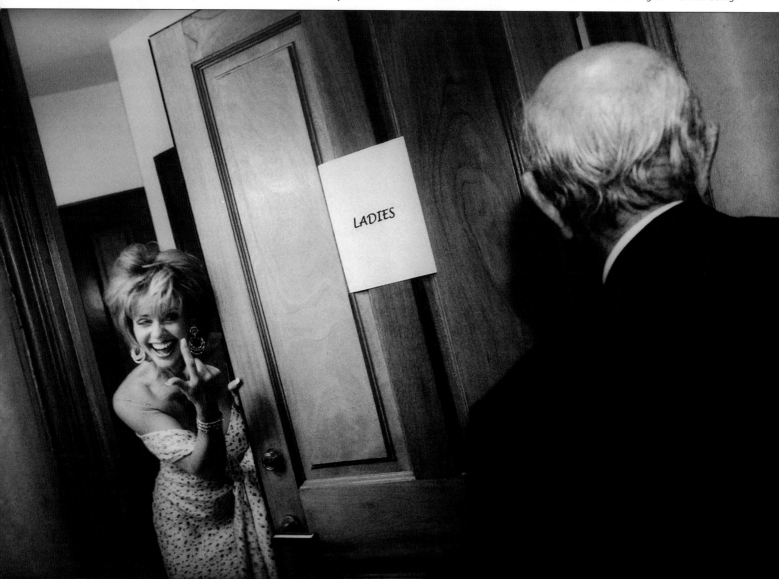

are not featured in the photographer's own promotional materials, but be assured, they are an important ingredient in every wedding and an expected part of the package.

● USING ASSISTANTS

While the photojournalist may possess extraordinary powers of observation paired with razor-sharp timing and reflexes, he or she may still miss the moment by virtue of someone getting in the way or one of the principals in the scene turning away at the last moment. Even with the best-laid plans, some great shots still get away. Robert Hughes, who offers both traditional and photojournalistic styles in covering his weddings, has come up with an interesting solution to this problem. He feels that one person cannot adequately cover a wedding because there's too much action going on at once. Therefore, Robert, his wife Elaine, and an assistant all shoot together, telling the wedding story using many different camera angles and lenses, a technique borrowed from the famous film director, Alfred Hitchcock. Hughes notes, "Years ago, I attended a Universal Studios exhibit of Alfred Hitchcock films. They had the set from the movie *Psycho,* and a torn-apart shower scene. Hitchcock used multiple cameras for different angles and perspectives of the same scene. *Nine* cameras were used just for the shower scene."

Hughes has incorporated a little of this philosophy into his weddings. For example, if the bride is cutting the cake, he says, "There should be a camera on her hands as she cuts it, then a more traditional longer shot of the cake and couple. A third photographer is shooting the entire room

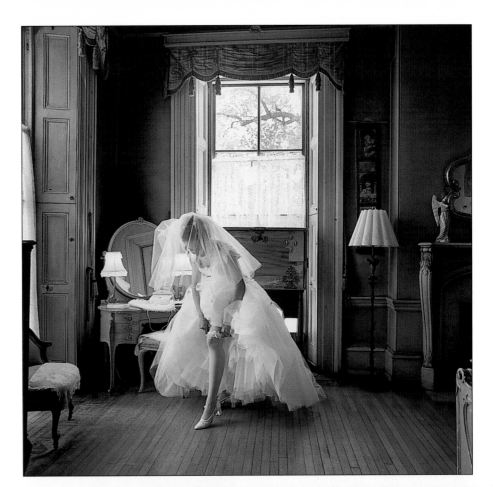

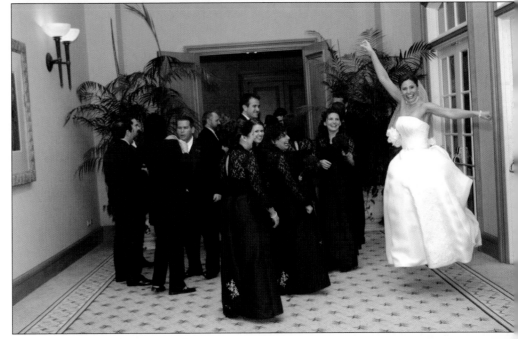

TOP—The window light from two sides elegantly illuminates this bride making final preparations for her wedding. Posed or unposed, it doesn't matter. Phil Kramer created this timeless image that makes the bride appear totally alone in this perfect room. **ABOVE**—While the groom and his best men primp and prepare, the bride leaps for joy. Joe Photo captured this moment with a Nikon D1X at a film speed setting of EI 800. His exposure was $1/60$ at f/2.8 with bounce flash used to stop the action. His timing was impeccable—the bride looks as if she's three feet off the ground!

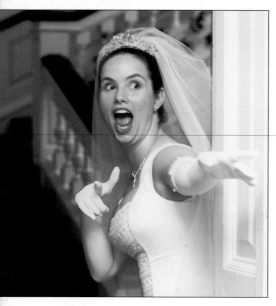

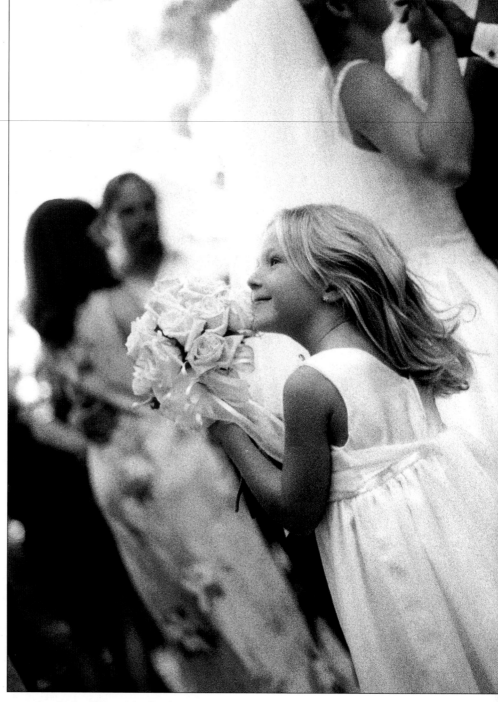

ABOVE—Who knows exactly what this bride is reacting to, but Dennis Orchard was there to record her reaction and she seems oblivious to the photographer. Dennis used bounce flash to freeze the action. RIGHT—All around this flower girl, there is the activity of couples dancing and having a good time. Yet the photographer, Mike Colón, honed in on this precious flower girl having the time of her life. Mike shot this scene at a wide-open aperture to limit depth of field and separate the little girl from the background action. FACING PAGE—Yervant Zanazanian captured this image by letting the bride and groom enjoy the moment. The couple seems removed from reality, in their own uniquely wonderful world.

from the back to show the crowd's reaction. Then all three photographers should turn around and shoot close-ups of the guest's faces." Hughes' crew captures everything from close-ups to the overall room. He calls this "introspective commentary," because each photographer adds his or her own perspective to the overall coverage, making the pictures more diverse.

● ANTICIPATION AND PREPARATION

Preparation is the key to anticipating photographic opportunities. By being completely familiar with the format of the ceremony and events, you will know where and when an event will take place and be prepared for it. This kind of planning must take place long before the wedding day.

It is a good idea for the photographer to scout all of the venues at the time of day at which the events will take place. Many photographers take extensive notes on ambient lighting, ceiling height and surfaces, placement of windows, reflective surfaces like mirrors or wood paneling, and other physical conditions that will affect the photography.

In addition, it is advisable to meet with the principle vendors, such as the florist, caterer, band director, hotel banquet manager, and so on to go over the wedding-day plans and itinerary in detail. This kind of detailed

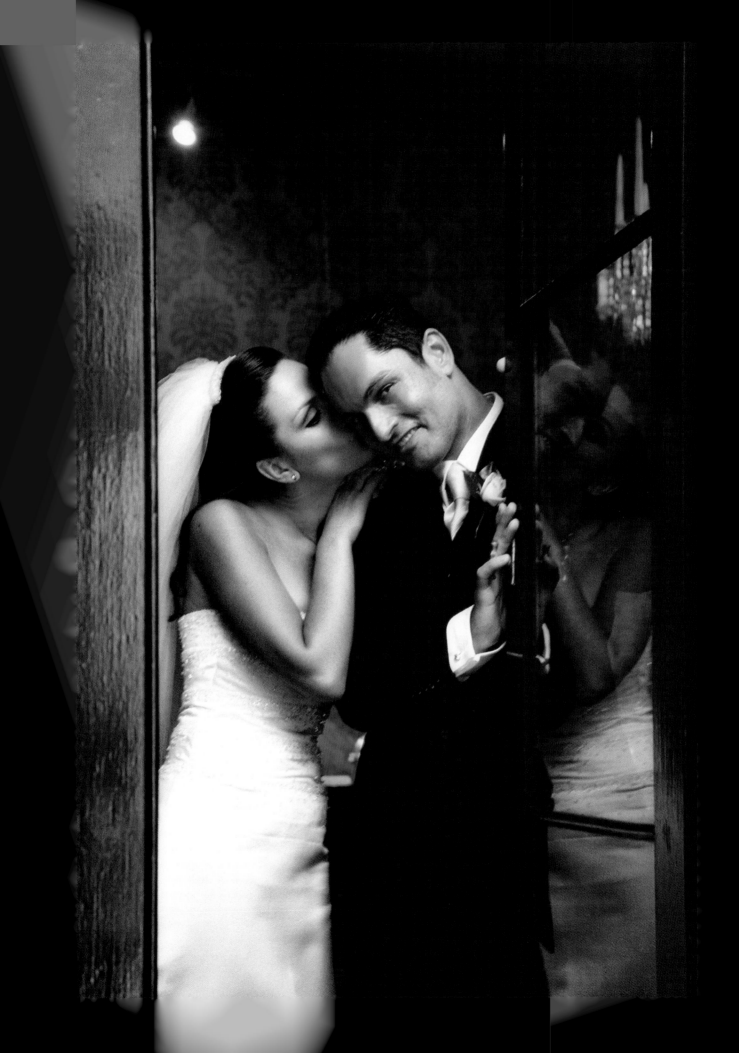

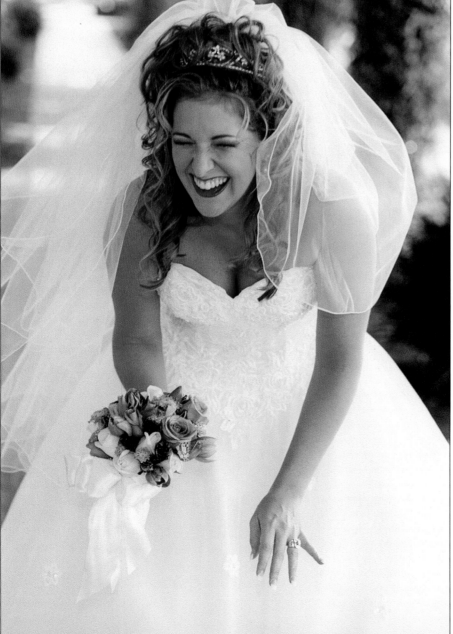

information will aid in not only being prepared for what's to come, but it will provide a game plan and specifics for where to best photograph each of the day's events.

Another good practice is to schedule an engagement portrait. This has become a classic element of wedding coverage. The portrait can be made virtually anywhere, but it allows the couple to get used to the working methods of the photographer, so that on the wedding day they are accustomed to the photographer's rhythms and style of shooting. The experience also helps the threesome get to know each other better, so that on the wedding day the photographer doesn't seem like an outsider.

Drawing on all of this information, the photographer will be able to choreograph his or her own movements to be in the optimum position for each phase of the wedding day. The confidence that this kind of preparation provides is immeasurable. It also helps to put in the time.

TOP—Charles Maring is a master at "making the ordinary extraordinary." Here, he isolated the tiny flower girl smiling, but left within the composition the smiles of the bridesmaids in the background. His focus was clearly on the little girl, but her joy is amplified by the smiles and implied smiles of the "big girls" in the background. **BOTTOM**—The wedding photojournalist simply known as Becker is known to interject himself into the events of the day. It's not clear what cracked up the bride here, but chances are it was the photographer's antics. While, by the strictest definition, a wedding photojournalist is the consummate observer, present-day wedding photojournalists like Becker are sometimes actively involved in the day and will often manipulate the scene to create the emotion they're after.

Arriving early and leaving late is one way to be assured you won't miss great shots.

● REACTION TIME

A good sports or action photographer builds the skill set needed to continuously improve his or her timing. The skills involved are the same for the wedding photojournalist as they are for the sports photographer: preparation, observation, concentration, and anticipation. In short, the better you know the event—whether it is a basketball game or a wedding—the better your reflexes will become.

But there is an intangible aspect to reaction time that all photographers must hone: instinct—the internal messaging system that triggers you to react. It is a function of trusting yourself to translate input into reaction, analyzing what you see and are experiencing into the critical moment to hit the shutter release.

This young girl, a guest at the wedding, was really knocked for a loop by something the bride said to her. In the moment of recognition, Dennis Orchard made the image entitled *Lauren*. Her utter delight, captured on film, is what wedding photojournalism is all about.

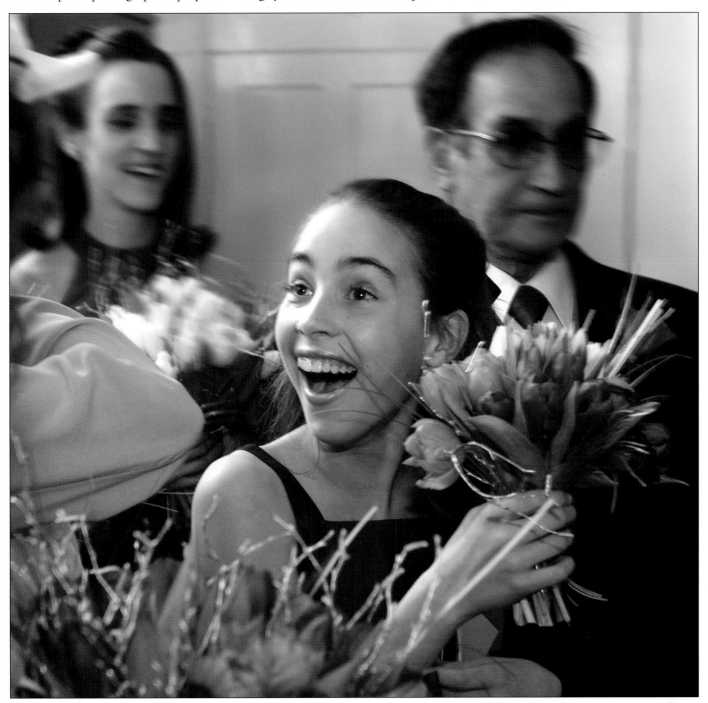

Joe Buissink, master at anticipation and timing, works remarkably fast when he shoots. An observer told me once that the first time he saw Joe shoot, he thought, "He couldn't possibly know what he's doing, he shoots so incredibly fast." The fact is Buissink *does* work quickly and *does* know what he's doing. Buissink trusts the process, saying, "Trust your intuition so that you can react. Do not think. Just react or it will be too late."

● **CAPTURING THE EMOTION**
Perhaps the most obvious characteristic of wedding photojournalism, and also the most difficult to attain consistently, is the ability to capture the emotion of the moment. Some of the items discussed above, like working unobserved, anticipation, and preparedness, are all part of this mind set. However, there is another key ingredient—the ability to immerse oneself

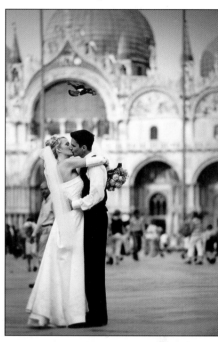

ABOVE—Flying to Italy to capture the romance of a wedding in Venice—in St. Mark's Square, no less—talk about pressure! Joe Photo, always cool, calm, and collected, came away with a signature image from this wedding that defines his love of romance and his jewel-thief's timing. LEFT—The Citroën, the romance, the style, and the sheer excitement of a kiss on the streets of Paris—Martin Schembri sure can set a scene! Notice how all the elements of the scene are a tone or two lower in value than the bride and groom, conveying atmosphere while the bride and groom show the pure magic of love. FACING PAGE—Joe Buissink is a master at isolating fine art from the "reel" of wedding events. Here, his white balance was set for daylight, while the lighting was tungsten—and there wasn't much of it. A slow shutter speed helped Buissink create this stylistic masterpiece.

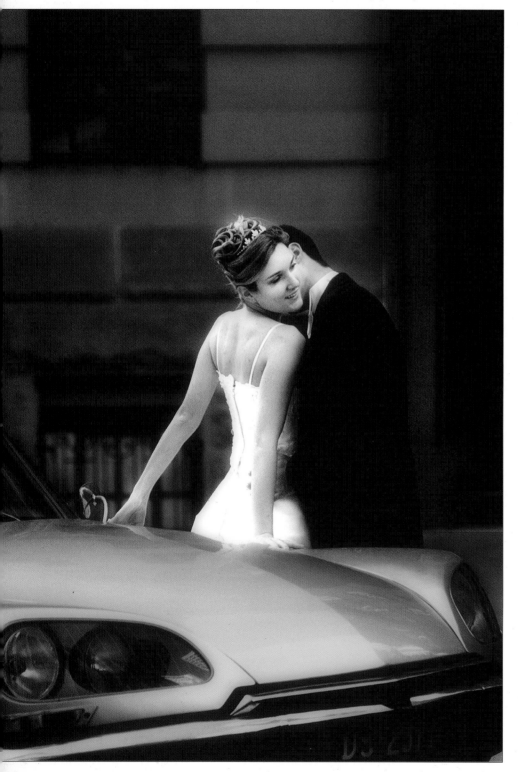

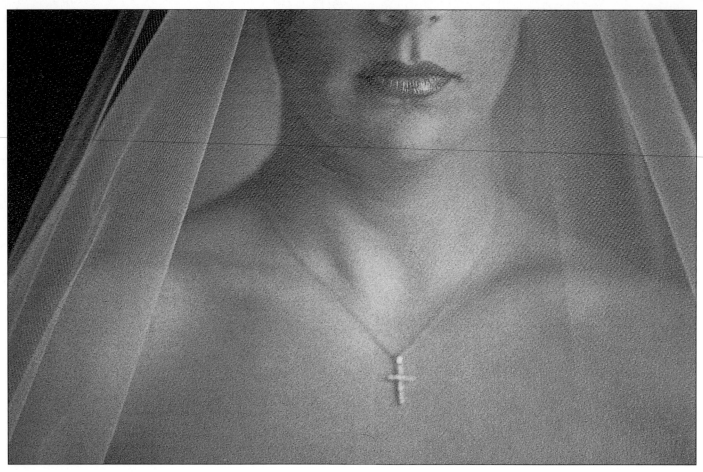

ABOVE—The veil, and what little available light there was, caused Alisha Todd to create this masterpiece of style. The blue tint was an afterthought. The lips, the cross, and the perfect lighting on the bride's shoulders were the impetus to fine art. It's often said that the greatest art reveals a minimum of information, which is certainly true here. Alisha made this picture with a 70–200mm lens at the 200mm setting using window light. Taken just after the bride had gotten ready in the hotel suite, this is a great example of a "staged moment," created during the wedding day. **FACING PAGE**—Charles Maring is a master at recording the defining moment—here, as the bride emerged from a white Rolls Royce, Maring recorded the anticipation in her eyes and on her face. He defined the moment by tilting the camera and using Photoshop to blur everything but the significant details. The result is a powerful and decidedly pleasing image.

in the events of the day. The photographer must be able to feel and relate to the emotion of the moment. At the same time, you cannot be drawn into the events to the extent that you either become a participant or lose your sense of objectivity.

All of one's photographic, journalistic, and storytelling skills go into making pictures that evoke the same emotion experienced on the wedding day. The photographer must move silently and alertly, always ready to make an exposure—listening, watching, sensitive to what is happening

and what could happen in the next instant.

To Brook and Alisha Todd, two San Francisco-area wedding photographers, capturing emotion is what the wedding day is all about and, in fact, is why they enjoy being wedding photojournalists. The emotional content that weddings hold for them rests in the feelings portrayed in these timeless rituals. Their goal in all of their combined coverage is to produce a remembrance of how the bride and groom, as well as their family and friends, felt on that wedding day.

Celebrated wedding photojournalist Michele Celentano feels the same way. "I will never give up weddings," she says. "I love brides, grooms, the flowers, the fanfare, the symbol of new life and the idea of a new beginning."

● **DRESSING FOR SUCCESS**
One might expect that a wedding photojournalist would dress down for the wedding—maybe not like the sports photographer with knee pads and a photographer's vest and jeans, but casual. One very successful wed-

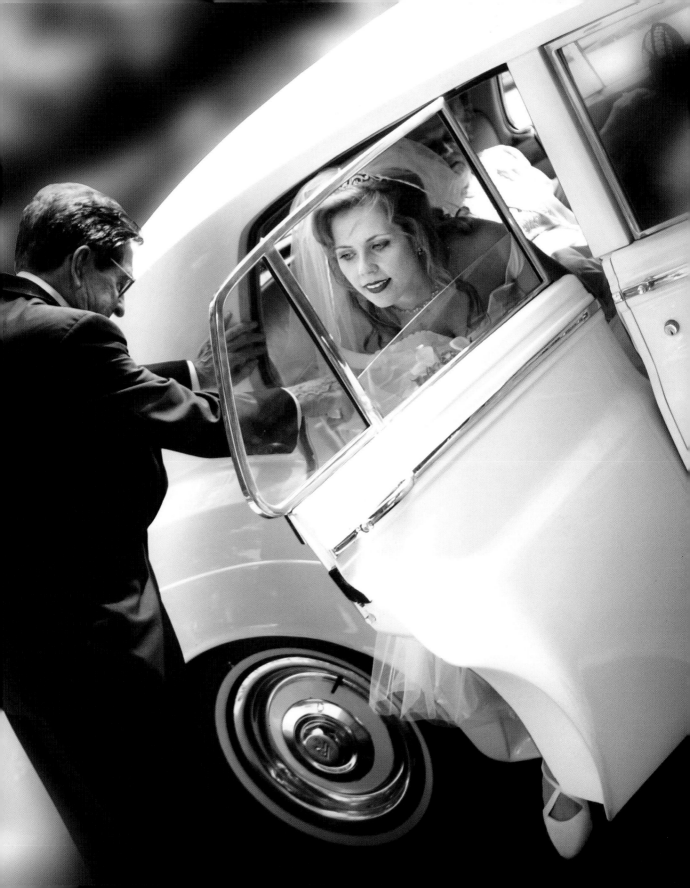

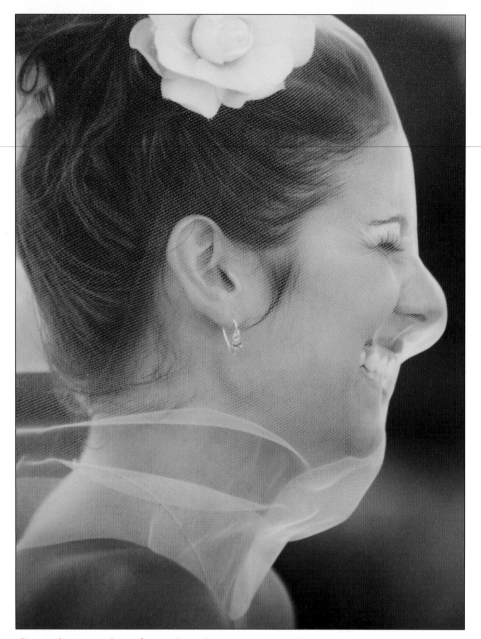

ding photographer from San Juan Capistrano, CA, Tony Florez, believes one of the keys to upscaling his business was to live the motto, "dress for success." To say he has upgraded his wardrobe is an understatement. He only wears Armani tuxedos to his weddings and he, like the couple he is there to photograph, looks like a million dollars. This is not to say that this is the secret to his success—he is also a gifted photographer, but in his mind it has added to his confidence and enhanced his reputation.

● **MAKING THE AVERAGE EXTRAORDINARY**

Dennis Orchard has a lighthearted approach to his weddings. He calls them "lifestyle weddings" and his coverage combines informal black & white reportage with creative, natural color photography. Like most photojournalists faced with photographing family groups, he grins and bears it, and tries to give them a friendly relaxed feeling, as opposed to a formal structure that most group photos exhibit. But what really appeals to Dennis is the challenge. "I love to

make the ordinary extraordinary. I thrive on average brides and grooms, Travel Lodge Hotels, and rainy days in winter." Orchard recently photographed an overweight bride who was "so frightened of the camera that every time I pointed it at her she would lose her breath and have a mini anxiety attack." Using long lenses, he photographed her all day long without her being aware of the camera. He said he couldn't believe the final shots—"she was beautiful in every frame!" She later wrote him a note in which she said, "I never thought I could have pictures like this of me!" It was Dennis' best wedding of the year.

● **UNIQUENESS**

No two weddings are ever the same, and it is the photographer's responsi-

bility to capture that uniqueness. This is also the fun part for the photographer. With the abandonment of the cookie-cutter style of posed portraits, every wedding is a new experience with all-new challenges for the wedding photojournalist. Part of what makes the wedding unique is the emotional outpouring between the participants.

Also, since the wedding photojournalist, by and large, does not pose the participants (except for the requisite group and formal portraits), but reacts to each situation with sensitivity and timing, no two weddings ever look alike. One of the main goals of the wedding photojournalist is to remain unobtrusive and not impose on moments that should remain natural and genuine. This is one of the primary means of preserving a wedding's uniqueness.

● STYLE

One of the traits that separate wedding photojournalists from traditional wedding photographers is the element of style, an editorial feel pulled from the pages of today's bridal magazines. Weddings and all the associated clothing and jewelry are big business and, as such, these magazines have flourished into behemoth issues each month. The wedding photojournalist emulates this style.

Noted Australian wedding photographer Martin Schembri calls the magazine style of wedding photography, "a clean, straight look." The style is reminiscent of advertising/fashion photography. If you study these magazines, you will quickly notice that there is often very little difference between the advertising photographs

The bride and groom spin around a single central point, while the bouquet remains slightly in focus because it spins less. A slow shutter speed and an intent to idealize the sense of joy created a winning image for Clay Blackmore.

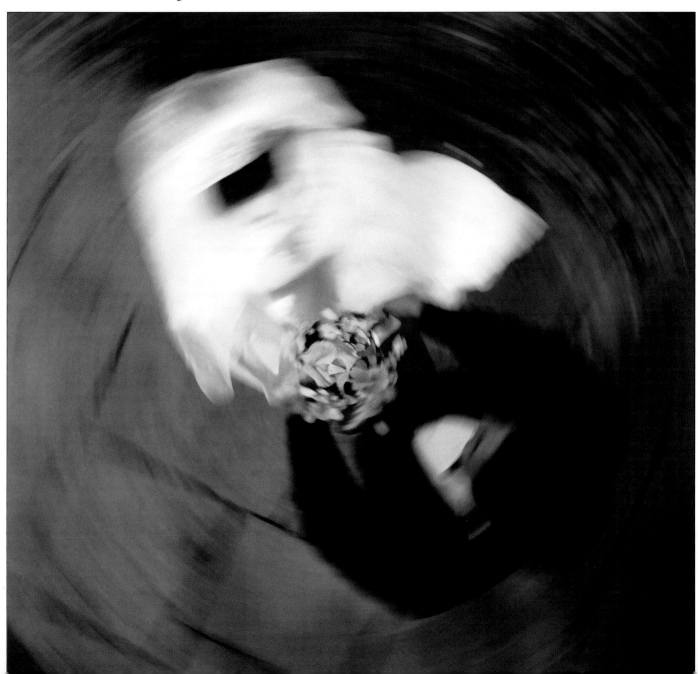

and the editorial ones that are used to illustrate the articles. Based on an understanding of consumer trends in wedding apparel, the photographer can better equip him or herself with an understanding of what contemporary brides want to see in their wedding photographs.

Some wedding photographers take style to the next level. Michael Schuhmann says of his work, "It's different; it's fashion, it's style. I document a wedding as a journalist and an artist, reporting what takes place, capturing the essence of the moment."

Wedding photojournalism seems to be bringing the best and brightest artists into the field because of its wide-open level of creativity. Martin Schembri, who produces elegant, magazine-style digital wedding albums, is as much a graphic designer as

a top-drawer photographer. Schembri assimilates design elements from the landscape of the wedding—color, shape, line, architecture, light and shadow—and he also studies the dress, accessories, etc. He then works on creating an overall work of art that reflects these design elements on every page.

● **AWARENESS**

Most wedding photojournalists greatly revere the work and philosophy of Henri Cartier-Bresson, who believed in the concept of "the decisive moment," a single instant that is released from the continuity of time by the photographer's skills. This moment is life defining; it's a moment like no other before or since, that defines the reality of the participants. As noted many times throughout this book,

revealing the decisive moment can only be accomplished through a complete awareness of the scene. This attitude requires concentration, discipline, and sensitivity.

Many fine wedding photojournalists are also masters of full awareness. Photographers like Joe Buissink are able to become one with their equipment, the moment, and the emotion of the wedding couple. Buissink considers his equipment to be an extension of his body, his eye, and his heart. He says of the state, "My sense of self fades away. I dance

Beneath the veil and the diffusion is pure joy. Kevin Kubota, like Joe Buissink, attains the "moment" in his wedding day coverage. This portrait of bride and groom captures the essence of wedding photojournalism—the photographer is invisible in this picture.

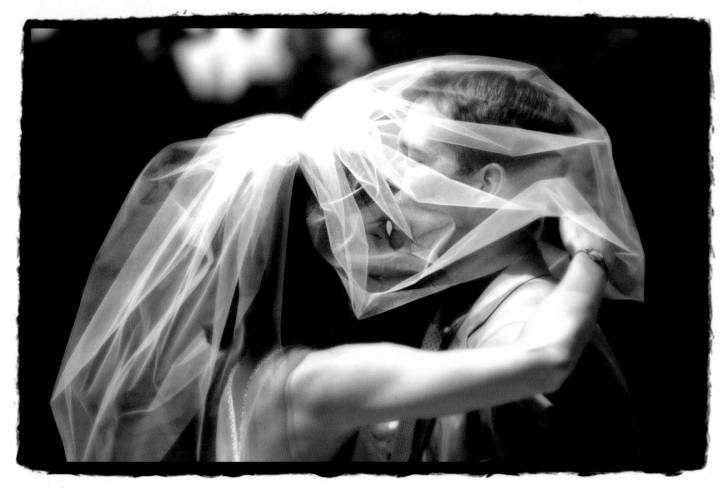

with the moment . . . capturing the essence of a couple." Buissink says the state of full awareness is not that difficult to find. "You must relax enough to be yourself and exhibit your pleasure in creating art. Do not look for the flow, it will find you. If you try to force it, it will be lost."

● **PEOPLE SKILLS**

Any wedding photographer, journalistic or traditional, needs to be a "people person," capable of inspiring trust in the bride and groom. Generally speaking, wedding photojournalists are more reactive than proactive, but they cannot be flies on the wall for the entire day. Interaction with the principal participants is crucial—and often at those inevitable stressful moments. That is when the photographer with people skills really shines. Joe Buissink has been blessed with a "salt of the earth" personality that makes his clients instantly like and trust him. That trust leads to complete freedom to capture the event as he sees it. It also helps that Buissink sees the wedding ceremonies as significant and treats the day with great respect.

Buissink says of his mental preparations for the wedding event, "You must hone your communication skills to create personal rapport with clients, so they will invite you to participate in their special moments." And he stresses the importance of being objective and unencumbered. "Leave your personal baggage at home. This will allow you to balance the three roles of observer, director, and psychologist."

Building a good rapport with your couple, the family, and people in general helps in the making of great

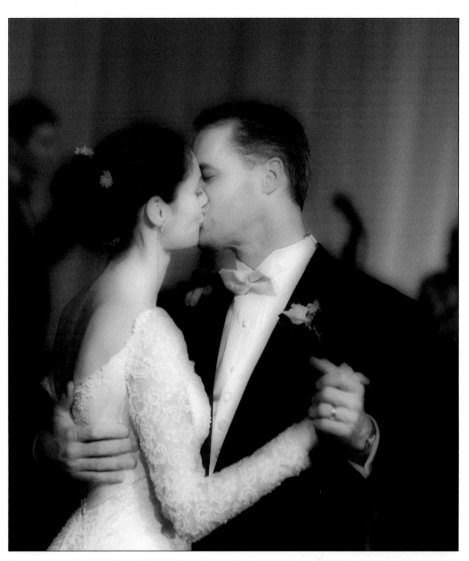

The essence of good wedding photojournalism is to be alert, in position, and ready. Bambi Cantrell made this loving image during the couple's first dance. She used a Canon D30 with a 85mm f/1.8 lens. With an E.I. 400 setting, her exposure was ¹/₉₀ at f/1.8.

pictures on the wedding day. This is not to say that wedding photojournalists are not great observers or that they do not possess a keen sense of timing, but there are those times when the photographer's interaction actually creates the impetus for a great "staged moment." This might be when formal portraits of the bride or groom (or both) are required, or when certain planned phases of the wedding are upcoming.

Rather than rejecting such situations as non-photojournalistic, the seasoned photojournalist embraces

these moments and may or may not stage their outcome. He or she may even direct the overall action, just as a film director choreographs the elements of a scene to be filmed. Take for instance the Clay Blackmore image of the spinning bride and groom (page 29). It is highly unlikely that Clay "happened" on the scene and snapped an award winner. More likely is that he directed the action, putting it into play and with his skills created a timeless image.

Photographer Kevin Kubota encourages his couples to be themselves

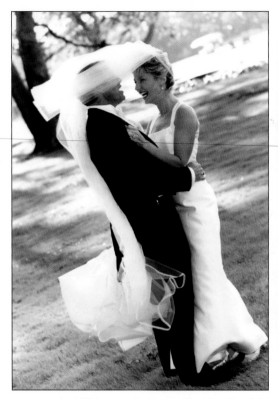

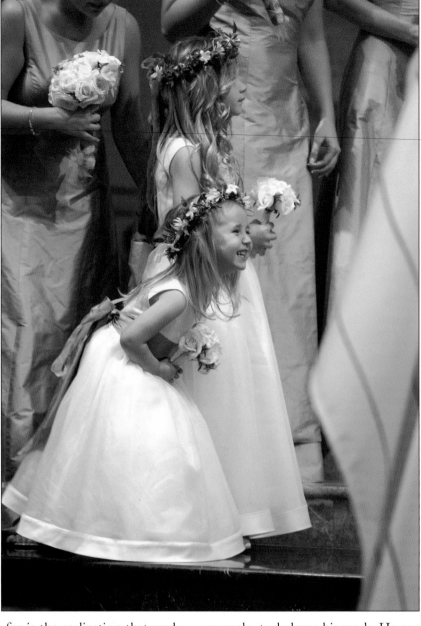

ABOVE—A stiff breeze is the motivation for this exposure by Becker. He tilted the camera to enhance the effect of the breeze, but the real charm of the photograph is in the bride's expression as her veil envelopes her groom. RIGHT—Nobody sees the humor here except the photographer, Mike Colón, and the subject, a flower girl. This is a one-of-a-kind image that can only happen when the photographer is concentrating intensely on the events. Colón used a Nikon D1X and an 80–200mm f/2.8 lens set to 145mm to make the shot. The photographer used an E.I. 800 film speed setting, and the exposure was $1/125$ at f/2.8 with a +1EV correction.

and to wear their emotions on their sleeves. He tries to get to know each couple before the wedding, and also encourages his brides and grooms to share their ideas, establishing a dynamic of mutual trust between client and photographer.

● HAVING FUN

Many wedding photojournalists feel blessed to be able to do what they do. Perhaps because of the romantic nature of the event, it helps if the photographer is also a romantic, but it is not completely necessary. What *is*

called for is the realization that weddings are a celebration for the family and friends of two people; and quite simply, a celebration is all about having fun. The wedding photographer gets to be part of the joy of the event and the pictures will tell the story of the celebration.

For many wedding photojournalists, the appeal of photographing weddings is not the fees or even the prestige, it's simply that it is an occasion to have fun and to be a part of a meaningful and beautiful ritual. Photographer Michael Schuhmann, for

example, truly loves his work. He explains, "I love to photograph people who are in love and are comfortable expressing it, or who are so in love that they can't contain it—then it's real." For the romantically inclined, wedding photojournalism is almost its own reward.

Equipment

● 35MM AF SLR

The days of exclusively medium format cameras being used for wedding photography seem to be at an end, particularly for wedding photojournalists. Faster lenses, cameras that feature six-frame-per-second motor drives, and incredible developments in film emulsion technology have led to the 35mm format becoming accepted in the realm of wedding photography. Many photographers are glad for the change. Kevin Kubota, for example, only brings the amount of equipment that he and his shooting partner can carry in one trip. He discovered several years ago that the 35mm format would let him capture the couple's spontaneity and excitement in real time. Kevin relished the speed that 35mm provided, allowing him to capture more of the shots he had envisioned or had seen happening, but was unable to capture with traditional medium format gear.

Beyond ease of use, the consumer has come to accept 35mm as a viable choice for weddings. In the not-too-distant past, a wedding photographer might not be considered for a wedding if he or she wasn't shooting with a Hasselblad. This brand had become so entrenched in the mind of the public as the one-and-only camera for wedding photographers that it became a symbol for excellent wedding photography.

The wedding photojournalist shoots with 35mm exclusively, although he or she may have medium-format cameras on hand for groups and formals, an integral part of every wedding. Autofocus,

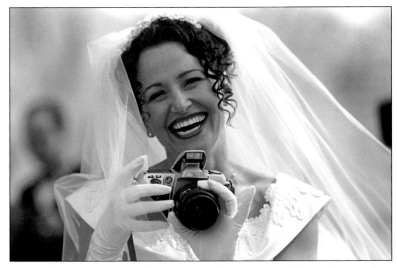

In a humorous reversal of roles, award winning wedding photographer Clay Blackmore captures a delightful shot of the bride wielding her Nikon on the photographer. Clay used a longer lens wide open to blur the background and spotlight the bride.

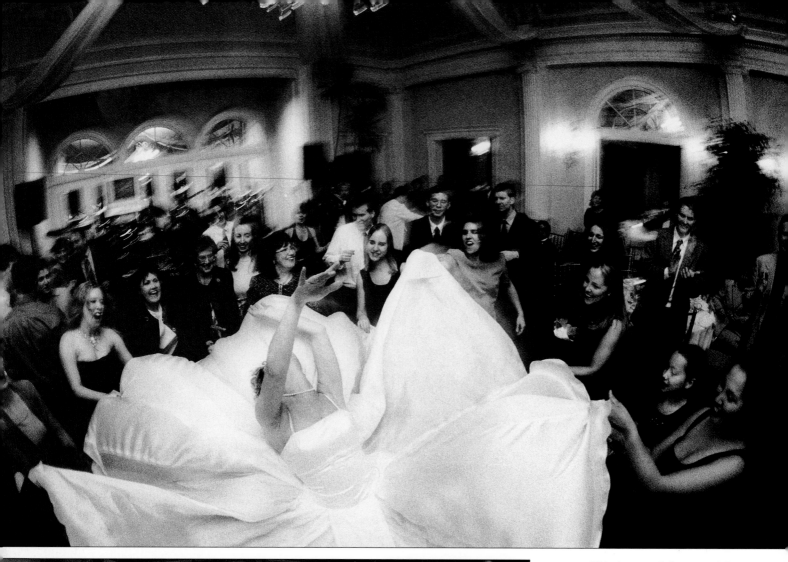

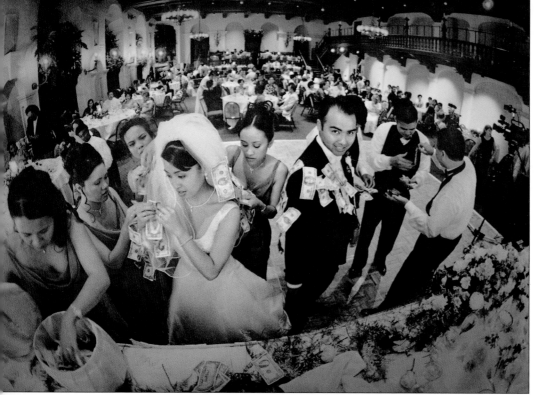

ABOVE—This is one of the most fabulous photojournalistic images I've ever seen. Carrillo captured this image with a very wide-angle lens, a high vantage point, and a very fast film speed setting. Because he wanted to extend his depth of field, he lengthened the exposure time (you see some blurring of the faster-moving subjects) and reduced the taking aperture. He used a bounce flash to freeze the motion of the bride, but knew it would do little to freeze the motion of those around her. It is an expression of unabashed joy. LEFT—Carrillo recorded this scene following a "money dance." He used a rectilinear fisheye lens, which brought him in closer to the many things going on. Of particular interest are the expressions on the bride's and groom's faces and the intense concentration of all the helers. The image was carefully printed by Robert Cavalli to bring out the groom and the scene around him.

once unreliable and unpredictable, is now thoroughly reliable and extremely advanced. Some cameras feature multiple-area autofocus so that you can, with a touch of a thumbwheel, change the AF sensor area to one of four or five areas of the viewfinder (the center and four outer quadrants, for example). This allows you to "de-center" your images for more dynamic compositions. Once accustomed to quickly changing the AF area, this feature becomes an extension of the photographer's technique.

Autofocus and moving subjects used to be an almost insurmountable problem. While you could predict the rate of movement and focus accordingly, the earliest AF systems could not. Now, however, almost all AF systems use a form of predictive autofocus, meaning that the system senses the speed and direction of the movement of the main subject and reacts by tracking the focus of the moving subject. This is an ideal feature for wedding photojournalism, where the action can be highly unpredictable.

The 35mm format not only provides great quality, thanks to improved films, but it is also maneuverable and quiet, the latter being a feature preferred by wedding photojournalists who work quietly and unobserved. Some 35mm camera motor drives even feature a quiet mode that can be used when shooting in churches or other public places where the "ca-chunk" of the camera's motor drive would be a distraction.

Photographers Brook and Alisha Todd work with four Canon EOS 35mm SLR camera bodies and seven lenses. They also take along three portable strobes with backup battery packs, several meters, light stands, and a Gitzo tripod for the overall shots. The lenses they use are primarily long, fast lenses and fast zooms. They say that 35mm lends itself to working in differing lighting conditions and fast-changing environ-ments. Deborah Lynn Ferro, who shoots the photojournalistic images while her well-known husband Rick shoots the formals, opts for Canon digital SLRs like the D30 and D60, with a wide assortment of lenses.

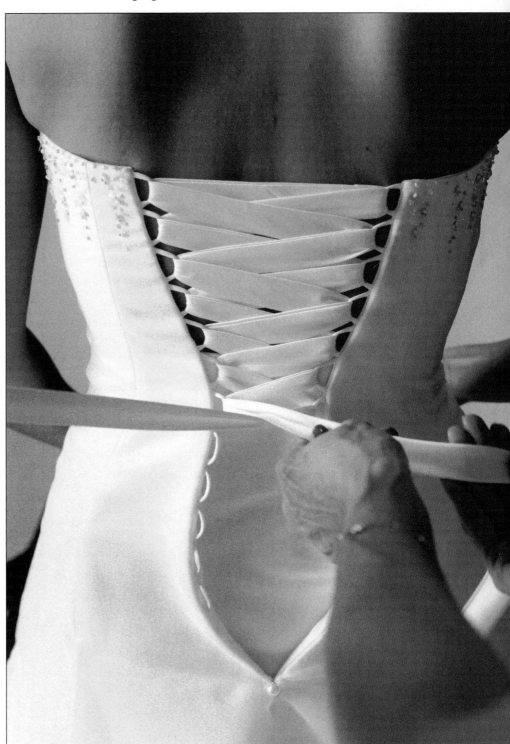

Alisha Todd created a very unusual but effective portrait of the bride in preparation. The delicate waistline of the bride contrasts with the considerable forearms of the woman helping the bride get dressed, creating a rather humorous image.

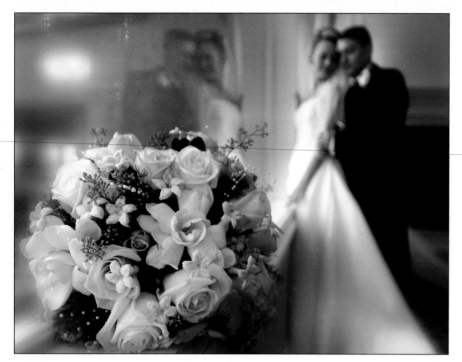

ABOVE LEFT—Charles Maring is a masterful photographer, employing the forced perspective of a wide-angle lens to focus primary attention on the bouquet, while letting the remainder of the image go soft to imply the emotion of the wedding couple. Maring further softened areas of the foreground and window glass to enhance the illusion. In another stroke of insight, he positioned a room light behind the couple to act like a studio background light, illuminating the background more brightly directly behind the couple. This is a great example of a staged formal. **ABOVE RIGHT**—Incredible spontaneity is what the 35mm format provides. An expression like this one, captured by Joe Photo, depends on timing and the ability to quickly turn and fire. This image was made with black & white film in a Nikon camera. The image was scanned and selectively softened in Photoshop so that only the bride's face remained in focus—the bouquet, foreground, and background were defocused intentionally. **FACING PAGE**—Michael Schuhmann uses the razor-thin band of focus of a very fast telephoto lens to gently "lift" the veil from the bride's face. By front-focusing on her veil, he allows the mysterious beauty of the bride to emerge. Schuhmann cleverly allowed her eyes to fall between highlights on the veil (i.e., in shadow areas) so her eyes would be a prominent part of the image.

● **LENSES**

Zoom Lenses. Another reason that 35mm is the format of preference for photojournalists is the range of ultra-fast zoom lenses available. The lens of choice seems to be the 80–200mm f/2.8 (Nikon) and 70–200mm f/2.8 (Canon). These are very fast, light-weight lenses that offer a wide variety of useful focal lengths for both the ceremony and reception. They are internal-focusing, meaning that auto-focus is lightning fast and the lens does not change length as it is zoomed or focused. At the shortest range, 70mm, this lens is perfect for full-length and three-quarter-length portraits. At the long end, 200mm is ideal for tightly cropped candid coverage or head-and-shoulders portraits. These zoom lenses also feature fixed maximum apertures, which do not change as the focal length varies. This is a prerequisite for any lens to be used in fast-changing conditions.

Fixed-Focal-Length Lenses. Fast fixed-focal-length lenses (f/2.8, f/2, f/1.8, f/1.4, f/1.2, etc.) will get lots of use, as they afford more "available light" opportunities than slower lenses. Any time the wedding photojournalist can avoid using flash, which naturally calls attention to itself, he or she will do so.

Wide Angles. Other popular lenses include the range of wide angles, both fixed-focal-length lenses and wide-angle zooms. Focal lengths from 17mm to 35mm are ideal for capturing the atmosphere, as well as for photographing larger groups. These lenses are fast enough for use by available light with fast film.

Telephotos. At the other end of the focal-length spectrum, many wedding photojournalists use ultrafast telephotos, like the 300mm f/2.8 or f/3.5 lenses. These lenses, while heavy, are ideal for working unobserved and can isolate some wonderful moments. Even more than the 80–200mm lens, the 300mm throws the backgrounds beautifully out of focus and, when used wide open, this lens provides a sumptuously thin band of focus, which is ideal for isolating image details.

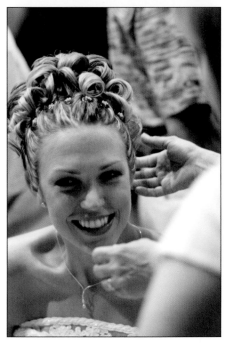

LEFT—A beautiful bride and a beautiful image by Joe Buissink. The print, made by Robert Cavalli, was converted to high key and diffused selectively. The eyes, minus catchlights, define this revealing wedding portrait. **TOP RIGHT**—Alisha Todd created this dreamscape of a bride hurrying up the steps of the church using a very wide lens to create a monument-like look to the church and to widen the steps in the foreground. Master printer Robert Cavalli defocused the top and bottom of the frame so that only the plane of the bride is sharp. **BOTTOM RIGHT**—David Beckstead, invisible to the bride, captured this wonderfully happy image of the bride enjoying the preparations. He used his Nikon D1X with a 100mm f/2.8 lens and a 400 ISO setting. Exposure was $^1/_{60}$ at f/2.8.

Another favorite lens is the 85mm (f/1.2 for Canon; f/1.4 for Nikon), a short telephoto with exceptional sharpness. This lens gets used frequently at receptions because of its speed and ability to throw backgrounds out of focus, depending on the subject-to-camera distance.

Sample Selections. Joe Buissink's wedding gear includes a number of Nikon F5s (film) and D1Xs (digital) and an assortment of lenses ranging from a 16mm f/2.8 to his trusty 80–200mm f/2.8.

Canadian photographer Vladimir Bekker uses a variety of focal lengths, including a fisheye lens and a panoramic camera. He believes that having great flexibility in viewpoint will pay big dividends when it comes time to design the album, which usually incorporates multiple panoramas as two-page spreads, sometimes with inset photos of close-ups placed strategically.

Mike Colón uses prime lenses (not zooms) in his wedding coverage and shoots at wide-open apertures

most of the time to minimize background distractions. He says, "The telephoto lens is my first choice because it allows me to be far enough away to avoid drawing attention to myself, but close enough to clearly capture the moment. Wide-angle lenses, however, are great for shooting from the hip. I can grab unexpected moments all around me without even looking through the lens."

● FILMS

Film Speed. Ultrafast films in the ISO 1000 to 3200 range offer an ability to shoot in very low light and produce a larger-than-normal grain pattern paired with lower-than-normal contrast—ideal characteristics for photojournalistic coverage. Many photographers use these films in color and black & white for the bulk of their photojournalistic coverage. Usually, a slower, finer-grain film will be used for formals and groups. These ultrafast films used to be shunned for wedding usage because of excessive grain. But the newer films have vastly improved grain structure, and besides, many brides and photographers equate grain with mood, a positive aesthetic aspect to the pictures.

Martin Schembri shoots his weddings on Nikon 35mm cameras loaded with Fuji NHG 800 film. He says, "It is incredibly fine-grained and allows me to move freely—no tripod, no flash." He says he hasn't used flash for ten years, and will only do so for effect or if absolutely necessary.

Color negative films in the ISO 100–400 range also have amazing grain structure compared to films of only a few years ago. They possess mind-boggling exposure latitude, from –2 to +3 over or under normal exposure. Of course, optimum exposure is still and will always be recommended, but to say that these films are forgiving is an understatement.

Film Families. Kodak and Fujifilm offer "families" of color negative films. Within these families are different speeds, from ISO 160 to 800 for

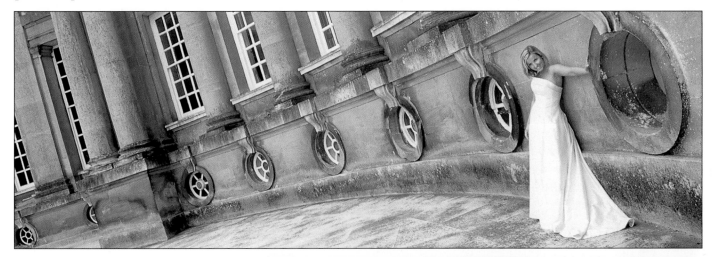

ABOVE—Panoramics make delightful album spreads and gatefolds and add visual variety to an album. Here, Stuart Bebb has created a wonderful panorama, placing the bride within the frame so as to avoid all distortion. She is certainly the focal point of the composition.
RIGHT—Mike Colón created this mixed-lighting dance shot using a Nikon D1X with a 24mm lens and on-camera TTL-balanced flash. He exposed the image at $^1/_{15}$ second at f/3.2 with a 17–35mm grid over the flash reflector to spread the light output. He also used a flash mode called front-curtain sync, meaning that the flash exposure occurred after the available light exposure, laying a sharp flash exposure down over the available light exposure.

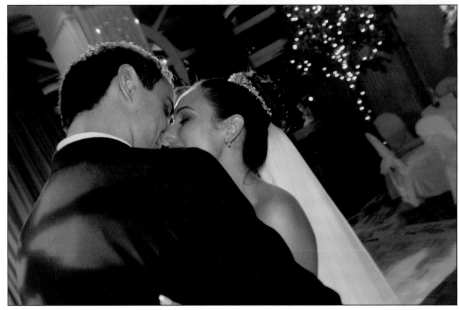

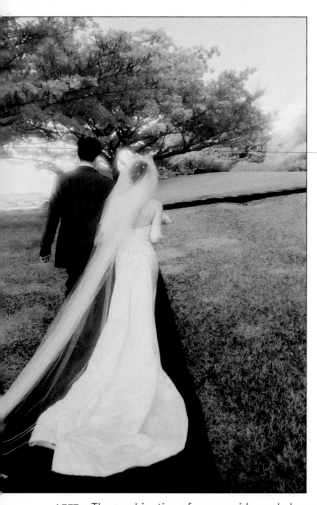

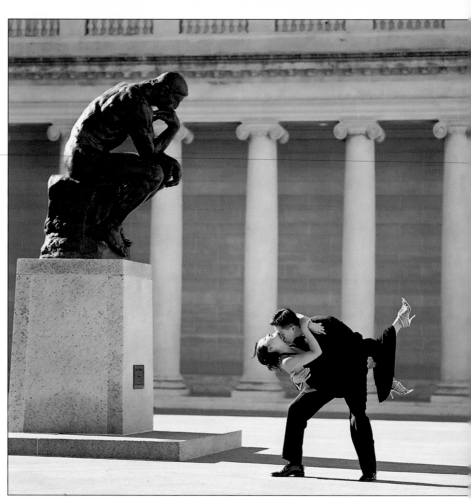

LEFT—The combination of a very wide-angle lens and black & white infrared film give this wedding image by Bambi Cantrell a very unusual but highly stylized look. Bambi keeps one Canon EOS camera body in reserve for infrared film at most weddings and uses it sparingly. The wide-angle spreads the train of the dress across the foreground of the image and the one small leaf in the foreground, which ordinarily might be a distraction, is a beautifully quirky element of the image. **RIGHT**—Bambi Cantrell used her Hasselblad to create a perfectly balanced portrait of the bride and groom. The size and shape of the two elements in the image are identical, but thematically they are total opposites. Rodin's *Le Penseur* (The Thinker) conjures up thoughtful introspection, while the bride and groom are delightfully kickin' up their heels—a pleasing contrast of outlooks. Hasselblad lenses are widely known as some of the finest optics on earth. In this situation, the backlighting does not alter the image contrast or sharpness even slightly.

example, and either varying contrast or color saturation, but with the same color palette. Kodak's Portra films include speeds from ISO 160 to 800 and are available in NC (natural color) or VC (vivid color) versions. Kodak even offers an ISO 100 tungsten-balanced Portra film.

Fujicolor Portrait films, available in a similar range of speeds, offer similar skin-tone rendition among the different films and good performance under mixed lighting conditions, because of a fourth color layer added to the emulsion. These films are ideal for wedding photographers because different speeds and format sizes can be used on the same day with minimal differences in the final prints.

Not only do these families of films offer similar color palettes, they also use the same scanner settings and produce scans of similar characteristics, regardless of film speed. This is a huge plus for photographers whose images are scanned either at the time of processing or afterward for digital output, previewing, or album layout.

Black & White Films. Many wedding photojournalists like to shoot color film and convert it later to black & white. That way there is always a color original. With digital, this is a simple matter of changing the mode to grayscale once the image has been brought into Photoshop. But many photographers prefer the emulsions offered in black & white, notably Kodak T-Max, which is available in a variety of speeds (ISO 100, 400, and 3200) and is extremely sharp and fine-grained—even in its fastest version. Black & white coverage is almost a necessity for the wedding photojournalist. It provides a

welcome relief from all-color coverage and offers a myriad of creative opportunities.

Chromogenic Films. About twenty years ago, Ilford introduced the first chromogenic film, XP1. This monochrome film was designed to be processed in a color film process (C-41) and produce a neutral dye image (as opposed to a silver-halide image made with conventional black & white films). The negatives may be printed as black & white on black & white paper, or with a slight sepia hue on color paper. Ilford later improved its film with the introduction of XP2. Kodak, not to be outdone, introduced a chromogenic film called T400CN. The image quality is good with both of these films, but the primary convenience is that it can be processed at the same lab that processes your color negative film.

● DIGITAL

Shooting a lot is another way to guarantee that all of your preparedness won't go unrewarded. Wedding photojournalist Bambi Cantrell shoots over a thousand exposures at every wedding. Switching to digital helps make this easier, as you can download memory cards to a laptop and then reuse them, or make sure to bring extra memory cards for this purpose.

Every photographer who shoots film is wary of the number of rolls shot and the number remaining—and

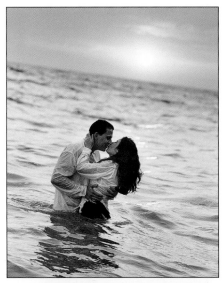

RIGHT—All of the elements in this fantastic engagement portrait by Joe Photo underscore the deep emotion of the couple. Joe used Kodak T400CN, a chromogenic black & white film designed to be processed in C-41 color negative chemistry. The film can be exposed at many different E.I.s, and when printed on color paper, often has a sepia color shift, ideal in this situation. **BELOW**—Joe Buissink also created this old-world style, available-light portrait with his D1X and an 80–200mm f/2.8 lens, one of his wedding standbys. Buissink uses very few lenses to shoot a wedding, preferring fast fixed-aperture (f/2.8) zooms for most of his work.

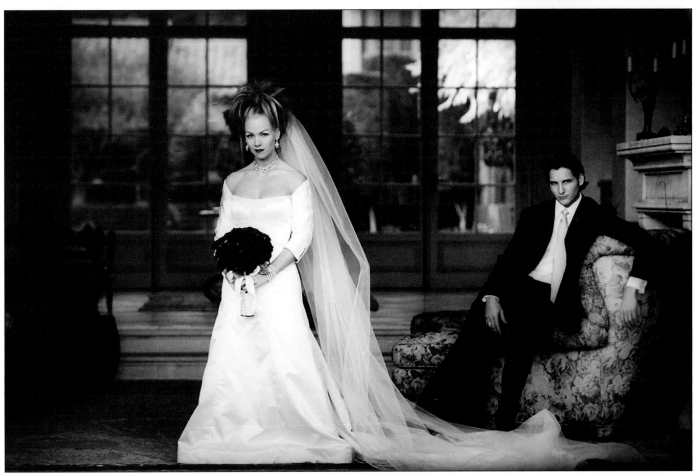

it is human nature to, at some point during the day, calculate the cost of all that film and processing. With digital no such internal dialogue occurs.

Joe Buissink shoots both digital and film but says he still prefers the look of film and the high quality, fine-art aspects of a good fiber-base print made from a film negative. But he also recognizes that he has to keep up with changing technology.

Instant Results. Kevin Kubota hasn't shot a wedding on film since he purchased his Nikon D1X digital camera, saying that the quality is at least as good as 35mm film and that the creative freedom digital affords him is mind boggling. He can take more chances and see the results instantly, immediately knowing whether or not he got the shot. And the digital tools he has come to master in Photoshop make him a better, more creative photographer.

ISO. Another reason digital has become popular with wedding photojournalists is that you can change the ISO on the fly. For example, if you are photographing the bride and groom before the ceremony outdoors in shade, you might select a 400 speed. Then you might move to the church, where the light level would typically drop off by three or more f-stops.

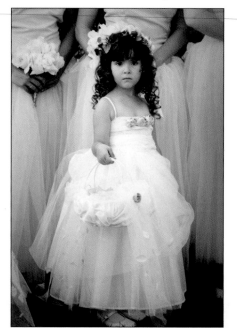

LEFT—As much as Joe Buissink likes digital, he likes the look and feel of a beautifully printed silver halide, fiber-based print. Here, Robert Cavalli, the master printmaker, has helped Buissink realize his vision. Notice how the bridesmaids, who could have become a visual distraction, are toned down and, in the case of the right side of the print, are flashed with "raw" light to subdue the brightness. The enigmatic little flower girl stands alone—a timeless wedding vignette. **BELOW**—Kevin Kubota claims he hasn't used his film cameras since he purchased his D1Xs a few years ago. Here, he has produced a beautiful portrait of the bride and groom in the rain—look closely and you can see the streaking raindrops against dark background areas. Kevin used the D1X, an 85mm f/1.4 lens, and an exposure of $^1/_{250}$ at f/2 to make the picture.

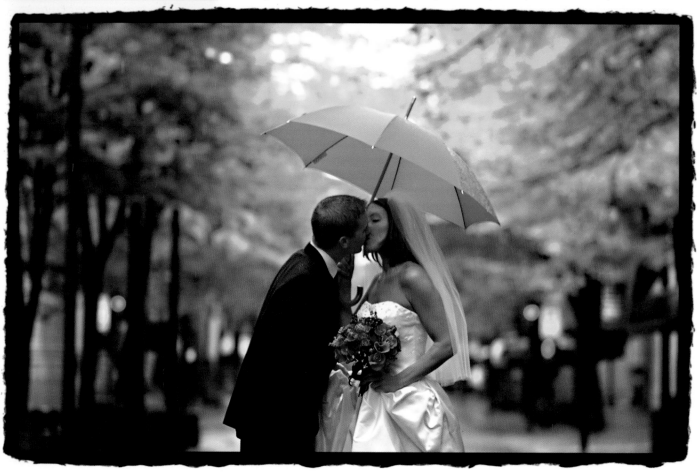

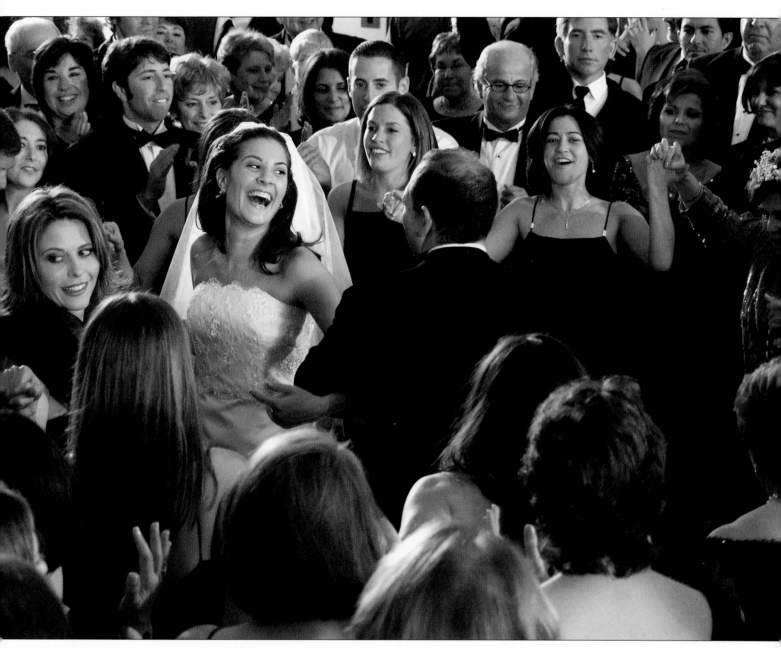

Sometimes you have to light the reception yourself with strobes or hot lights, and sometimes you get lucky and the videographer, also hired to shoot the wedding, will fully light the reception. All you need to do is show up with tungsten-balanced film. Here, Robert Hughes captured this fun image where the bride and groom seem to leap out of the crowd. The lighting is done with hot lights, expertly set so there are no holes or double shadows.

Simply adjust the ISO to a higher setting, like 1600 or faster, to compensate for the lower light levels. Unlike film, where you would have to change rolls or cameras to accomplish this, setting the ISO on a digital camera only affects the frame being recorded.

Focal Length and Chip Size. There are a number of full-fledged professional 35mm digital systems available with a full complement of lenses, flash units, and system accessories. Most of these cameras take the system lenses that a photographer may already own. The focal length, however, is not the same, since the chip size is slightly smaller than a full 24x36mm frame. This reduced coverage area changes the effective focal length of your existing lenses, making all the lenses slightly longer in focal length. This is not usually a problem where telephotos and telephoto zooms are concerned, but when your wide-angles become significantly less wide on the digital camera body, it is somewhat annoying.

Chip sizes are, however, getting larger; some digital SLRs are now becoming available with full-size

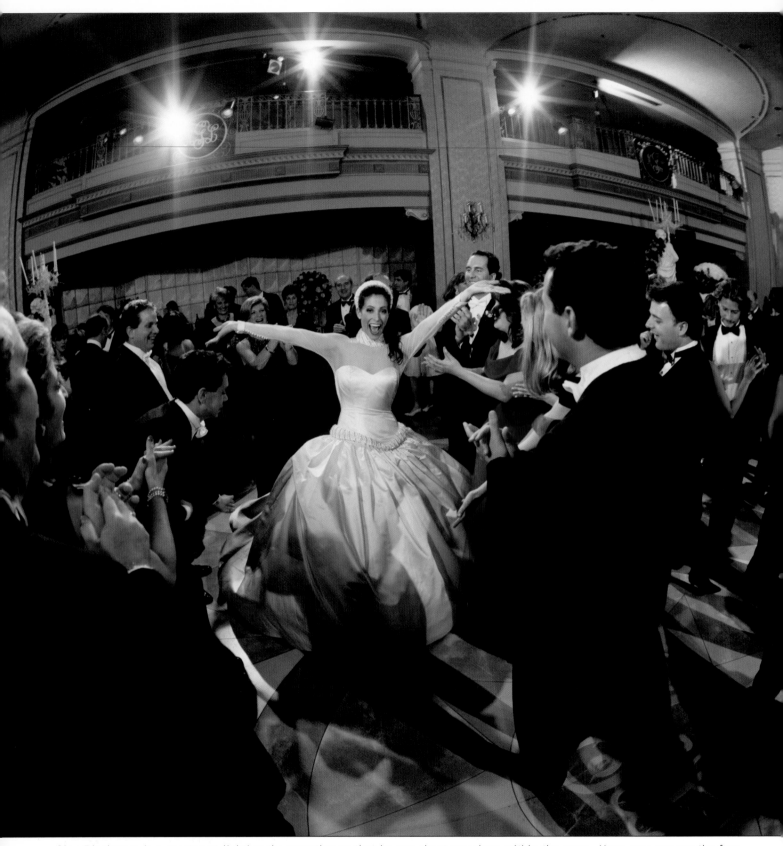

Clay Blackmore is a master at lighting the reception so that he can shoot anywhere within the room. Here, you can see the four synced strobes in the balcony going off as part of Clay's ensemble of lighting. Such preparation allows him to get shots like this without the need for blowing a straight flash directly onto the bride. The bride is evenly lit from around the room, and he knows his exposure settings anywhere in the room.

24x36mm imaging chips, meaning that there is no change to your lenses' effective focal length. Some camera manufacturers who have committed to chip sizes that are smaller than full-frame 35mm have also started to introduce lens lines specifically geared to digital imaging. The circle of coverage (the area of focused light falling on the film plane or digital-imaging chip) is smaller to compensate for the smaller chip size. Thus, the lenses can be made more economically and smaller in size, yet still offer the wide range of focal lengths as the company's traditional lenses.

Images in Hand. Perhaps the greatest advantage of shooting digitally is that when the photographer leaves the wedding, the images are in hand. Instead of scanning the images when they are returned from the lab, the original is already digital and ready to be brought into Photoshop for retouching or special effects and subsequent proofing and printing.

● **FLASHMETER**

A handheld flashmeter is essential for work indoors and out, but particularly crucial when mixing flash and daylight. It is also useful for determining lighting ratios. A flashmeter will prove invaluable when using multiple strobes and when trying to determine the overall evenness of lighting in a large room. Flashmeters are also ambient-light meters of the incident type, meaning that they measure the light falling on them and not light reflected from a source or object.

● **REMOTE TRIGGERING DEVICES**

If using multiple flash units, some type of remote triggering device will be needed to sync all the flashes at the instant of exposure. There are a variety of these devices available, but by far the most reliable is the radio remote triggering device. These devices use a radio signal that is transmitted when you press the shutter release and received by the individual receivers mounted on each flash. Radio remotes transmit signals in either digital or analog form.

Digital systems, like the Pocket Wizard Plus, are state of the art. Complex 16-bit digitally coded radio signals deliver a unique code, ensuring the receiver cannot be triggered or "locked up" by other radio "noise." The built-in microprocessor guarantees consistent sync speeds even under the worst conditions. As part of their standard equipment, some photographers include a separate transmitter for as many cameras as are being used (for instance, an assistant's camera) as well as a separate transmitter for the handheld flashmeter, allowing the photographer to take remote flash readings from anywhere in the room.

● **FLASH**

On-Camera Flash. On-camera flash is used sparingly at weddings because of its flat, harsh light. As an alternative, many photographers use on-camera flash brackets, which position the flash over and away from the lens, thus minimizing flash red-eye and dropping the harsh shadows behind the subjects—a slightly more flattering light. On-camera flash is often used outdoors, especially with TTL-balanced flash exposure systems. With such systems, you can adjust the flash output for various fill-in ratios, thus

Here is a big group—the entire reception—with the bride and groom centrally positioned to avoid distortion from the use of a rectilinear fisheye lens. Notice the people at the edges of the frame are distorted—but the bride and groom, in the center of the image, are not. The photographer used slaved flash (you can see the second photographer behind the couple, whose flash is providing backlighting) and diffused flash in the foreground for an elegant group portrait. The photographer, Dennis Orchard, "dragged the shutter" so that the flash exposure would be close to the room light exposure and both would record accurately.

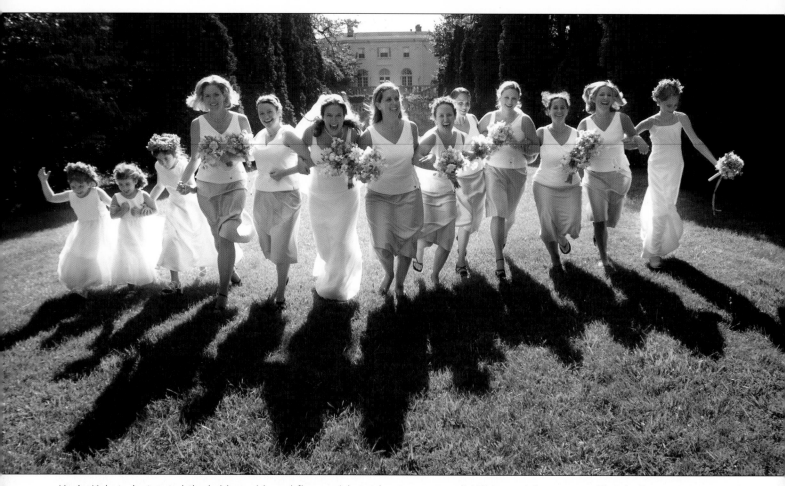

Kevin Kubota instructed the bridesmaids and flower girls to charge up a small hill toward the camera. The shadows were to create a significant part of the composition, but detail in the girls' faces and dresses was equally important. With a 17mm lens on his D1X, he biased his exposure toward the faces and froze the scene's action with a $^{1}/_{640}$ second shutter speed. He later burned-in the foreground in Photoshop to make the shadows an important design element.

producing consistent exposures. In these situations, the on-camera flash is most frequently used to fill in the shadows caused by the daylight, or to match the ambient light output, providing direction to the light.

Bounce-Flash Devices. Many photographers use their on-camera flash in bounce-flash mode. A problem, however, with bounce flash is that it produces an overhead soft light. And with high ceilings, the problem is even worse—the light is almost directly overhead.

A number of devices on the market have been created to address this problem. One is the Lumiquest Pro-Max system, which allows 80 percent of the flash's illumination to bounce

off the ceiling while 20 percent is redirected forward as fill light. The system includes interchangeable white, gold, and silver inserts as well as a removable frosted diffusion screen. This same company also offers devices like the Pocket Bouncer, which enlarges and redirects light at a 90-degree angle from the flash to soften the quality of light and distribute it over a wider area. While no exposure compensation is necessary with TTL flash exposure systems, operating distances are somewhat reduced. With both systems, light loss is approximately $1^{1}/_{3}$ stops. With the ProMax system, using the gold or silver inserts will lower the light loss to approximately $^{2}/_{3}$ of a stop.

Barebulb Flash. Perhaps the most frequently used handheld flash at weddings is the barebulb flash, such as Dyna-Lite's NE-1 flash, which provides 360-degree light coverage as well as a 1000 watt-second barebulb pencil-style flash tube. This great location tool is compact and lightweight and can literally fit in your pocket. These units are powerful and, instead of a reflector, use an upright mounted flash tube sealed in a plastic housing for protection. Since there is no housing or reflector, barebulb flash generates light in all directions. It acts more like a large point-source light than a small portable flash. Light falloff is less than with other handheld units, and they are ideal for flash-fill

situations. These units are predominantly manual flash units, meaning that you must adjust their intensity by changing the flash-to-subject distance or by adjusting the flash output. Many photographers mount a sequence of barebulb flash units on light stands, using ball-head adapters to infinitely position the light in the reception for doing candids on the dance floor.

Studio Flash Systems. You may find it useful to have a number of studio flash heads with power packs and umbrellas. You can set these up for formals or tape the light stands to the floor and use them to light the reception. Either way, you will need enough power (at least 50–100 watt-seconds per head) to light large areas or produce smaller apertures at close distances. The most popular of these type of lights is the monolight, which has a self-contained power pack and usually has an on-board photo cell, which will trigger the unit to fire when it senses a flash burst. All you need is an electrical outlet and the flash can be positioned anywhere. Be sure to take along plenty of gaffer's tape and extension cords. Tape everything in position securely to prevent accidents.

One such monolight preferred by wedding photographers is the Dyna-Lite Uni400JR, a 3.5-pound compact 400 watt-second unit that can be plugged into an AC outlet or used with the Dyna-Lite Jackrabbit high-voltage battery pack. The strobe features variable power output and recycle times, full tracking quartz modeling light, and a built-in slave.

Studio flash units can be used with umbrellas for lighting large areas

Bounce flash is often used at the reception to simulate natural light. The light bounces off the ceiling and down onto the subjects. If one chooses an exposure setting that closely resembles the ambient light exposure, then the background will match the foreground for a uniformly lit exposure. This charming image was made by Robert Hughes.

of a room. Be sure, however, that you "focus" the umbrella—adjusting the cone of light that bounces into and out of the umbrella surface by moving the umbrella closer and farther away from the light source. The ideal position is when the light fills the umbrella but does not exceed its perimeter. Focusing the umbrella also helps eliminate hot spots as well as to maximize light output.

● LIGHT STANDS

Light stands are an important part of location lighting. You should use heavy-duty stands and always tape them firmly in place and try to hide them in corners of the room. The light stands should be capable of extension to a height of twelve to fifteen feet. Lights should be aimed down and feathered so that their beams criss-cross, making the lighting as even as possible. The lights can be set to backlight the people at the reception, and an on-camera flash used to trigger the system.

● REFLECTORS

When photographing by window light or outdoors, it is a good idea to have a selection of white, silver, gold, and black reflectors. Most photographers opt for the circular disks, which unfold to produce a large size reflector. They are particularly valuable when making portraits by available light.

● BACKUP AND EMERGENCY EQUIPMENT

Wedding photographers live by the expression, "If it *can* go wrong, it *will* go wrong." That is why most seasoned pros carry backups and double backups—extra camera bodies and flash heads, extra transmitters, tons of batteries and cords, double the

David Beckstead created a three-panel triptych of the bride getting ready for her big day. Using his Nikon D1X, a 17mm lens, and the light from the closet and the window on the far side of the room, he managed to record both scenes well, telling a nice story for this bride's album.

required amount of film or storage cards, and so on. In addition, if using AC-powered flash, extra extension cords, several rolls of duct tape (for taping cords to the floor), power strips, flash tubes and modeling lights need to be backed up. An emergency tool kit is also a good idea.

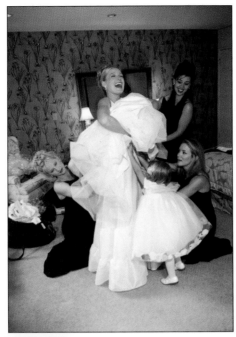

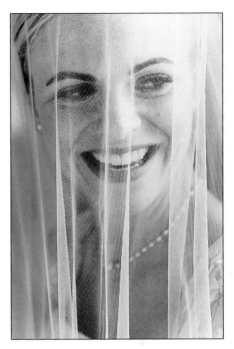

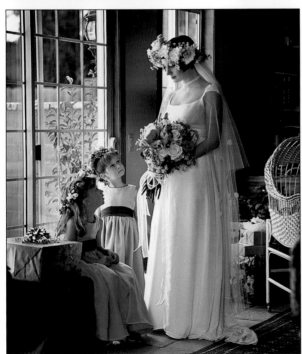

TOP LEFT—Using flash was the only way to get this image. The photographer, Becker, used on-camera flash and tilted the camera for a more dynamic composition. The flash exposure was two stops brighter than the background exposure so that the colors of the sunset became rich and saturated. He could have fired the flash at the same exposure settings as the twilight, but the colors would not have recorded so saturated. **TOP CENTER**—Becker always seems to be in the right place at the right time. Here, he used an umbrella flash to the left of the scene. The flash output matched the room exposure so that the room lights exposed normally. It seems that this bride couldn't possibly have one more person helping her. **TOP RIGHT**—Window light can resemble umbrella flash. Here, Brook Todd created a beautiful available light portrait of the bride by shooting through her veil. The soft wraparound window light elegantly contours her face. **LEFT**—Window light perfectly illuminates this trio. The white wedding dress reflects light back into the faces of the little girls, who are backlit. A silver reflector was used to the right of camera to fill in the folds of the wedding gown. Photograph by Jerry D.

Preparation and the Wedding Day

The wedding photojournalist's best weapon, so to speak, is preparedness. Knowing each phase of each couple's wedding day, when and where every event will happen, and the details of each mini-event during the day, will help build mutual confidence and rapport. It will also increase the percentage of successful shots that will be made.

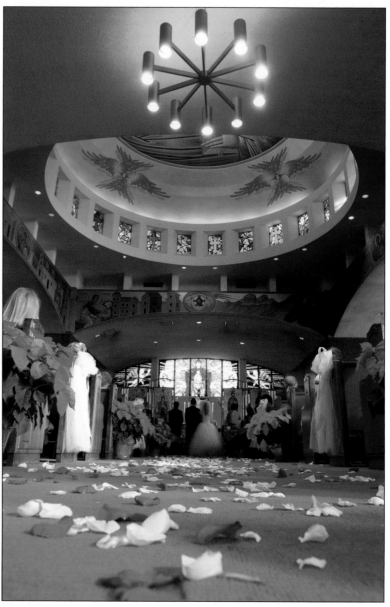

While the attendees' and celebrants' attentions were focused on the wedding ceremony, David Beckstead snapped this image from floor level. Most people probably never knew he was there. Beckstead used a Nikon D1X and 17mm lens and exposed the mixed lighting scene for $^1/_{20}$ second at f/4.5.

● MEETING WITH THE BRIDE AND GROOM

Arrange a meeting with the couple at least one month before the wedding. Use this time to take notes, formulate detailed plans, and get to know the couple in a relaxed setting. This initial meeting also gives the bride and groom a chance to ask any questions they may have. They can tell you about any special pictures they want you to make, as well as let you know of any important guests that will be coming from out of town. Make notes of all the names—the parents, the bridesmaids, the groomsmen, the best man, and the maid of honor—so that you can address each person by name. Note the color scheme, and get contact information for the florist, the caterer or banquet manager, the limo driver, the band, and so on.

● SCOUTING THE WEDDING LOCATIONS

Scheduling this pre-wedding meeting allows you a month to check out the locations and introduce yourself to the people at the various venues. As you do so, you may find out interesting details that will affect your time-table or how you must make certain shots.

When you meet with the minister or rabbi, make sure you ask about any special customs or traditions that will be part of the ceremony. At many religious ceremonies you can move about and even use flash, but it should really be avoided in favor of a more discreet, available-light approach. Besides, available light will provide a more intimate feeling to the images. At some churches you may only be able to take photographs from the back, in others you may be offered the chance to go into a gallery or the

Knowing every detail of the wedding day, down to the beautiful pearl necklace that the bride will be wearing, gives the photographer an edge in telling a richly detailed wedding story. David Beckstead photographed this beautiful image with a Nikon D1X and a 135mm lens using an exposure of $1/60$ second at f/2.8 in available light—mixed daylight and tungsten. He later brought out the overall golden tones in Photoshop.

balcony. In some cases, you may not be able to make pictures at all during the ceremony.

If you have not been there before, try to visit each venue at the same times of day as the wedding and

reception, so that you can check lighting, make notes of special locations, and catalog any potential problems you might foresee. Make detailed notes and sketches of rooms and include information like the color and height of the ceiling, windows and their locations, walls and wall coverings, and where tables and chairs will be positioned.

Look for locations for special pictures. For instance, if your couple has requested a big group portrait of all the family members and wedding party, then you might look for a high vantage point, such as a balcony over a courtyard. If you can't find such a location, you'll know you need to bring along a stepladder. The more of your shots and locations you can pre-plan, the smoother things will go on the wedding day.

The names and addresses of the vendors can also be used to generate referrals. After the wedding, send each vendor a print (or a digitally printed card) of their specialty—a close-up of the floral display, an overview of the reception before the guests arrive, a place setting, a shot of the band, etc.—with a note of thanks. It is a special touch that networks you and your business among important wedding specialists.

You should also know how long it will take to drive from the bride's home to the ceremony. Inform the bride that you will arrive about an hour before they leave. You should arrive at the church at about the same time as or a little before the groom, who should arrive about a half-hour to forty-five minutes before the ceremony. At that time you can make portraits of the groom and his groomsmen and his best man. Bridesmaids

ABOVE—Alisha Todd created this dreamlike vision of the wedding ceremony by focusing on the bridesmaid's bouquet in the foreground. Letting the bride and minister go out of focus added to the sentimental recollection of the day. Alisha says, "I squatted down behind a huge vase of flowers, trying to hide myself and not distract (I was actually trying not to breathe). I peeked out and focused on the maid of honor's bouquet while the bride and groom were facing each other, hand in hand." The minister is on the left. FACING PAGE—Award-winning Australian wedding photographer Jerry Ghionis created this beautiful dream moment of the bride in front of a dressing mirror. Ghionis doesn't pose his subjects, he "directs" them after first previsualizing the image. He prompts his subjects and creates the illusion of spontaneity and naturalness.

will arrive at about the same time. You should also determine approximately how long the ceremony will last.

● ASSISTANTS

Assistants are invaluable in covering a wedding. They can run interference for you, change film, or download

memory cards (if shooting digitally). They can organize guests for group shots, help you by taking flash readings and predetermining exposure, tape light stands and cords securely with duct tape, and tend to a thousand other chores. They can survey your backgrounds, looking for unwanted elements, and they can be a moveable light stand, holding your secondary flash.

An assistant must be trained in your unique brand of photography so that he or she knows how best to help you. At the wedding is not the time to find out that the assistant either does not understand or, worse yet, *approve* of your techniques. A good assistant will be able to anticipate your needs and help prepare you for upcoming shots. An assistant should be completely familiar with your "game plan" and know everything that you know about the details of the day.

Most assistants go on to become full-fledged wedding photographers. After you've developed confidence in

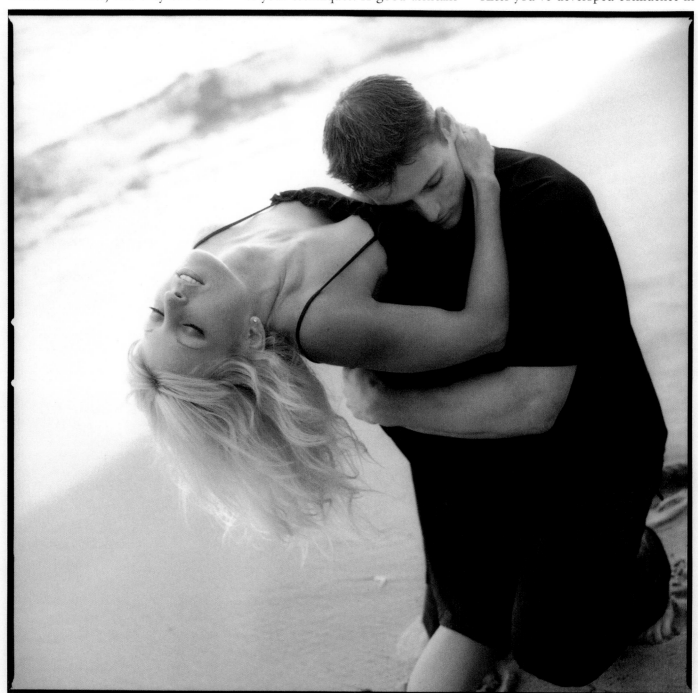

The engagement portrait offers an excellent opportunity to become acquainted with your bride and groom. Here, Tony Florez has created an award-winning portrait made at twilight. As the bride leans back her head, she is facing a beautiful softbox of late-afternoon light. The image was split-toned and printed with the negative frame edges.

an assistant, he or she can help you photograph the wedding—particularly during the reception when there are too many things going on at once for one person to cover. Most assistants will try to work for several different wedding photographers to broaden their experience. It's not a bad idea to employ more than one assistant, so that if you get a really big job, you can use both of them—or if one is unavailable, you have a backup assistant.

Assistants also make good security guards. I have heard all too many stories of photographers' gear "disappearing" at weddings. An assistant can serve as another set of eyes to safeguard the equipment.

Many husband-and-wife teams cover a wedding together, creating different types of coverage (formals vs. reportage, for example). These teams may also use assistants to broaden their coverage into a real team effort.

● **ENGAGEMENT PORTRAIT**

The engagement portrait can be a significant part of forging a good relationship with the bride and groom. Once Alisha and Brook Todd book a wedding, they call the couple once a month to check in and see how they are doing. When the contract goes

TOP—Joe Photo created this action engagement portrait of the couple riding in the desert. Joe used a Nikon D1X and an 80–200mm f/2.8 lens at the 200mm setting. He exposed the image with a "shade" setting for white balance at $^{1}/_{500}$ second at f/2.8. **BOTTOM**—This engagement portrait by Jerry D is one of his signature images. The light bouncing off the building behind the couple creates soft rim lighting, and the pose is pure romance. Jerry used Photoshop filters to diffuse the image selectively.

out to the couple, they send a bottle of Dom Perignon with a handwritten note. They soon schedule the engagement portrait, which is a stylized romantic portrait of the couple made prior to the wedding day at the location of their choice. Once the wedding day arrives, they have spent quality time with the couple and have been in touch numerous times by phone and in person. "We really try to establish a relationship first," says Brook. "It's how we do business."

Since this one image is so important to establishing a good rapport between photographer and couple, many photographers include the engagement portrait as part of their basic coverage. In other words, they don't charge extra for it.

Many couples choose to use their engagement portrait for newspaper announcements, and often the photographer will produce a set of note cards using the engagement portrait as a cover. The couple can use these as thank-you notes after they return

FACING PAGE TOP—Jerry D knew he wanted to capture the train zooming past but wanted to freeze his couple and get a cobalt blue sky. Using a slow shutter speed of around $^1/_{15}$ second blurred the train. A flash, positioned to the left of camera, exposed the train and couple perfectly. Jerry underexposed the sky by about two stops to oversaturate the colors. A wide-angle lens makes the image a panoramic with a "Hollywood" feeling. **FACING PAGE BOTTOM**—Jeff and Kathleen Hawkins created this image of the bride by removing most of the detail from the image in Photoshop. The original image was reduced to only a few tones in Photoshop and the contrast increased. The red lipstick and lips were also created in Photoshop. The effect is stark, but beautiful. **RIGHT**—There are some pictures that almost take themselves. Here, Becker came across a young man in the wedding party whose look is perfect. Note the multiple cowlicks. Becker photographed the scene with available light from nearby windows. **BELOW**—Carrillo has flawless timing when it comes to capturing the decisive moment. As part of the entourage while the bride and her bridesmaids were getting ready, Carrillo used backlighting, very fast film, and quick reflexes to record this priceless image. In case you're not sure, they are all looking at the bride's (left) image in a mirror, which is not pictured. Carrillo, as far as those pictured were concerned, was not even there, which is exactly what the wedding photojournalist strives for.

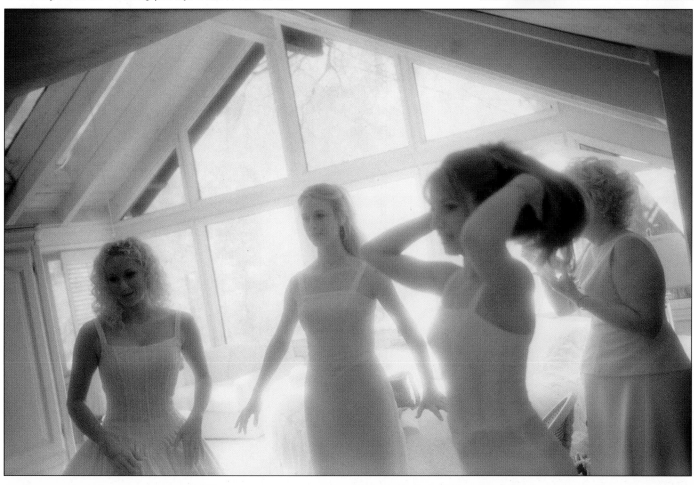

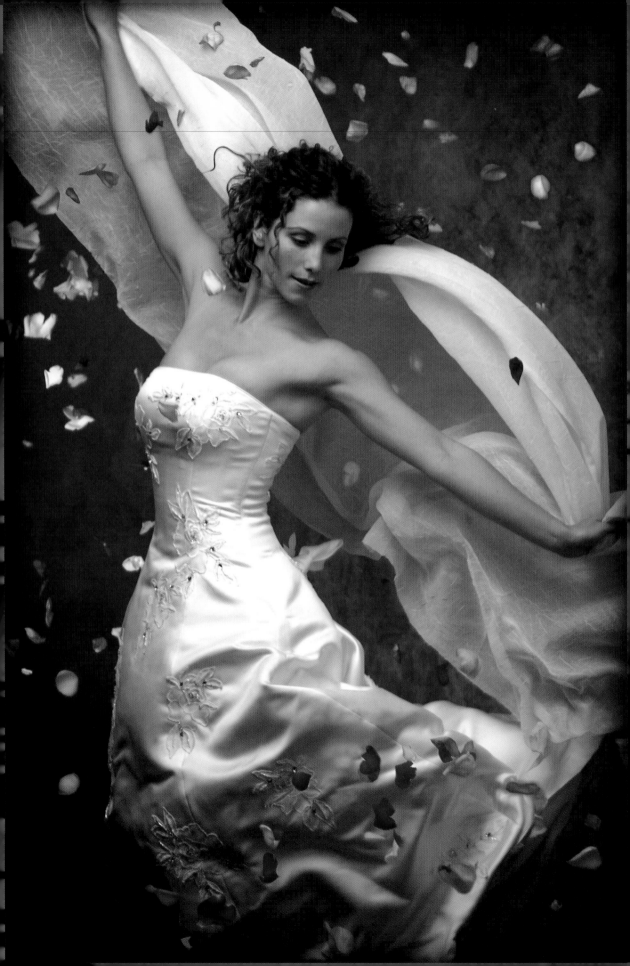

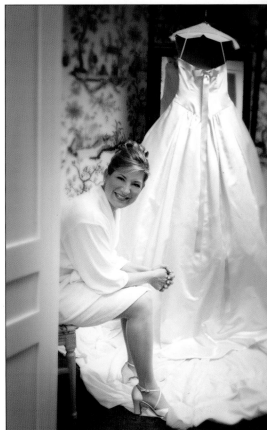

from the honeymoon (they can be delivered to the bride's mother before the wedding or while the couple is away).

● **PRE-CEREMONY COVERAGE**

Generally, the actual wedding photography begins at the bride's home, as she is preparing for her big day. Some of the most endearing and genuine photographs of the day can be made at this time. By being a good observer and staying out of the way, you are sure to get some great shots, as everyone's emotions are on his or her sleeves. Don't forget to include the maid of honor and/or the bride's mother, both of whom are integral to the bride's getting ready.

It is important to avoid photographic clichés and instead, be alert for the unexpected moment. There are all too many photos of the bride looking into the mirror as she gets ready. In fact, the photographer does not have to rely at all on clichés, as there is usually an abundance of good photo opportunities. Since the ceilings of most homes are quite low, and upstairs bedrooms often have multi-

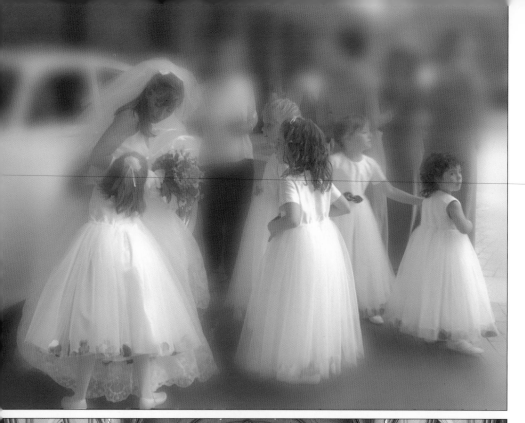

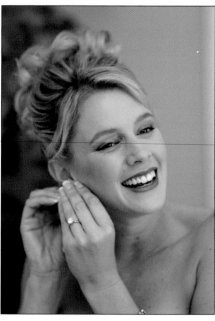

TOP LEFT—What a shot! Five little brides-to-be surround the bride. Clay Blackmore, understanding that the car and background only distracted from what the picture was really all about, used Photoshop to soften everything but the ladies. BOTTOM LEFT—This church scene is a fine-art photograph made by Robert Hughes, who is a huge fan of the cathedrals in Europe. He took great care in aligning verticals and exposing the scene so that detail is visible throughout the image. ABOVE—Joe Photo observes and records without ever being noticed. Here, he captured the bride putting on her earrings and reacting to a funny comment. Joe created the image with his D1X, 85mm f/1.4 lens and Nikon Speedlight in bounce mode. The exposure was $^1/_{320}$ second at f/1.4 with his ISO sensitivity set to E.I. 800.

ple windows, you can expect to get by with either exposing these images by bounce flash or by available light.

During this process, tensions are high and you must tread lightly. Choose your moments and don't be afraid to step back and get out of the way once you have been admitted, which will usually be when the bride is almost ready. It is important not to wear out your welcome at the bride's home.

Although you should arrive an hour or more earlier (before the bride is due to arrive at the ceremony), you should be prepared to depart in time to arrive at the ceremony at the same time as the groom. Photographing him before the ceremony will also produce some wonderful shots, and it is a great time to create both formal and casual portraits of the groom and his groomsmen. Although he won't admit it, the groom's emotions will also be running high and this usually leads to some good-natured bantering between the groom and his friends.

If you have an assistant or are shooting the wedding as a team, have your counterpart be prepared to handle the groom at the ceremony, while you finish up with the bride at her home.

This is also a good time to capture many of the details of the wedding attire. The flowers being delivered at the bride's home, for instance, can make an interesting still life, as can many other accessories for the wedding-day attire. The groom's boutonniere is another stylish image that will enhance the album.

● **PHOTOGRAPHING THE CEREMONY**
Before the guests arrive is a good time to create an overall view of the church, as no two weddings ever call for the same decorations. If there is an overhead vantage point, like a choir loft, this is a good place to set up a tripod and make a long exposure with good depth of field so that everything is sharp. This kind of record shot will be important to the historic aspects of the wedding album.

Bride's Arrival. When the bride arrives at the ceremony and is helped out of the car, sometimes by her dad, there are ample opportunities for good pictures. It isn't necessary to choreograph the event as there is plenty of emotion between the bride and her father. Just observe, be ready, and you will be rewarded with some priceless images.

Procession. When the bridesmaids, flower girls, ring bearers, mother of the bride, and the bride herself (sometimes with her dad) come up the aisle, you should be positioned at the front of the church so that the participants are walking toward you. If part of a shooting

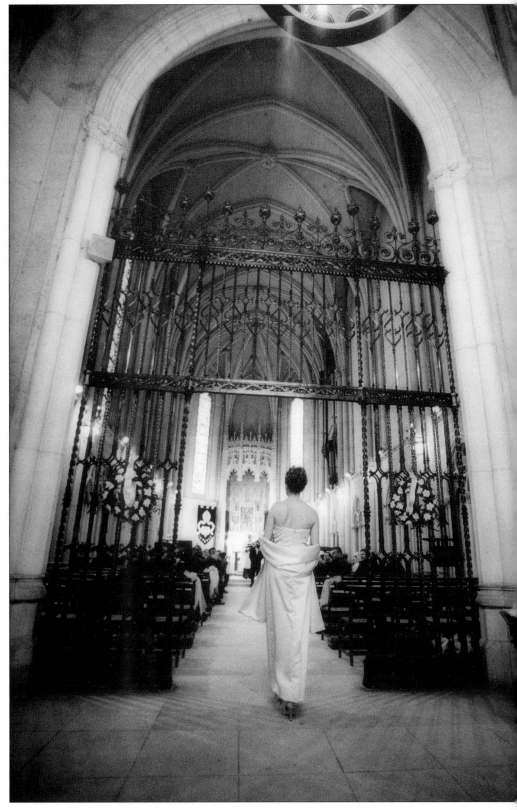

Alisha Todd captured this beautiful scene as one of the bridesmaids made her way down the aisle. She captured the image by available light with a 17–35mm lens set at 17mm, so that all of the architecture would be an integral part of the image. The image was recorded on T-Max 3200.

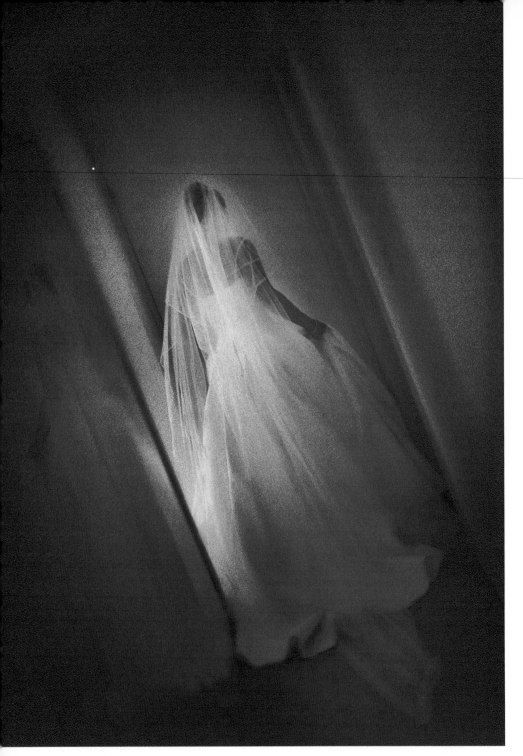

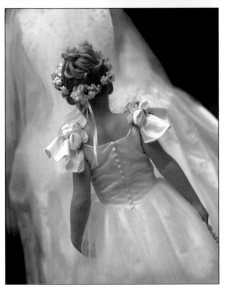

team, have another photographer positioned at another location so that you can get multiple viewpoints of this processional.

Ceremony. Once the ceremony begins, you should be as discreet and invisible as possible, shooting from an inconspicuous or even hidden vantagepoint and working by available light. Often a tripod will be necessary as exposures, even with a fast ISO setting, may be on the long side—like $\frac{1}{15}$ second. Weddings are solemn occasions. While the ceremony will present many emotion-filled moments, its sanctity is more important than the photographer or even the pictures, so prioritize the event by being as discreet as possible. Do be alert for surprises, though, and pay special attention to the children, who will do the most amazing things when immersed in a formalized ritual like a wedding ceremony.

For the ceremony, try to position yourself so that you can see the faces of the bride and groom, particularly the bride's face. This will usually place you behind the ceremony or off to the side. This is when fast film and fast, long lenses are needed, since you will almost surely be beyond the range of an 80–200mm zoom, the wedding photojournalist's most often-used lens. Look for the tenderness between the couple and the approving expressions of the best man and maid of honor. Too many times the photographer positions him- or herself in the congregation so that the person performing the ceremony is facing the camera. Quite honestly, the minister or rabbi will not be purchasing any photographs, so it is the faces of the bride and groom that you will want to see.

Exit. You must be aware that if you are behind the ceremony, you cannot immediately bolt to the back of the church or synagogue to capture the bride and groom walking up the aisle as man and wife. This is when it is important to have a second shooter, who can be perfectly positioned to capture the bride and groom and all of the joy on their faces as they exit the church or synagogue for the first time as man and wife.

Be aware of changing light levels. Inside, the church will be at least three to four stops darker than the

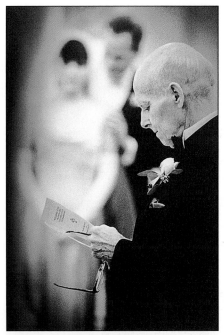

RIGHT—Joe Buissink recorded a subtle moment from the wedding ceremony. The father of the bride reads the "program" to see what is coming next, as the bride and groom stand lovingly in soft focus—the two scenes are delightfully in contrast to each other. Master printer Robert Cavalli made the final print. **BELOW**—The solemnity of the Greek Orthodox wedding ceremony as well as the strength of the emotions of the bride and groom are recorded in this single, telling image by Joe Buissink.

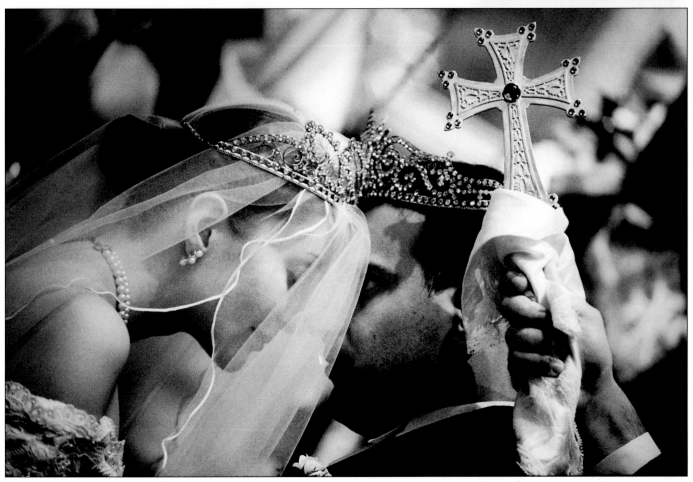

vestibule or entranceway. As the couple emerges toward daylight, the light will be changing drastically and quickly. Know your exposures beforehand and anticipate the change in light levels. Many a gorgeous shot has been ruined by the photographer not changing exposure settings to compensate for the increased light.

When photographing the bride and groom as they are leaving the church, include the door frame as a

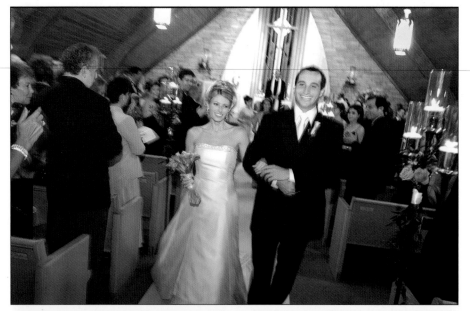

LEFT—Look at the joy on these faces as the brand new couple emerges from the ceremony. Michael Schuhmann recorded this scene with on-camera flash and a slow shutter speed, so all of the different lighting (daylight, tungsten, and flash) mixed and matched. BELOW—Robert Hughes created this Impressionist version of the head table, transforming it into a work of art. Sure to be loved by the couple, it would also make a beautiful card to send to the banquet manager or maitre d' after the wedding.

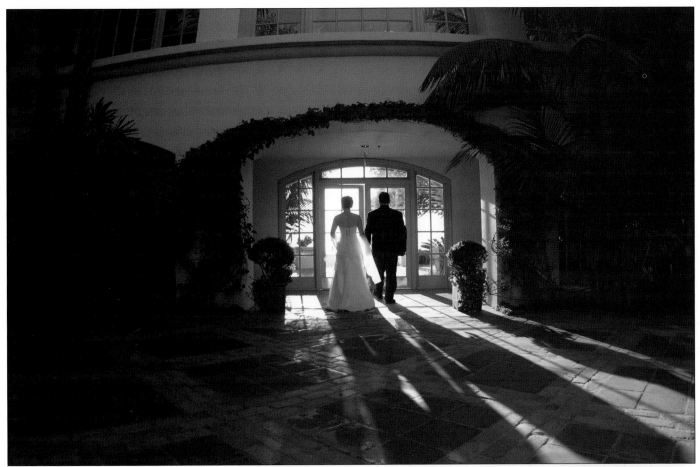

reference. If photographing from the side, try to position yourself on the bride's side, so she is nearest the camera. Because of diminishing perspective, if the groom is in the foreground of your picture, the bride will look even smaller than she might be in reality—or she might be blocked from the camera view.

If there is to be a rice/confetti/ bubble toss, these are best photographed with a wide-angle lens from close up, so that you can see not only the bride and groom, but also the confetti (rice or bubbles) and the faces of the people in the crowd. While the true photojournalistic purist would never choreograph a shot, many such successful shots have been made by working with the outdoor crowd so that they toss their confetti (or whatever) on your signal. Be sure to tell them to throw the stuff

TOP—Joe Photo made this wonderful shot of the bride and groom and their shadows entering the reception hall. Joe used a Nikon D1X, 16mm f/2.8 lens, and exposed this image at $^{1}/_{320}$ at f/2.8 at an E.I. 800 film speed setting. **ABOVE LEFT**—The details of the wedding reception are often, by themselves, objets d'art. These images make important contributions to the overall scope and beauty of the finished album. Photograph by Phil Kramer. **ABOVE RIGHT**—Unobserved by most, this instant where the bride leaned down to console an out-of-sorts flower girl in a very grown-up hat is utterly charming. Notice the older flower girl trying to be "good" in the light of such anarchy—imagine; sitting down on the job! Photograph by Joe Buissink.

above the head height of the bride and groom so that it descends into your photograph. Give them a signal count of "On three . . . 1-2-3!" While it may be choreographed, it will look unstaged as the bride and groom will be unaware of your planning and will undoubtedly flinch when they see the rice/confetti in the air. This type of scene is best photographed with two photographers, both shooting motor-driven cameras.

Many photographers who love photographing weddings have told me that they get overwhelmed sometimes by the emotion of the wedding event. This is easy to do, particularly if you relish the ritual and the tenderness of the wedding ceremony—in short, if you're a hopeless romantic.

The best way to keep your emotions in check is to intellectually focus on every detail of the event. Immersing yourself in the flow of the wedding and its details and not the emotion of the ceremony will help you to be more objective. Although still allowing you to remain sensitive to all of the nuances, this mind set will not hinder your performance.

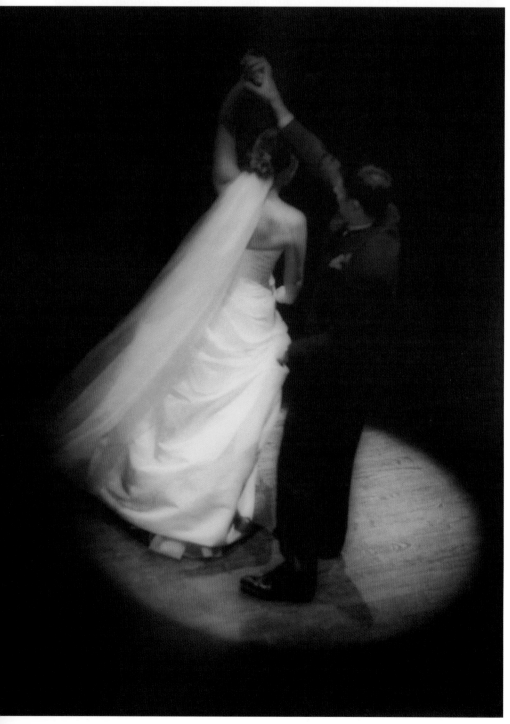

● RECEPTION

Since the bride and groom are so pre-occupied at the reception, they actually get to see very little of it. Therefore, they will depend on your pictures to provide the priceless memories. You will want to photograph as many of the details and events of the reception as possible.

Overviews. Before anyone enters the reception, you should make several good overviews of the decorated room. This should be done just before the guests enter, when the candles are lit and everything looks perfect. Be sure to photograph the details—table bouquets, place settings, name cards, etc., as these help enrich the finished wedding album.

Key Players. The photo opportunities at the reception are endless. As the reception goes on and guests relax, the opportunities for great pictures will increase. Be aware of the bride and groom at all times, as they

Is this image particularly sharp? Definitely not; it's lit by a spotlight from a balcony high above the dance floor. Is it charming and one of the finest wedding images ever? Decidedly, yes. This image, by Brook Todd, captures the spontaneity and elegance of all weddings in a single swirl. This image could be from 1932 or 2032. It's a signature image.

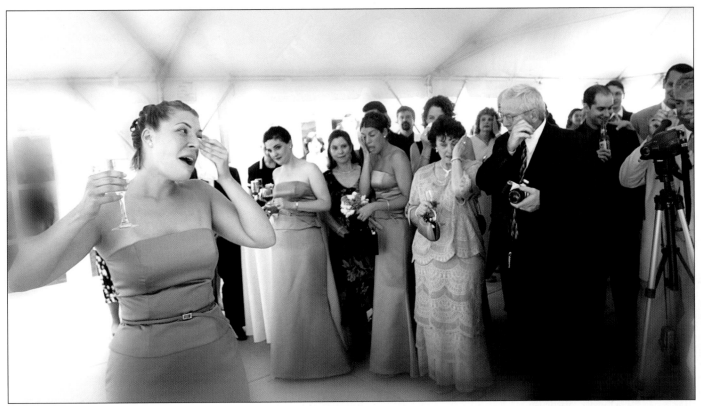

are the central players. Fast zooms and fast film speeds will give you the best chance to work unobserved.

Scheduled Events. Be prepared for the scheduled events at the reception—the bouquet toss, removing the garter, the toasts, the first dance, and so on. If you have done sufficient preparation, you will know where and when each of these events will take place and you will have prepared to light and photograph them. Oftentimes the reception is best lit with a number of corner-mounted umbrellas, triggered by your on-camera flash. That way, anything within the perimeter of your lights can be photographed by strobe. Be certain you meter various areas within your lighting perimeter so that you know what your exposure will be everywhere within the reception area.

One of the key shots at the reception is the cutting of the wedding cake. This is often a good opportunity to make an overhead group shot of the crowd surrounding the bride and groom. Bring along a stepladder for these types of shots. A second shooter is a good idea in these situations so that details and priceless moments won't be missed.

Also, be sure to get a still life of the cake before it is cut. Both the couple and the baker/caterer will want to see a beautiful shot of their creation.

The first dance is another important moment in the reception, and one that you will want to document thoroughly. Don't turn it into a cliché. Just observe, try to shoot it with multiple shooters so as not to miss the good expressions, and you will be rewarded with emotion-filled, joyful moments.

The bouquet toss is one of the more memorable shots at any wedding reception. Whether you're a photojournalist or traditionalist, this shot always looks best when it's spontaneous. You need plenty of depth of field, which almost always dictates a

It must have been a heck of a toast! Everyone has completely lost it and is now wiping the tears from their eyes. The only one who hasn't lost it is Charles Maring, the photographer who made this image.

wide-angle. You'll want to show not only the bride but also the expectant faces in the background. Although you can use available light, the shot is usually best done with two flashes—one on the bride and one on the ladies hoping to catch the bouquet. Your timing has to be excellent, as the bride will often "fake out" the group (and you), just for laughs. Try to get the bouquet as it leaves the bride's hands and before it is caught and if your flash recycles fast enough, get a shot of the lucky lady who catches it. Of course, if you have enough light to shoot this scene by available light, then use a motor drive and blast away.

Table Shots. These are the bane of every wedding photographer's existence. Table shots rarely turn

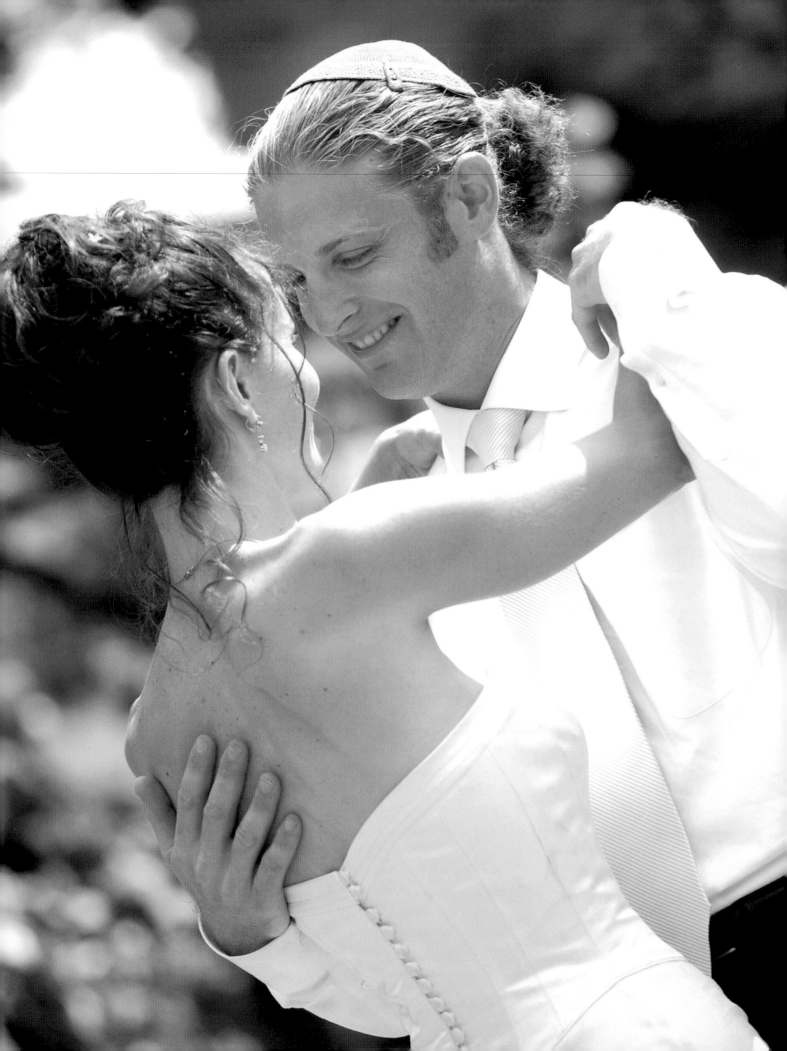

out well, are rarely ordered, and are tedious to make. If your couple absolutely wants table shots, ask them

FACING PAGE—Mike Colón photographed the first dance at this outdoor wedding with a Nikon D1X and 80–200mm f/2.8 lens (at the 155mm setting) using an exposure of $^1/_{2500}$ at f/2.8 with an E.I. 400 film speed setting. He used the maximum lens aperture to keep the depth of field to a minimum. He also tilted the camera to improve the dynamics of the image. RIGHT—Capturing the fun and frivolity of the moment, Michael Schuhmann made this image at an exposure setting of $^1/_{10}$ second at f/3.5, with on-camera flash set to +0.7 EV, and film speed set to E.I. 400. Because Schuhmann set the exposure settings to record the ambient lights in the background, the flash exposure matches. BELOW—Joe Photo got the bride enjoying herself during this wacky circle dance. Joe used the Nikon D1X's "slow-sync" flash mode and on-camera Nikon SB-flash to capture the bride in sharp focus with flash, while the ambient light illuminated of the rest of the scene. This is commonly referred to as dragging the shutter. Note the secondary flash, slaved to the on-camera flash, going off in the background.

to accompany you from table to table. That way they can greet all of their guests, and it will make the posing quick and painless. You might also consider talking the couple into one big fun group that encompasses nearly everyone at the reception. These are always fun to participate in and to photograph.

Being Prepared. The reception calls upon all of your skills and instincts. Things happen quickly. Don't get caught with an important event coming up and only two frames left in the camera. Use two camera bodies and always have plenty of exposures available—even if it means changing rolls (or cards) when they

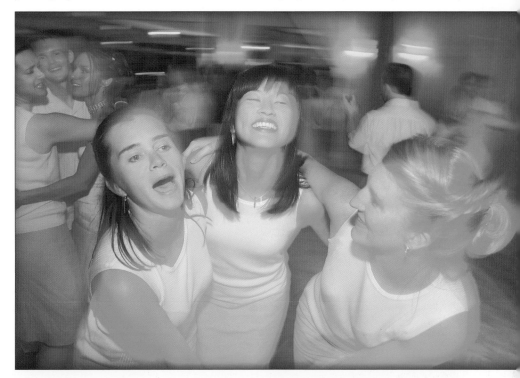

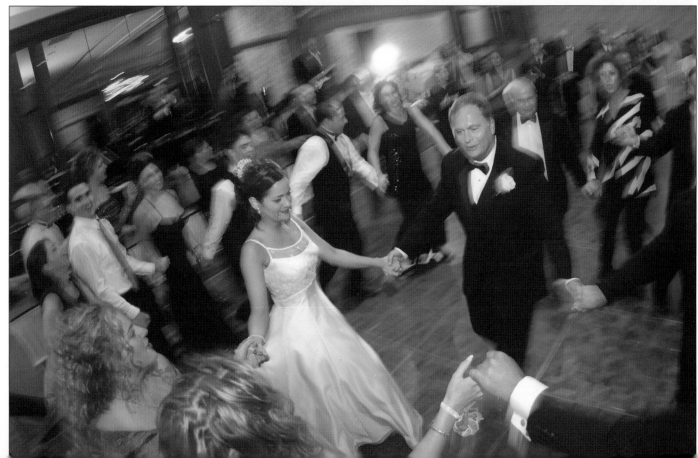

After the ceremony, Marcus Bell positioned himself outside the little church and knew he had to include the incredible late after-noon sky. Using a very wide lens that took in the pie-shaped street, Bell created a wonderful portrait of the moment. While the couple embraces, the kids blow bubbles, unaware of the incredible joy and beauty surrounding them. What at first seems to be a "snapshot," on closer examination is really a remarkable wedding moment in the style of Norman Rockwell.

are not completely finished. People are having a great time, so be cautious about intruding upon events. Watch the flow of the reception and choose your vantage point for each shot carefully. Coordinate your efforts with the wedding coordinator or banquet manager, whomever is in charge. He or she can run interference for you as well as cue you when certain events are about to occur, often not letting the event begin until you are ready.

The wedding photojournalist must learn to get shots without alert-ing the people being photographed. Some photographers walk around the reception with their camera held low, but with both hands in position on the camera so that they can instantly raise the camera to eye level, frame, and shoot. Still others will use a wide-angle lens prefocused at an intermedi-ate distance like eight feet (or set to autofocus) and set to the proper exposure settings. With the camera at waist or hip height, the photographer will wander around the reception, mingling with the guests. When a

shot seems to be taking place, they will aim the camera up toward the people's faces and fire, never even looking through the viewfinder. It's a great way to get unobserved expres-sions. Autofocus and autoexposure modes will take care of the technical side of things and all the photogra-pher has to do is concentrate on the action and the scene.

The final shot of the day will be the couple leaving the reception, which is usually a memorable photo. Like so many events at the reception,

planned and spontaneous, it is best to have as many angles of the event as possible, which is why so many wedding photojournalists work with a shooting partner or assistants.

Pole Lighting. Many photographers employ an assistant at the reception to walk around with a barebulb flash attached to a monopod. The strobe is slaved and can be triggered by a radio transmitter on the camera or by an on-camera flash. The pole light can be positioned anywhere near the subjects and can be set to over-power the on-camera flash by one or two f-stops so that it becomes a key light. Your assistant should be well versed in the types of lighting you like to create with this rig. For instance, if he or she is at a 45-degree angle to the subject and the light is held about four feet over the subject's head height, the resulting lighting will resemble Rembrandt-style portrait lighting. If you prefer to backlight your subjects, then your assistant can position himself behind the group to create a rim lighting effect.

Robert Hughes often uses this technique of lighting the reception hall. He says, "Since most of our reception shots are at f/2.8, we need just a 'wink' from the room lights. I also have a roving light, a Lumedyne. An assistant roams with this and I

RIGHT—Charles Maring created this wonderfully stylized image of the sax player during the reception. He softened the image substantially so that the sax was sharp, relatively, and everything else in the image was diffused. He also altered the tone of the image in Photoshop. **BELOW**—What a great idea! Instead of bothering everyone in sight during the crucial part of the ceremony, David Beckstead decided to peer over the shoulder of an amateur videographer. He made the image with a Fuji FinePix S2 Pro, using an 80–200mm f/2.8 lens set to 100mm, at an exposure setting of $^1/_{250}$ at f/2.8. The ISO setting was E.I. 800. Beckstead made sure his background was free of distractions before making the shot.

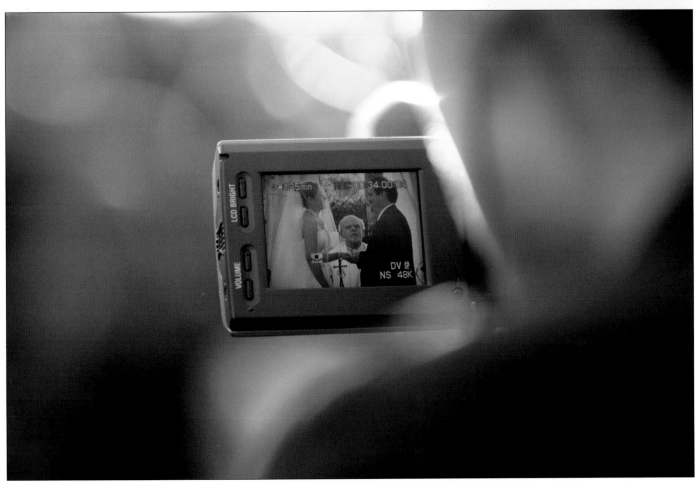

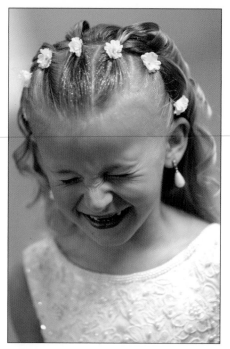

will go 'off' and 'on' channels on the radio remote to create the most appropriate lighting for the scene."

Videographers' Lighting. If a wedding video is being produced, you will have the luxury of the videographer rigging and lighting the reception hall with hot lights—usually quartz halogen lights, which are very bright and will make your reception photography much easier. The only problem is that you will have to color correct your film (or adjust your white balance, if shooting digitally) to compensate for the change in color temperature of the quartz lights.

● RINGS

The bride and groom usually love their new rings and would surely like a shot that includes them. A close-up of the couple's hands displaying their new rings makes a great detail image in the album. You can use any type of attractive pose, but remember that hands are difficult to pose. If you want a really close-up image of the rings, you will need a macro lens, and you will probably have to light the scene with flash, unless you make the shot outdoors or in good light.

● LITTLE ONES

One of the best opportunities for great pictures comes from spending some time with the smallest attendees and attendants—the flower girls and ring bearers. They are thrilled with the pageantry of the wedding day, and their involvement often offers a multitude of picture opportunities.

TOP LEFT—Both the bride and groom love their new rings and a shot of them is in order for the wedding album. Most photographers opt for the rings-and-hands-entwined shot. Because the ring bearer also had a silver platter on which to carry the rings, Kevin Kubota decided to photograph them this way, with the rings in sharp focus and the smiling ringbearer in the background. **TOP RIGHT**—Joe Photo created this wonderful shot of a flower girl in the midst of a huge giggle. Children bring great emotion and fun to such a formal event as a wedding. The image was made with a Nikon D1X and 85mm f/1.4 lens. The exposure was ¹/₂₀₀ at f/1.4. **BOTTOM LEFT**—Mercury Megaloudis created this priceless image of two kids at a wedding using available mid-afternoon light. **BOTTOM RIGHT**—Mike Colón captured this unforgettable wedding shot with his Nikon D1X and a 80–200mm f/2.8 lens at the 135mm setting at E.I. 500. His exposure setting was ¹/₆₀ at f/2.8 in the fading daylight.

"Formals"

Even as a wedding photojournalist, there are a set number of formals that must be made at every wedding. These are posed, controlled portraits in which the subjects are well aware of the camera and the principles of good posing and composition are essential. For those times, and because any good wedding photographer not aware of the traditional rules of posing and composition is deficient in his or her education, the basics are included here.

In any photojournalistic wedding, up to 15 percent of the coverage may be groups and formals. This is simply because gatherings of this type bring together many people from the couple's lives that may never be assembled together again, that it is imperative that pictures be made to commemorate this event. Also, brides and families want to have a formal remembrance of the day, which may include the formal portraits of bride alone, groom alone, bride and groom together, bride and bridesmaids, groom and groomsmen, full wedding party, family of the bride, family of the groom, and so on. These requests are something that the couple expects the photographer to make on the day of their wedding.

As you will see, formals and groups done by a contemporary wedding photojournalist differ greatly from the stiff "boy–girl, boy–girl" posing of the traditional wedding photographer, where everyone is looking directly into the camera lens. A lot of imagination goes into the making of these formals, and many times one cannot really tell that the photographer staged the moment. The photographer preserves the naturalness and spontaneity in keeping with the photojournalistic spirit.

Wedding photojournalists draw a great deal from editorial and advertising photography. In fact, many of the more famous wedding photojournalists often do work for some of the bridal magazines, illustrating new bridal fashions and trends. The fact that these pictures are posed and highly controlled doesn't seem to diminish their popularity among brides. The images have a certain style and elegance, regardless of whether or not the subjects are "looking into the camera." The purists of wedding photojournalism have termed this type of photography, somewhat cynically, "faux-tojournalism."

The rigors of formal posing will not be seen in these photos. But knowledge of posing fundamentals will increase the likelihood of capturing people at their best—a flattering likeness. No matter what style of photography is being used, there are certain posing essentials that need to be at work, otherwise your technique (or lack

ABOVE—This glamorized portrait of the bride by Robert Hughes has an informal air about it, yet it displays excellent posing fundamentals. **RIGHT**—This delicate portrait by Bambi Cantrell illustrates the classic three-quarter view of the face, in which the far ear is hidden from the camera and one side of the face is prominent. Bambi performed a little Photoshop magic to create a very blended lighting effect. **FACING PAGE**—This unusual infrared formal was made by Anthony Cava. The "separate but together" style of this portrait is a very popular editorial style. Notice both subjects have their weight on their back feet; the groom so much so that his front foot is actually coming off the ground!

of it) will be obvious. The more you know about the rules of posing and composition, and particularly the subtleties, the more you can apply to your wedding images. And the more you practice these principles, the more they will become second nature and a part of your overall technique.

● THE HEAD-AND-SHOULDERS AXIS

One of the basics of good portraiture is that the subject's shoulders should be turned at an angle to the camera. With the shoulders square to the camera, the person looks wider than he or she really is. Simultaneously, the head should be turned a different direction than the shoulders. This provides an opposing or complementary line within the photograph; when seen together with the line of the body, this creates a sense of tension and balance. With men, the head is often turned the same general direction as the shoulders (but not exactly the same angle), but with women, the head is usually turned toward the near shoulder for the classic "feminine" pose (see above left).

Arms should not be allowed to fall to the subject's sides, but should project slightly outward to provide gently sloping lines and a "triangle base" for the composition. This is achieved by asking the subjects to move their arms away from their torsos. Remind them that there should be a slight space between their upper arms and their torsos. This triangular base in the composition visually attracts the viewer's eye upward, toward the face.

● WEIGHT ON THE BACK FOOT

The basic rule of thumb is that no one should be standing at attention, both feet together. Instead, the front foot should be brought forward slightly. The subject's weight should generally be on the back leg/foot. This has the effect of creating a bend in the front knee and dropping the rear shoulder slightly lower than the forward one. When used in full-length bridal portraits, a bent forward knee will give an elegant shape to the dress. With one statement, "Weight on your back foot," you have introduced a series of dynamic lines into an otherwise static composition.

● HEAD POSITIONS

The face should be viewed from an angle so that more planes of the face are visible; this is much more attractive than a full-face portrait. There are three basic head positions (relative to the camera) in portraiture. With all of these head poses, the shoulders should be at an angle to the camera.

The Seven-Eighths View. This is when the subject is looking slightly away from the camera. If you consider the full face as a head-on "mug shot," then the seven-eighths view is when the subject's face is turned just slightly away from camera. In other words, you will see a little more of one side of the subject's face. Usually, you will still see both of the subject's ears in a seven-eighths view.

The Three-Quarters View. This is when the far ear is hidden from the camera and more of one side of the face is visible. With this pose, the far eye will appear smaller because it is farther away from the camera than the near eye. It is important when posing subjects in a three-quarter view to position them so that the smallest eye (people usually have one eye that is slightly smaller than the other) is closest to the camera. This way both eyes appear, perspective-wise, to be the same size in the photograph. It is important to note that you do not have the luxury of much time in posing groups of people at a wedding,

LEFT—Jerry D created this elegant portrait in which the bride is in a seven-eighths view—her face is turned just slightly away from camera. Jerry used a great deal of Photoshop manipulation to blur and diffuse the image for just the right stylized look. Notice how the highlights are "blown out," with no detail—this is an intentional effect, making the skin look almost like smooth white marble. **ABOVE**—This beautiful formal image of the bride was taken as she emerged from Castle Green. Photographer Carrillo may have supplied some direction, particularly what to do with her veil, but the result is a stylishly staged moment that captures all the glamour of the day.

but when photographing the bride and groom, care should be taken to notice the subtleties.

Profile. In the profile, the head is turned almost 90 degrees to the camera. Only one eye is visible. When photographing profiles, adjust your camera position so that the far eye and eyelashes disappear.

Knowing the different head positions will help you provide variety and flow to your images. In group portraits, you may need to incorporate more than one of the head positions. At times, you may end up using all three head positions in a single group pose. The more people in the group, the more likely that becomes.

● THE GAZE

The direction the person is looking is important. If the subject is aware of your presence, start by having the person look at you. If you step away slightly and engage your subject in conversation, allowing you to hold the subject's gaze, you will create a slight rotation to the direction of the face. You can also have the person look away from you until you best utilize the light and flatter your subject. One of the best ways to enliven the subject's eyes is to tell an amusing story. If they enjoy it, their eyes will smile—one of the most endearing expressions that people can make.

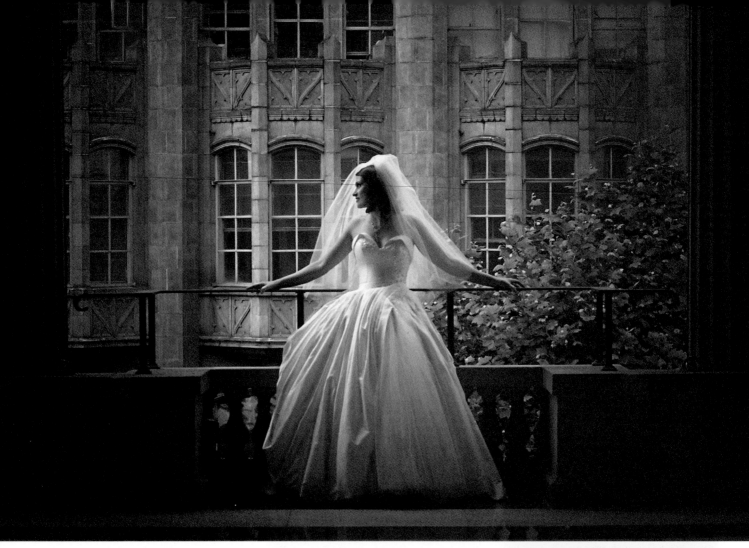

One of the best photographers I've ever seen at "enlivening" total strangers is Ken Sklute. In almost every image he makes, the people are happy and relaxed in a natural, typical way. Nothing ever looks posed in his photography—it's almost as if he happened by this beautiful picture and snapped the shutter. One of the ways he gets people "under his spell" is his enthusiasm for the people and for the excitement of the day. His enthusiasm is contagious, and his affability translates into attentive, happy subjects.

● HANDS

Hands can be strong indicators of character, just as the mouth and eyes are. However, hands are very difficult to photograph, because in most portraits they are closer to the camera

ABOVE—Australian photographer Mercury Megaloudis harnessed the soft, directional sidelight and created a pose that flattered the bride and revealed her richly detailed wedding dress. The image was captured with a Canon EOS D30 and 70mm lens at $\frac{1}{60}$ at f/6.7. Mercury darkened the corners of the image in Photoshop so that the bride and elegant background would dominate the portrait. Notice how simply and elegantly her hands are posed and the relaxed nature of the pose. **RIGHT**—This small but delicate portrait of a bride and groom is by Michael Schuhmann. The focal point of the portrait is the connection made by their hands touching. They appear to be meeting for the first time as husband and wife. Hands are very often an expressive element of the image.

than the subject's head, and thus appear larger. One thing that will give hands a more natural perspective is to use a longer lens than normal (an

80–200mm in the 35mm format). Although holding the focus of both hands and face is more difficult with a longer lens, the size relationship

between them will appear more natural. If the hands are slightly out of focus, it is not as crucial as when the eyes or face of the portrait are soft.

One should never photograph a subject's hands pointing straight into the camera lens. This distorts the size and shape of the hands. Always have the hands at an angle to the lens, and if possible, try to bend the wrist to produce a gentle sloping line. Try to photograph the outer edge of the hand when possible. This gives a natural, flowing line and eliminates distortion. As generalizations go, it is important that the hands of a woman have grace and the hands of a man have strength.

● **CAMERA HEIGHT**

When photographing people with average features, there are a few general rules that govern camera height in relation to the subject. These rules will produce normal, undistorted perspective. For head-and-shoulders portraits, the rule of thumb is that camera height should be the same as the tip of the subject's nose. For three-quarter-length portraits, the camera should be at a height midway between the subject's waist and neck. In full-length portraits, the camera should be the same height as the subject's waist.

ABOVE—This Joe Buissink image is highly stylized and has been altered in printing so that much of the original information in the negative has been deleted. The bend of the wrist, the self-confident smile and the line of the flowing veil combine to make this an unforgettable wedding image. **RIGHT**—In another interesting portrait by Michael Schuhmann, hands are again a prominent part of the image. Taken with a Nikon D1X and 16mm lens from close up, Schuhmann uses the natural distortion of this lens to create a stylized image that reveals the bride's rings and bouquet. Notice how her hands are flattened and the fingers separated for good perspective.

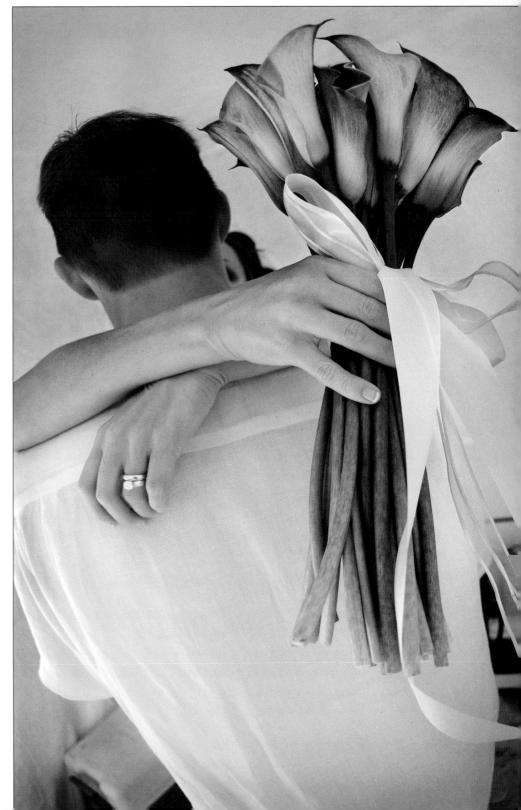

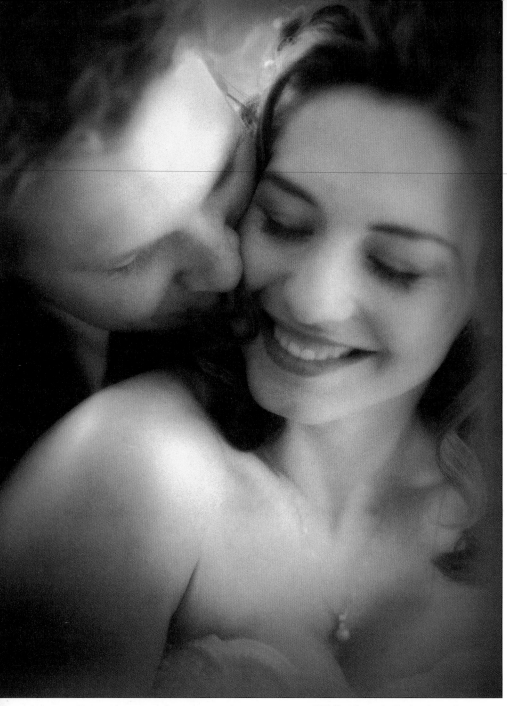

LEFT—Carrillo has such a good eye that his wedding images never reveal any posing or manipulation on his part. This formal portrait is made intimate by his choice of camera height, which is perfectly in the middle between the top and bottom of the frame. Aside from rendering the best perspective with no distortion, it is an intimate viewpoint—as if you were peeping through a keyhole, seeing this incredible picture. **ABOVE**—A wedding portrait from the early 1900s? No, it's a Martin Schembri–made contemporary wedding portrait created to resemble a turn-of-the-century photograph. It is grainy, the light level is low, but the posing of the bride, who is only defined by highlights, is incredible. Her gaze, which is looking away from the groom, is Victorian in nature and coincides with the style of the portrait.

In each case, the camera is at a height that divides the subject into two equal halves in the viewfinder. This is so that the features above and below the lens/subject axis will be the same distance from the lens, and thus recede equally for "normal" perspective. As you will see, when the camera is raised or lowered, the perspective (the size relationship between parts of the photo) changes. This is particularly exaggerated when wide-angle lenses are used.

While there is little time for many such corrections on the wedding day, knowing these rules and introducing them into the way you photograph people will make many of these techniques second nature.

● **THREE-QUARTER- AND FULL-LENGTH POSES**

It should be noted that, in any discussion of subject posing, the two most important goals are that the pose appear natural (one that the person would typically fall into), and that the person's features be undistorted. When you photograph a person in a three-quarter- or full-length pose, you have arms, legs, feet, and the total image of the body to deal with as you pursue these goals.

A three-quarter-length portrait is one that shows the subject from the head down to a region below the waist. Such portraits are usually best composed by having the bottom of the picture fall mid-thigh or mid-calf.

Never break the portrait at a joint—a knee or ankle, for example (or an elbow, in the case of shorter views). Crop between joints instead. When you break the composition at a joint, it produces a disquieting feeling to the photograph.

A full-length portrait shows the sitter from head to toe. A full-length shot can show the subject standing or sitting, but it is important to angle the person to the lens—usually at 30–45 degrees to the camera, with their weight on their back foot. Feet

should point at an angle to the camera. Just as it is undesirable to have the hands facing the lens head-on, so it is with feet. Feet look stumpy when shot head-on.

● **HEAD-AND-SHOULDERS PORTRAITS**

In a head-and-shoulders portrait, all of your camera technique will be evident, so the focus is especially critical (start with the eyes), and lighting must be flawless.

With close-up portraits, it is important to tilt the head and retain good head-and-shoulders positioning. The shoulders should be at an angle to the camera lens, and the angle of the person's head should be slightly different. Often, head-and-shoulders portraits are of only the face—as in a beauty shot. In this case, it is important to have a dynamic element, such as a diagonal line, which will create visual interest.

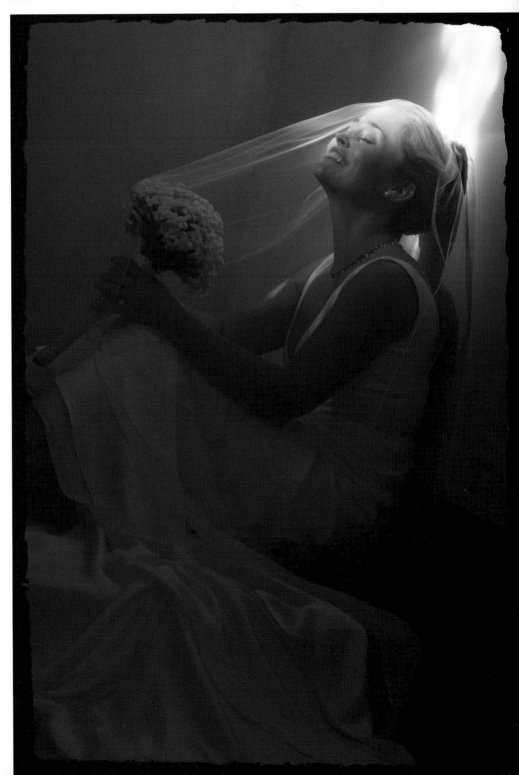

BELOW—Michael Schuhmann is a devotee of stylized portraiture in his wedding coverage. Here, he includes only part of the bride's face in favor of including the S-shaped line of her veil—style over form. **TOP RIGHT**—David Beckstead idealized this beautiful bride in profile. The image was made by available light with a Nikon D1X and 35mm f/2.8 lens. His exposure was $^1/_{90}$ at f/2.8. He later used Photoshop to add a golden tint. The profile posing is elegant, seeming completely natural and undisturbed. **BOTTOM RIGHT**—Carrillo created this beautiful profile of this bride in which the woman's face is completely high key and secondary to the hair beyond the veil. All of the lines of the veil lead up to the bride's eyes and face. It is a masterpiece. The final print was made by master printer, Robert Cavalli.

Use changes in camera height to correct various irregularities. Don't be afraid to fill the frame with the bride's or the couple's faces. They will never look as good as they do on their wedding day!

● **SCHEDULING THE IMPORTANT FORMALS**

In your game plan, devote about ten minutes for the formal portraits of the bride and groom singly. The bride's portraits can be done at her home before the wedding, and the groom can be photographed at the ceremony before everyone arrives. Generally, you will have to wait until after the

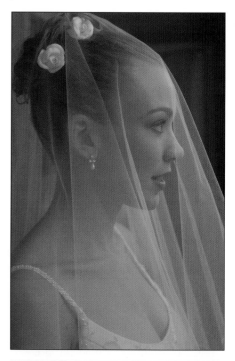

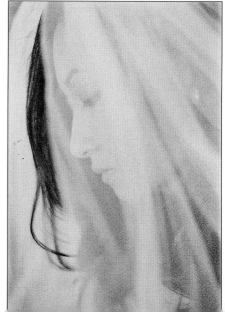

wedding ceremony to photograph the bride and groom together.

Formal Bridal Portrait. In the bride's portraits, you must reveal the delicate detail and design elements of her bridal gown. Start with good head-and-shoulders axis, with one foot forward and weight on her back leg. Her head should be dipped toward the near (higher) shoulder, which places the entire body into a flattering "S-curve"—a classic pose.

The bouquet should be held on the same side as the foot that is placed forward and the other hand should come in behind the bouquet. Have her hold the bouquet slightly below waist level, revealing the waistline of the dress and still creating a flattering bend to the elbows.

Turn the bride around and have her gaze back at you so that your portrait reveals the back of the dress, which is often quite elegant. And don't forget about the veil—shooting through the tulle material of the veil for a close-up portrait makes a good portrait.

If the gown has a full train, then you should devise a pose that shows it in its entirety, either draped around

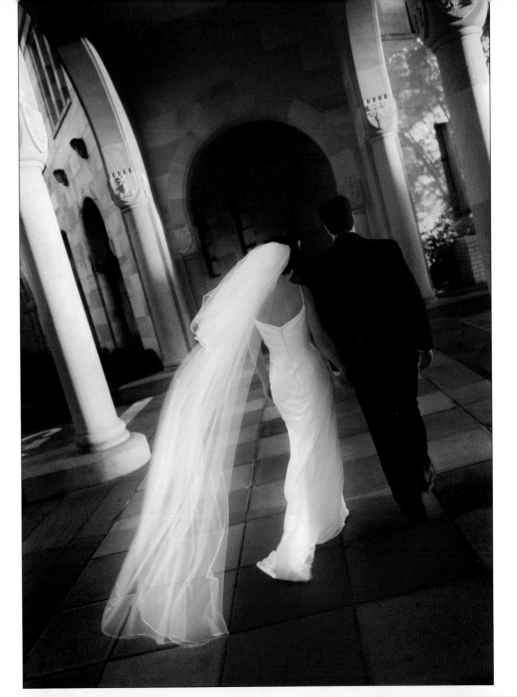

TOP—Golden sunlight bounces all around this magnificent place where the couple was married. Australian Marcus Bell captured this magical moment, preserving both the beauty (and correct color balance) of the bride's gown and veil, as well as the outrageous afternoon colors striking the pillars and arches. He tilted the camera for style and direction. **BOTTOM**—Here, what is usually a big problem (a moiré pattern caused by the veil) is used as a beautiful pattern that leads you directly to the eyes of this gorgeous and very natural bride. All photographers love the veil, because it adds a softness that is otherwise difficult to attain without the use of gimmicks and filters. Photograph by Joe Buissink.

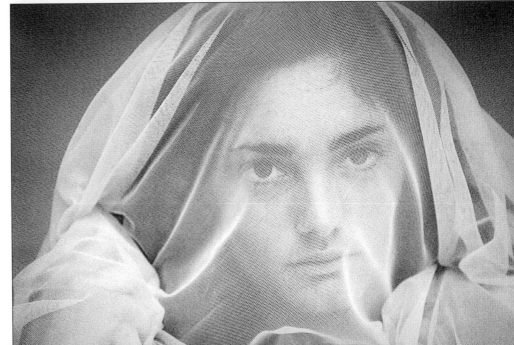

to the front or behind her. Remember, too, to have someone help her, as you don't want to be responsible for the train dragging around in the flowerbeds.

If you photograph the bride outdoors by shade, or indoors in an alcove while using the directional shade from outdoors, you will probably need an assistant to hold a reflector close to her to bounce light into her face. This will give a sparkle to her eyes and also fill in any shadows caused by directional lighting.

Formal Portrait of the Groom. Generally speaking, the groom's portrait should be less formal than the bride's. Strive for a relaxed pose that shows his strength and good looks. A three-quarter-length pose is ideal, since you are less concerned about showing his entire ensemble than you are about the bride's.

If the groom is standing, use the same "weight-on-the-back-foot" guideline you employed in the bridal portrait. The front foot should be pointed at an angle to the camera. With the shoulders angled away from the camera lens, have the groom tilt his head toward the far shoulder in the classic "masculine" pose.

Side lighting often works well, and the classic pose with the arms crossed is usually a winner. Remem-

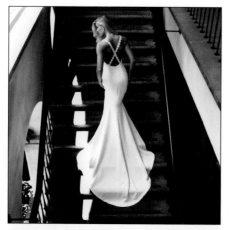

LEFT—What a dress and what a bride! Photographer Gigi Clark realized the best way to show off this dress was from behind and on a stairwell, where the train would be fully displayed. She made this image by available light and had the bride look to her left slightly, so her profile would be visible. This is the type of stylized editorial portrait one finds on the pages of the top bridal magazines. **BELOW**—Kevin Kubota had his bride and groom take a stroll in a field in late afternoon to create their formal portrait. Not knowing what the exercise would produce, the groom, ever chivalrous, helped protect her train in the thick brush. The result is a charming portrait. The stroke of genius is the yellow bouquet, a trick accomplished in Photoshop by creating a duplicate layer and erasing all of the information not desired in the final image. The original image was made with a Nikon D1X, 85mm f/1.4 lens at an exposure of $^1/_{90}$ second at f/1.4 at a film speed setting of E.I. 125.

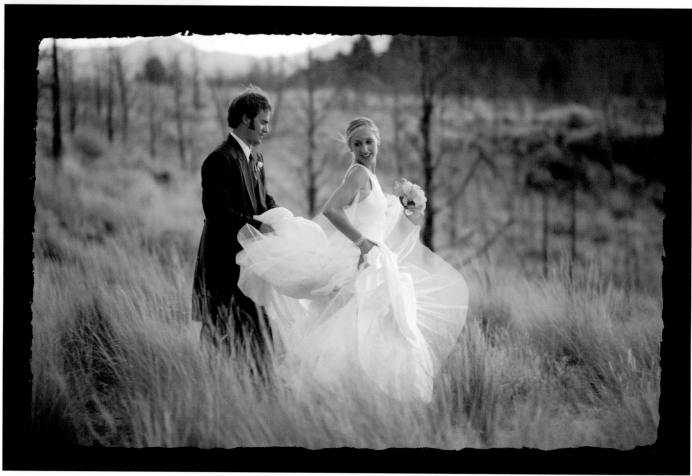

A pleasant smile is better than a serious pose or a "big smiley laughing" pose. Although there are no hard and fast rules here, "strong" and "pleasant" are good attributes to convey in the groom's portrait. The men's fashion magazines are a good source of inspiration for contemporary poses.

Formal Portrait of the Bride and Groom. The most important formal portrait is the first picture of the bride and groom that is taken immediately after the marriage ceremony. Take at least two portraits, a full-length shot and a three-quarter-length portrait. These can be made on the grounds of the church or synagogue, in a doorway, or in some other pleasant location, directly following the ceremony.

The bride should be positioned slightly in front of the groom. They should be facing each other, but each subject should also remain at a 45-degree angle to the camera. Their weight should be on the back legs, and there should be a slight bend in the knee of the bride's front leg, giving a nice line to the dress. They will naturally lean into each other. The groom should place his hand in the center of the bride's back, and she should have her bouquet in her outside hand (the other hand can be placed behind it).

Have your assistant ready and waiting in the predetermined location, and take no more than five minutes making this portrait. Your assis-

ber, if using this pose, to show the edge of the hands and don't let him "grab" his biceps—this will make him look like he's cold.

Another good pose for a groom is one with his hands in his pockets in a three-quarter-length view—but have his thumbs hitched on his pants pockets so that you can break up all of the dark tones of his tuxedo. Also, if he

has cuffs and cuff links, adjust his jacket sleeves so that these show and look good. It's always a good idea to check the groom's necktie to make sure it's properly tied. You can also have the groom rest one foot on a stool, bench, or other support that is out of view of the camera. He can then lean on his raised knee and lean forward toward the camera.

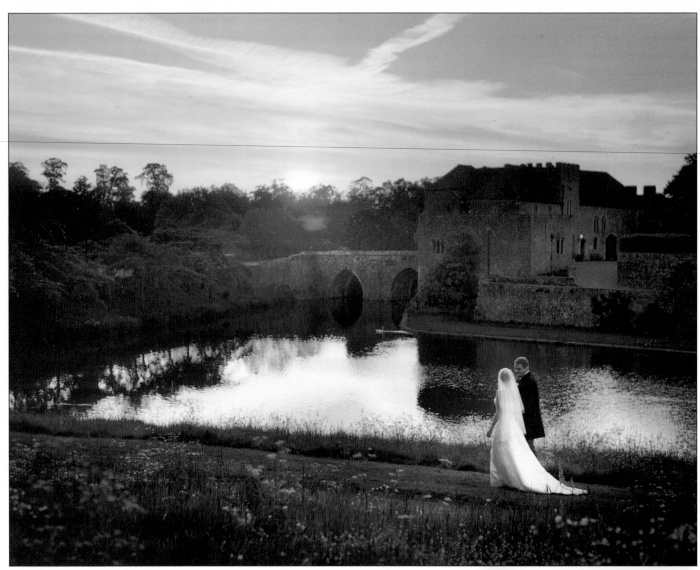

ABOVE—This formal but casual portrait of the bride and groom owes a lot to the photographer Stephen Pugh's sense of color and composition, as well as the location—an old English castle, complete with a moat. RIGHT—This casual portrait made by Brook Todd captures all of the relaxed attributes of the modern-day wedding. It is not a formal portrait, but a casual one, with close cropping, and friendly, loving expressions.

tant should have reflectors, flash or whatever other gear you will need to make the portrait.

Vary your poses so that you get a few with them looking at each other, a few looking into the camera, etc. This is a great time to get a shot of them kissing, since—believe it or not—very few images like this get made on the wedding day, because the couple is so busy attending to details and guests.

● AFTER YOU'VE
SNAPPED THE SHUTTER

Many wedding photographers will tell you that the best groups and formals occur seconds after you've told the people, "Thanks, I've got it." Everyone relaxes and they revert to having a good time and being themselves. This is a great time to fire off a few more frames—you might get the great group or formal that you didn't get in the posed version.

Groups

Formal portraits and groups fall outside the area of interest of most photojournalists. However, they are still an integral part of the wedding. While most wedding photojournalists don't exhibit their formal groups, they do include them in the albums, because the bride has specifically asked for certain group portraits. The purist, while he or she may internally object, will gladly oblige the bride's request, but will add the special twist that takes the images out of the realm of traditional wedding coverage.

● WEDDING PARTY

You will also want to photograph the groom and his groomsmen, the bride and her bridesmaids, as well as the complete wedding party in one group. You do not have to make the portrait boy–girl, boy–girl, since that is usually a pretty boring shot—even if you have

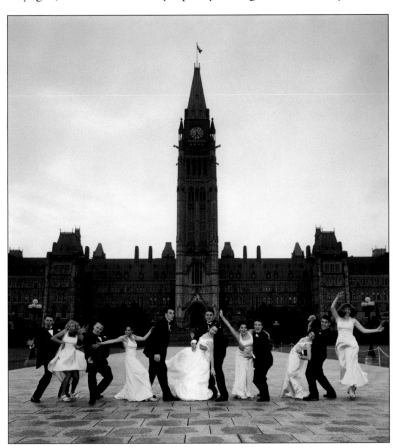

If you examine this group portrait by Frank Cava you will see that every couple is doing something quite different, and the end result is a raucous good-time portrait. The stateliness of the Ottawa Parliament building in the background lends a sense of formality and symmetry to the image, but the out-of-control poses change the image completely.

a great background and all else is perfect. Opt for something completely unexpected. Incorporate the environment or architecture, or ask your wedding group to do something uncharacteristic. Even though this is a posed shot, it does not have to represent a pause in the flow of the wedding day—it can still be fun, and you can still get a wonderful group image if you exercise a little imagination.

● **FAMILIES**

Other groups you will need to photograph depend on the wishes of the bride. She may want family formals, extended families, or a giant group shot including all of the attendees.

● **GROUPS AND BACKGROUNDS**

While it might be tempting to find a great background and shoot all of your groups with the same background, the effect will be monotonous when viewed in the album. Strive for several interesting backgrounds, even if they are only ten or twenty feet apart. This will add visual interest to the finished album.

● **COMPOSITION**

Designing groups of people successfully depends on your ability to manage the intangibles—implied and inferred lines and shapes within the composition. Line is an artistic element used to create visual motion within the image. It may be implied by the arrangement of the group, or inferred, by grouping the elements in the scene. It might also be literal, as well; like a fallen tree used as a posing bench that runs diagonally through the composition. Shapes are groupings of like elements: diamond shapes, circles, pyramids, etc. These shapes

ABOVE—This group portrait by Brook Todd is interesting because the men are all individual and unposed. The hierarchy dictates who is the groom, the best man, and the ushers. The farther they are from the front row, the more relaxed they appear. According to Brook, "Would you believe Alisha [his wife and shooting partner] actually set the guys up and told them where to sit and then told them to just 'hang out'?" RIGHT—This is a very sexy portrait by Mike Colón. She leans into him, his back is arched but it also produces a strong diagonal line within the composition. The portrait is tilted to further enhance the dynamics.

are usually a collection of faces that form the pattern. They are used to produce pleasing shapes that guide the eye through the composition. The more you learn to recognize these elements, the more they will become an integral part of your compositions. These are the keys to making a dynamic portrait. The goal is to move the viewer's eye playfully and rhythmically through the photo.

● **GROUPINGS**

Couples. The simplest of groups is two people. Whether the group is a bride and groom, mom and dad, or

the best man and the maid of honor, the basic building blocks call for one person slightly higher than the other. A good starting point is to position the mouth of the lower person parallel to the forehead or eyes of the higher person.

Although they can be posed in parallel position, a more interesting dynamic with two people can be achieved by having them pose at 45-degree angles to each other, so their shoulders face in toward one another.

With this pose, you can create a number of variations by moving them closer or farther apart.

For an intimate pose for two, try showing two profiles facing each other. One should still be higher than the other, to allow you to create an implied diagonal between their eyes, which gives the portrait better visual dynamics. Since this type of image is usually fairly close up, make sure that the frontal planes of the subjects'
faces are roughly parallel so that you can hold focus on both.

Trios. A group portrait of three is still small and intimate. It lends itself to a pyramid or diamond-shaped composition, or an inverted triangle, all of which are pleasing to the eye.

Use a turn of the shoulders of those at both ends of the group as a means of looping the group together, and ensuring that the viewer's eye does not stray out of the frame. Once
you add a third person, you will begin to notice the interplay of lines and shapes inherent in good group design. The graphic power of a well defined diagonal line in a composition will compel the viewer to keep looking at the image.

Try different vantage points—a bird's-eye view, for example. Cluster

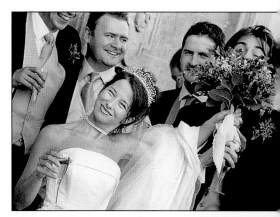

RIGHT—What started out as the beginnings of a semiformal group lost all semblance of order when the bride decided to bop her groom with the bouquet. The resulting image is lots of fun, and without any of the formal elements of group portraiture. For a photojournalistic wedding, this is a terrific image. Photograph by Stuart Bebb. **BELOW**—The bride and two of her bridesmaids converse in animated fashion. While they are oblivious to the photographer, Mercury Megaloudis, the group nevertheless displays good group dynamics—the endmost ladies are turned toward the center and the crook of the finger of the bridesmaid at left points directly back to the bride. Notice too how the background is completely blurred.

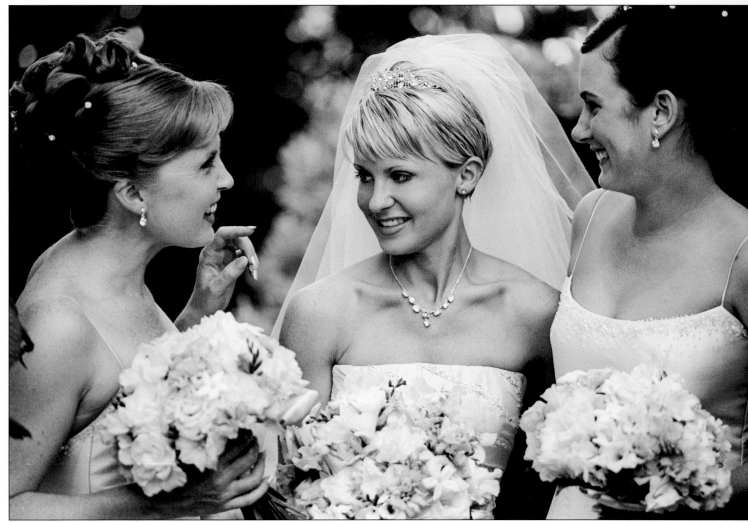

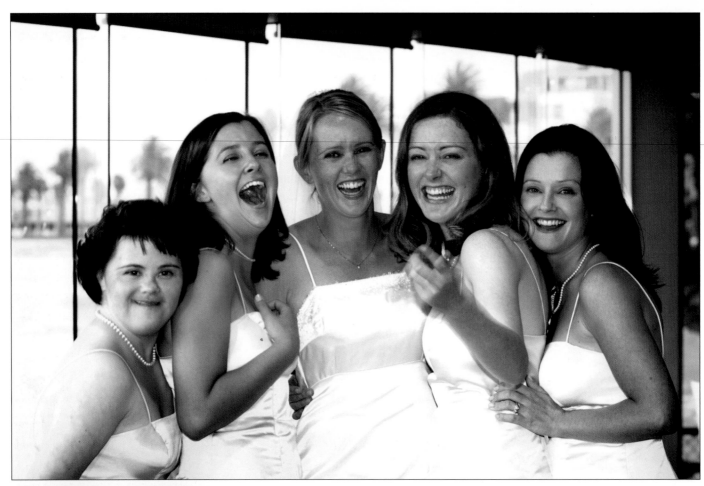

LEFT—Dennis Orchard chose an interesting way to depict the bride and bridesmaids in one of his "required" group portraits. He chose a high vantage point, a staircase, then clustered the group together and had them look up. Dennis used a wide-angle lens and diffused flash to make this unusual portrait. The final composition is reminiscent of a floral bouquet. ABOVE—This is another group that ended up in a spoof when the photographer, Mercury Megaloudis, said something that must have been hilarious. Notice the rudiments of good posing—shoulders turned in towards the bride and a perfect semi-circle of faces. These things are still prominent but the portrait is now something much different and actually, much more appealing.

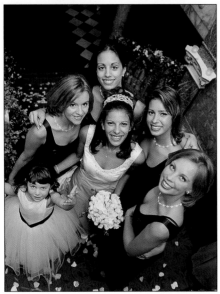

the group together, use a safe stepladder or other high vantage point, and you've got a lovely variation on the small group.

Even-Numbered Groups. You will find that even numbers of people are more difficult to pose than odd-numbered groupings. The reason is that the eye and brain tend to accept the disorder of odd-numbered objects more readily than even-numbered objects. As you add more people to a group, remember to do everything you can to keep the film plane parallel to the plane of the group to ensure everyone in the photograph is sharply focused.

With four people, you can simply add a person to the existing poses for three described above. Be sure to keep the head height of the fourth person different from any of the others in the group. Also, be aware that you are now forming shapes with your composition—pyramids, extended triangles, diamonds, and curved lines.

Larger Groups. With five or six people, you should begin to think in terms of creating linked subgroups. This is when a posing device like the armchair can come into play. An armchair is the perfect posing device for photographing from three to eight people. The chair is best positioned

roughly 30 to 45 degrees to the camera. Whoever will occupy the seat (usually the bride), should be seated laterally across the cushion on the edge of the chair, so that all of their weight does not rest on the chair back. This promotes good sitting posture and narrows the lines of the waist and hips, for both men and women. Using an armchair allows you to seat one person and position the others close and on the arms of the chair, leaning in toward the central person. Sometimes only one arm of the armchair is used to create a more dynamic triangle shape.

Big Groups. The use of different levels helps to create a sense of visual interest and lets the viewer's eye bounce from one face to another (as long as there is a logical and pleasing flow to the arrangement). The placement of faces, not bodies, dictates how pleasing and effective a composition will be.

As your groups get bigger, keep your depth of field under control. The stepladder is an invaluable tool for larger groups, because it lets you elevate the camera position and keep the camera back (film plane) parallel to the group for the most efficient focus. Another trick is to have the back row of the group lean in, while the front row leans back, thus creating a shallower subject plane that makes it easier to hold the focus across the entire group.

When you are photographing large groups, an assistant is invaluable in getting all of the people together and helping you to pose them. Keep in mind that it also takes less time to photograph one large group than it does to create a series of smaller groups, so it is usually time well spent

(provided that the bride wants the groups done in this way).

● **PANORAMIC GROUPS**
If you have the capability to produce panoramic pages in your album, this is a great way to feature groups, especially large ones. These should be shot on an extra-wide format, like 6x9cm or 6x17cm. Your camera technique will definitely show up with images this large, so be sure the plane of focus is aligned with your group and that everyone is in focus. Also, as needed, use the proper amount of fill-flash to fill in facial shadows across the

group. Generally speaking, if you use fill-flash across a wide group, it will take several flash units spaced equidistant across the group and fired at the same aperture/output. The flash output should be one stop less than the ambient light reading. For example, if the daylight exposure reading is $\frac{1}{250}$ at f/5.6, your flash units should be set to fire at f/4 for adequate and unnoticeable fill-in flash.

● **TECHNICAL CONSIDERATIONS**
If you are short of space, use a wide-angle lens or a wide-angle camera, like the Brooks Veri-Wide, a 35mm pano-

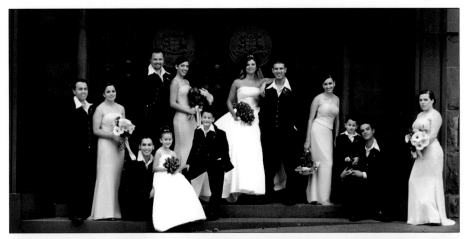

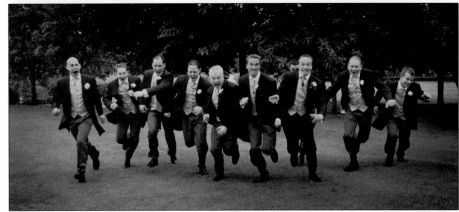

TOP—This is a terrific job of posing by Martin Schembri. Each group and subgroup is arranged handsomely with good head and shoulder dynamics and pleasing, relaxed poses. The only ones not posed so formally are the bride and groom, who stand out by their casualness, which was the point. **ABOVE**—Here is a big, fun group of mad Englishmen—the groom and his groomsmen. The photographer, Stephen Pugh, simply asked them to charge across the field toward him, where he was waiting. The shape of the group is rather out of control, which is precisely what the photographer wanted. Stephen waited "until he could see the whites of their eyes" before firing, and the resulting expressions are worth it.

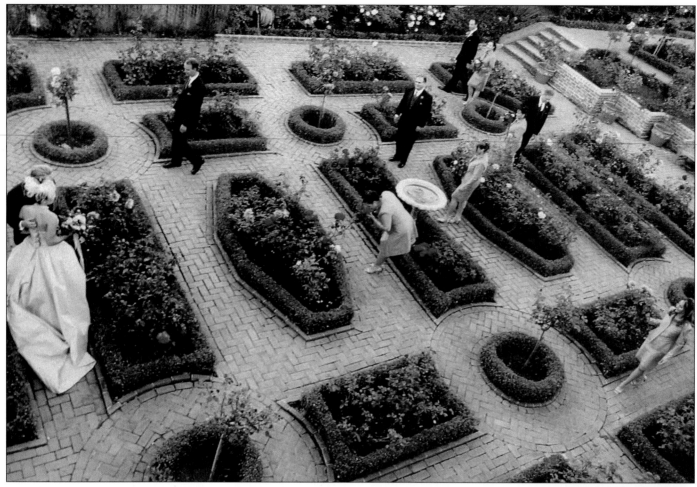

ABOVE—This is a very strange but wonderful group shot taken as each individual in the wedding party explored this rather unique rose garden. Brook and Alisha Todd captured this scene from a balcony above using available light. **RIGHT**—This is like getting two groups in one—precisely. Joe Buissink saw the opportunity to photograph the little girls through the window, and the guys staring at the little girls in the window.

ramic camera with a rotating shutter. Wide-angle coverage results in the people at the front appearing larger than those at the back, which may be advantageous if the wedding party is at the front of the group. Make sure everyone is sharp. This is more of a certainty with a wide-angle lens and its inherent depth of field. Focus at a distance one-third of the way into the group. This should ensure that everyone is sharp at f/5.6 or f/8 with a wide-angle lens. If the guests wave to the camera, this usually results in too many faces being lost behind raised arms. However, this is a good time for the bride to throw her bouquet. Ask

her to throw it over her head into the crowd behind, mainly upward and slightly to the rear.

● **HANDS IN GROUPS**

Hands can be a problem in groups. Despite their small size, they attract visual attention—particularly against dark clothing. They can be especially troublesome in seated groups, where at first glance you might think there are more hands than there should be. A general rule of thumb is to either show all of the hand or show none of it. Don't allow a thumb, or half a hand, or a few fingers to show. Hide as many hands as you can behind

flowers, hats, or other people. Be aware of these potentially distracting elements, and look for them as part of your visual inspection of the frame before you make the exposure.

Wedding Albums and Special Effects

Like any good story, a wedding album has a beginning, a middle, and an end. For the most part, albums are layed out chronologically. However, there are now vast differences in the presentation—primarily caused by the digital page-layout process. Often, events are jumbled in favor of themes or other methods of organization. There still must be a logic to the layout, though, and it should be readily apparent to everyone who examines the album. The wedding album has changing drastically, evolving into more of a storytelling medium. Still, album design is basically the same thing as laying out a book, and there are some basic design principles that should be followed.

● BASIC DESIGN PRINCIPLES

Title Page. An album should always include a title page, giving the details of the wedding day. It will become a family album, and having a title page will add an historic element to its pricelessness.

Left and Right Pages. Look at any well designed book or magazine and study the images on left- and right-hand pages. They are decidedly different, but have one thing in common: they lead the eye into the center of the book, commonly referred to as the "gutter." These photos use the same design elements photographers use in creating effective images—lead-in lines, curves, shapes, and patterns. If a line or pattern forms a "C" shape, it is an ideal left-hand page, since it draws the eye toward the gutter and across to the right-hand page. If an image is a backward "C" shape, it is an ideal right-hand page. Familiar shapes like hooks, loops, triangles, or circles are used in the same manner to guide the eye into the center of the two-page spread and across to the right-hand page.

There is infinite variety in laying out images, text, and graphic elements to create this left and right orientation. For example, a series of photos can be stacked diagonally, forming a line that leads from the lower left-hand corner of the left page to the gutter. That pattern can be mimicked on the right-hand page, or it can be contrasted for variety.

Even greater visual interest can be attained when a line or shape starts on the left-hand page, continues through the gutter into the right-hand page, then moves back again to the left-hand page. This is the height of visual movement in page design. Visual design should be playful and coax the eye to follow paths and signposts through the visuals on the pages.

TOP—This is a good example of a trip-tych, three images of equal size and visual weight but completely different. This series of images is by Dennis Orchard, and was used as a DVD cover for the bride and groom. **BOTTOM**—This is a beautiful detail of the wedding gown and bouquet that could stand alone on an album page or be used as an inset. Notice it has a natural left-to-right orientation and would be ideal as an opening image on a left-hand page. Photograph by Deborah Lynn Ferro.

Variety. When you lay out your images for the album, think in terms of variety of size. Some images should be small, some big. Some should extend across the spread. Some, if you are daring, can even be hinged and extend outside (above or to the right or left) the bounds of the album. No matter how good the individual photographs are, the effect of an album in which all the images are the same size is static.

You can introduce variety by combining black & white and color, even on the same page. Try combining detail shots and wide-angle panoramas. How about featuring on facing pages a series of close-up portraits of the bride as she listens and reacts to the toasts? Don't settle for the one-picture-per-page approach; it's static and boring. As a design concept, it has outlived its usefulness.

Visual Weight. Learn as much as you can about the dynamics of page design. Think in terms of visual weight, not just size. Use symmetry and asymmetry, contrast and balance. Create visual tension by combining dissimilar elements. Don't be afraid to try different things. The more experience you get in laying out the images for the album, the better you will get at presentation. Study the albums presented here, and you will see great

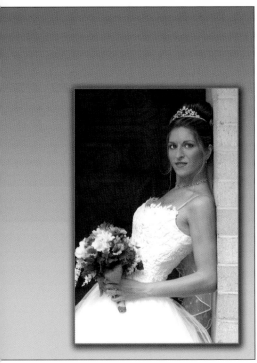

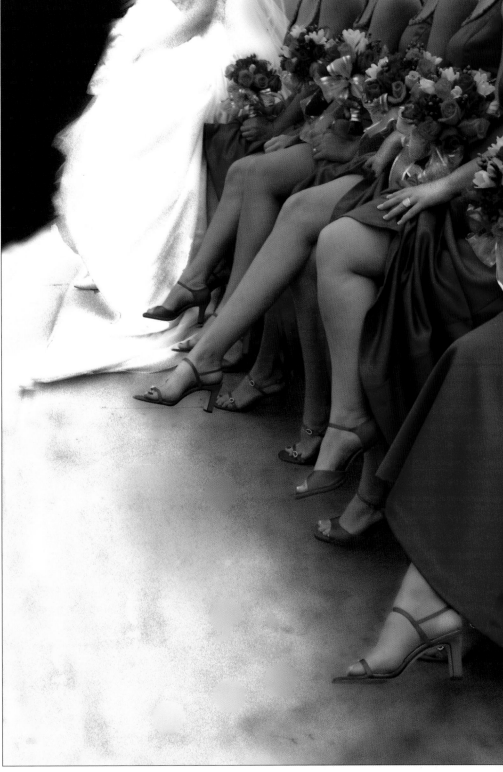

ABOVE—Jeff and Kathleen Hawkins created a beautiful right-hand page for an album. The shape of the bride's pose resembles a triangle shape, forcing the viewer's eye in toward the gutter. They have produced a blend from light to dark on the background, ideal for dropping in type, and they have created a soft-edged drop shadow on the image to give it depth. RIGHT—This is another good example of a right-hand page by Jerry D. The lines of the legs point toward the middle of the album page, driving the viewer in toward the contents of the two-page spread.

creativity and variety in how images are combined and the infinite variety of effects that may be created.

Reading Direction. Remember a simple concept: in Western civilization, we read from left to right and top to bottom. We start on the left page and finish on the right. Good page design starts the eye at the left and takes it to the right, and it does so differently on every page.

● **TRADITIONAL ALBUMS**

Many wedding photojournalists still prefer to use traditional wedding albums, either because their clients request them or because they feel that traditional albums represent a hallmark of timeless elegance.

Post-Mounted Albums. Album companies offer a variety of different page configurations for placing horizontal or vertical images in tandem on a page, or for combining any number of small images on a single page. The individual pages are then post-mounted, and the final album can be as thick or thin as the number of pages. Photos are inserted into high

TOP—Deborah Lynn Ferro created this charming two-page spread. Notice that the left-hand image and right-hand image each "point" towards the gutter. If the album were bound, you would have a noticeable line where the pages are cut and mounted. With this image, it would not interrupt the flow of the design if the gutter ran right down the middle of the spread. **BOTTOM**—A selection of album types from Albums Australia. Note the minis in the foreground—an idea which is becoming quite popular, as the bride can take it in her purse to show her friends.

quality mattes, and the albums themselves are often made of the finest leathers.

Bound Albums. A different kind of album is the bound album, in which all the images are permanently mounted to each page, and the book is bound professionally by a bookbinder. These are elegant and very popular. Since the photos are dry-mounted to each page, the individual pages can support any type of layout from "double-truck" (two bleed pages) layouts to a combination of any number of smaller images.

Library Binding. Another form of album uses conventional photographic prints made to the actual page size. These prints are then mounted, trimmed, and bound in an elegant leather album that is actually a custom-made book. If you want to create album pages with multiple images, your lab must prepare these prints to size before submitting them to the album company for binding.

Montage. Montage is a software program designed to be used with Art Leather Manufacturing's albums. Montage offers several useful features.

Once the lab has scanned your negatives the images can be loaded into Montage, which resides on your computer. With Montage you can present a slide show of images from which the couple makes their selections. The program can then be used to design the actual album layout, showing pages with images inset exactly how they'll appear in the final album. Many photographers will include the couple in this process, allowing them to see how certain images combine on the album page for a special storytelling effect. Once the album's been approved by the couple, the negatives are then sent to your lab for printing in the desired sizes. The album is then assembled once the prints are returned to you.

One of the added benefits of such a system is that you never have to part with proofs, which not only delays the album-ordering process, as they are handed around from family member to family member, but also invites unauthorized scanning.

● **MAGAZINE-STYLE DIGITAL ALBUMS**
In recent years, there has been a backlash against traditional drop-in album types. While elegant, the contemporary wedding photojournalist does not want to see his or her stylish images placed in an outdated album concept.

Layout. Digital output allows the photographer or album designer to create backgrounds, inset photos, and output the pages as complete entities. Sizing the photos does not depend on what size or shape mats you have available; you can size the photos infinitely on the computer. Once the page files are finalized, any number of pages can be output simply and inexpensively. Albums can be completely designed on the computer in programs like QuarkXPress, Photoshop, or PageMaker, or by using specially designed programs specific to the album manufacturer.

These magazine-style albums feature graphic page layouts with a sense of design and style. Images are not treated as individual entities, necessarily, but are often grouped with like images, organized by theme rather than in chronological order. This affords the photographer the luxury of using many more pictures in varying sizes throughout the album. Collages and other multimedia techniques are common in the magazine-style album, and you will often see type used sparingly throughout.

Charles Maring suggests sampling the colors of the images using the eyedropper tool in Photoshop. When you click on an area with the eyedropper, the color palette displays the component colors in the CMYK and RGB modes. You can then use

those color readings for graphic elements on the page you create with those photographs, producing an integrated, color-coordinated design. If using a page-layout program like QuarkXPress, those colors can be used for color washes on the page or

for background colors that match the Photoshop colors precisely.

Signing Off on the Design. Digital albums, unlike traditional albums in which prints are inserted into interchangeable mats, cannot be changed once they are bound. I have

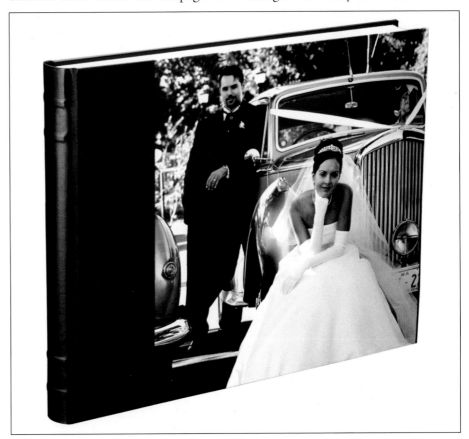

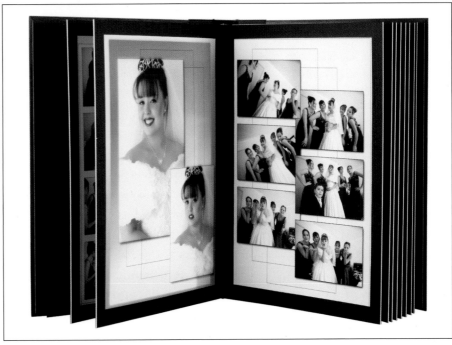

TOP—What could be more classically modern than the black & white photo cover spined in black leather? Album by Albums Australia. BOTTOM—Magazine-style albums feature a new blend of graphic arts and individual photographs layed out in a pleasing manner. There is a cohesiveness and similarity in the pages of the design, but each page is unique.

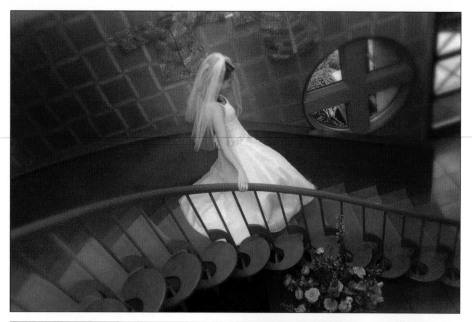

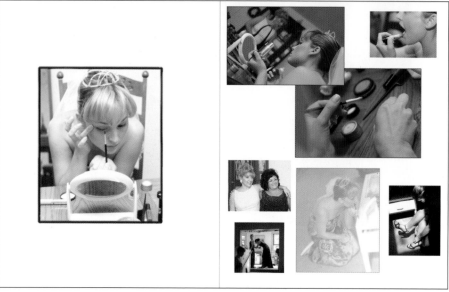

TOP—Charles Maring, who regularly wins awards for his creative albums, will take a shot like this and run it across two pages using insets throughout. **ABOVE**—A two-page spread from a Charles Maring album shows many different photographic styles in one design. This is possible because his wife, Jennifer, who has a somewhat different style, shoots with him on weddings. He organizes spreads around themes—here, preparation.

which assembles all the image files, fonts, and monitor profiles into a single folder, so that the people on the other end have everything they need to create your pages.

Storytelling. Perhaps the most attractive feature of the digitally produced magazine-style albums is that they are an ideal complement to the storytelling images of the wedding photojournalist. Because there are no boundaries to page design or the number of images used on each page, the album can be designed to impart many different aspects of the overall story. The difference between the standard drop-in album type and the magazine-style album is almost like the difference between an essay and a novel. The first tells the story in narrative terms only, the latter illuminates the story with greater nuance and flavor.

Wedding and portrait photographer David Anthony Williams has created a genre of pictures that he produces at weddings called "Detail Minis," which are a series of shots loosely arranged by theme, color, or subject matter. He carries a camera with him specifically for doing the minis. It's a 35mm SLR with a 50mm f/1.4 lens. He shoots this lens wide open on all of the minis and uses primarily fast (ISO 800-speed) film so that he can shoot in any light.

The minis Williams shoots are sometimes incorporated into double-truck image panels with larger, more conventionally made images. Or, sometimes the minis are alone on a page grouped in sixes or twelves in a window-pane treatment. They add a flavor to the album that is unsurpassed because, invariably, the minis are things that almost no one else

heard a number of horror stories about discrepancies between what was ordered and what was delivered. Further, the lab may also make a mistake, which at least gets you off the hook for the cost of a remake, but significantly delays delivery while the album is remade.

There are two things you can do to streamline the process and minimize mistakes. First, bring the couple

back for one last look at the design (on your computer) and have them "sign-off" on the final design. Then, before you ship the files off to the binder or album company, use Flight-check (an application used by publishers) to double-check that all the files are present, and in the right size and format. If using QuarkXPress to build the album, you can use a similar function called "Collect for Output,"

even noticed. There is no theme too far-fetched for him to photograph. Sometimes, the minis might be structured around a certain color—gold or yellow for instance. Or they may be about something, like the architecture of the reception hall. These detail minis add flavor to the album, and are sometimes called scene setters by other photographers who use these same techniques in their albums.

Charles Maring, well known for his award-winning wedding albums, believes that each page of the album should make a simple statement or tell a story within the overall wedding story. Instead of cluttering pages, he tries to narrow his focus and utilize the images that make the best state-

ment of the moment. He likes to think more like a cinematographer, analyzing the images he sees on the computer monitor and reinventing the feelings of the moment.

Maring thinks of the album as a series of chapters in a book. He uses a scene setter to open and close each chapter. Within the chapter, he includes a well rounded grouping of elements—fashion, love, relationship, romance, preparation, behind the scenes, ambience, etc. These are the key elements he keeps in mind while documenting the wedding day in his photographs.

Design Templates. Photographer Martin Schembri has created a set of commercially available album design templates that come on four different CDs and are designed to help photographers create elegant album-page layouts in Photoshop. The design templates, drag-and-drop tools that work in Photoshop, are available in four different palettes: traditional, classic, elegant, and contemporary. The tools are also cross-platform, meaning that they can be used for either Macs or PCs, and are customizable so that you can create any size or type of album with them.

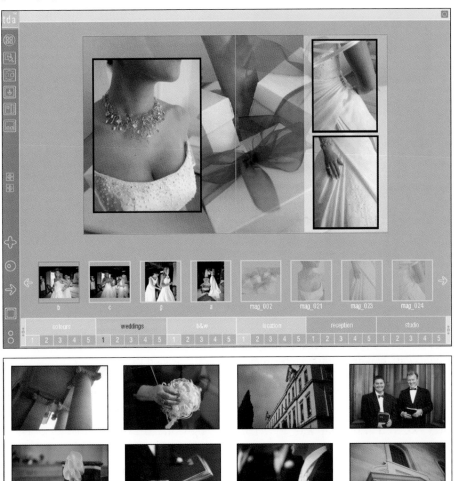

TOP—Custom album design often features interesting elements like hand-painted page corners, as seen in this album by Michael Ayers. **TOP RIGHT**—Albums Australia's TDA album design software lets you see the full selection of your scanned images so that you can simply drag and drop an image into a composite layout such as this. When you're all done, you FTP your layouts to a lab in Australia and, like magic, you have a finished album in a few weeks. **BOTTOM RIGHT**—Call them minis, or details, or montages; they produce an exciting effect in an album. David Williams shoots his details all with a 50mm lens on a Canon 35mm, and he shoots all the images at a wide-open aperture to give them the same kind of style. He shoots everything by available light and creates many pages of them in a typical album, organized loosely around a theme.

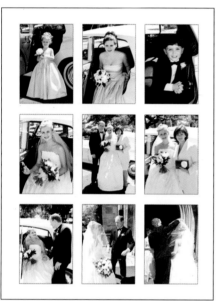

This is an amazing array of pages taken at random from one of Martin Schembri's wedding albums. Schembri is the designer of a series of drag-and-drop templates for Adobe Photoshop that vastly simplify the design procedure.

More information can be had by visiting www.martinschembri.com.au.

The Design Factor. Charles Maring sees digital technology producing a whole new kind of photographer. "I consider myself as much as a graphic artist and a designer as I do a photographer," he explains. The majority of Maring's images have what he calls "layers of techniques that add to the overall feeling of the photograph." None of these techniques would be possible, he says,

without the creativity that Photoshop and other programs, such as Corel Painter, give him. "Having a complete understanding of my capabilities has also raised the value of my work. The new photographer that embraces the tools of design will simply be worth more than just a cameraman," he says.

"The design factor has also given our studio a whole different wedding-album concept that separates us from other photographers in our area. Our

albums are uniquely our own, and each couple has the confidence of knowing that they have received an original work of art. I am confident that this will actually separate photographers further in the years to come. I have seen a lot of digital album concepts, some good, some not so good. When you put these tools in the hands of somebody with a flair for fashion, style, and design, you wind up with an incredible album. There is something to be said for good taste, and with all of these creative tools at hand, the final work of art winds up depending on who is behind the mouse, not just who is behind the camera," he notes.

Gatefolds. One of the more interesting aspects of digital albums is the gatefold, which is created using a panoramic size print on the right- or left-hand side, hinged so that it folds flat into the album. Sometimes the gatefold can be double-sided, revealing four page-size panels of images. The bindery can handle such pages quite easily, and it provides a very impressive presentation—particularly if it is positioned in the center of the album.

Albums Australia is one such digital album manufacturer that offers gatefolds as a standard feature of their TDA-2 album design software (TDA stands for "total design ability"). This is a drag-and-drop program with full preview capability that lets you design your digital album using just about any page configuration you can imagine. Additionally, the program also features all of the materials variations that the company offers, such as the different colors and styles of leather cover binding and the interior page treatments.

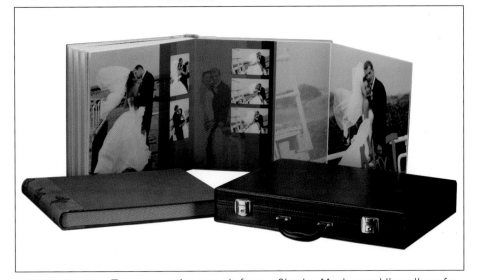

TOP TWO IMAGES—Two consecutive spreads from a Charles Maring wedding album feature a half-dozen different photographic styles. He is a master at combining images into a layout and is probably more than half graphic designer. **BOTTOM IMAGE**—This is an example of an Albums Australia gatefold. The briefcase is merely for scale—it doesn't have anything to do with the album.

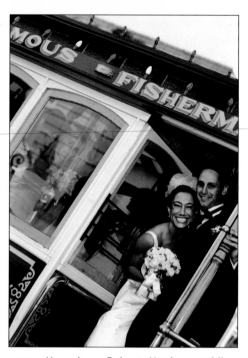

LEFT—Here is a Robert Hughes wedding portrait that uses a beautiful custom edge treatment. **ABOVE**—Bambi Cantrell often uses digital cross-processing techniques as a means of introducing variety into her wedding albums.

Mini Albums. Photographer Martin Schembri also creates what he calls a "mini-magazine" album—a miniature version of the main album that is small enough for brides to pop in their handbags to show all of their friends. Because they are so portable, the mini albums get far more exposure than a large, precious album. It also works as a great promotion for the photographer.

Covers. Companies like Albums Australia offer everything from stainless steel covers to something natural, like pearwood with a golden spine of leather imprinted with autumn leaves. Or perhaps the cover should be something artistic like "fusion," a brushed metal cover that can be accented with a spine that resembles modern art. Or how about a clear cedar cover with a leather spine that is emblazoned with monarch butterflies. Or maybe something hot, like Chili Red Leather.

What could be more classically modern than the black & white photo cover with an elegant black leather spine? These are just a few of the myriad cover combinations it is possible to create with Albums Australia's TDA-2 software—and you get to see exactly what the album will look like before placing the order.

● **SPECIAL EFFECTS**
The sheer number of special effects possible in today's albums is almost mind-numbing. Like anything else, overuse of such effects makes them not so special any more. Here are a few that are contemporary with wedding photojournalists and worth considering.

Borders. Border treatments, whether they are created by the lab or by the photographer in Photoshop or QuarkXPress, can enliven a special section of the album. One edge that is

quite popular is called "sloppy borders," which calls for the lab to print the negatives with milled, oversize negative carriers so that the edges of the frame show.

A wide range of edge treatments are available as plug-ins. Extensis frame effects operate in page-layout programs like Quark. Photoshop 7.0 also has a full range of border treatments that are accessed by going to the Actions menu and activating Frames.atn.

Cross-Processing. This is a technique that involves either processing color slides in C-41 (negative) chemistry, or color negatives in E-6 (color slide) chemistry. The former is the simpler of the two. These images will generally be more contrasty than normal, and will offer subtle changes in color balance. Processing color negative film in E-6 slide film chemistry produces images with an overall blue

cast (because of the inherent orange mask of color negative films). Highlights turn yellow, generally, and scenes with strong contrast work better than flatly lit scenes.

With both of these techniques, experimentation is called for—particularly in the area of film speed. You may have to lower or raise the ISO by as much as two stops, depending on the lab's processing characteristics. Also, finding a lab that will cross-process film is sometimes difficult.

Infrared Film. Infrared (IR) film is very grainy and renders green foliage in shades of white or light gray. It also does some beautiful things with light-colored skin tones,

producing a milkiness that resembles marble. Black & white infrared film must be handled carefully—the camera must be loaded and unloaded in total darkness. It is probably best to devote one camera body exclusively to IR film, so that you do not have to bring along a lighttight changing bag. The correct shooting ISO is a matter of testing, as is filtration. Most often, black & white infrared is used with a #25 Red filter.

Digital Infrared. Wedding photographer Patrick Rice has come up with a way to use digital cameras to produce black & white infrared effects. Digital cameras block most IR because it is known to contaminate

the visible light being captured on the digital media, thus degrading image quality. Most digital cameras use an IR cutoff filter that blocks all of the infrared radiation. Rice uses a Nikon Coolpix 950 camera, which does not have an effective IR cutoff filter in place. Employing an IR pass filter (Wratten filter #87) in an elaborate series of step-up rings to block some or most of the visible light, but yet transmit the infrared radiation, Rice produces an effect that is strikingly like black & white infrared—minus the grain. As with IR film, skin tones are fabulous and quite different than when recorded normally in digital. The drawback to this technique is

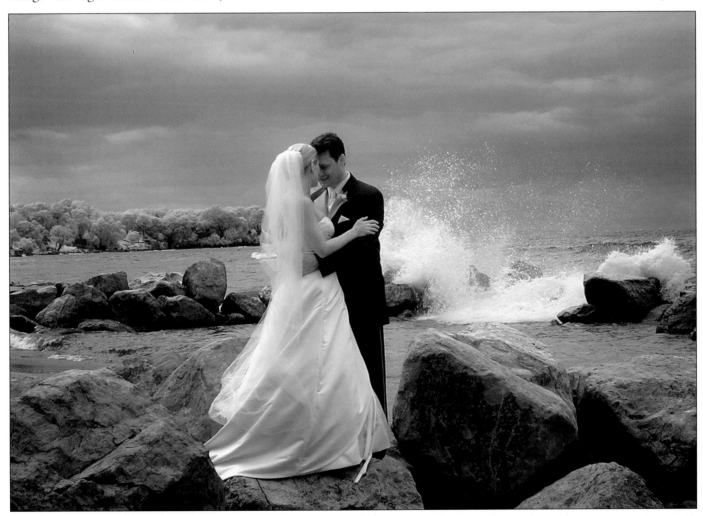

Digital infrared has a different feeling than black & white infrared film. There is less grain and, while foliage reacts typically, skin tones have a smooth and milky look that is very attractive. Photograph by Patrick Rice made with a modified Nikon Coolpix 950 camera and 17mm lens setting.

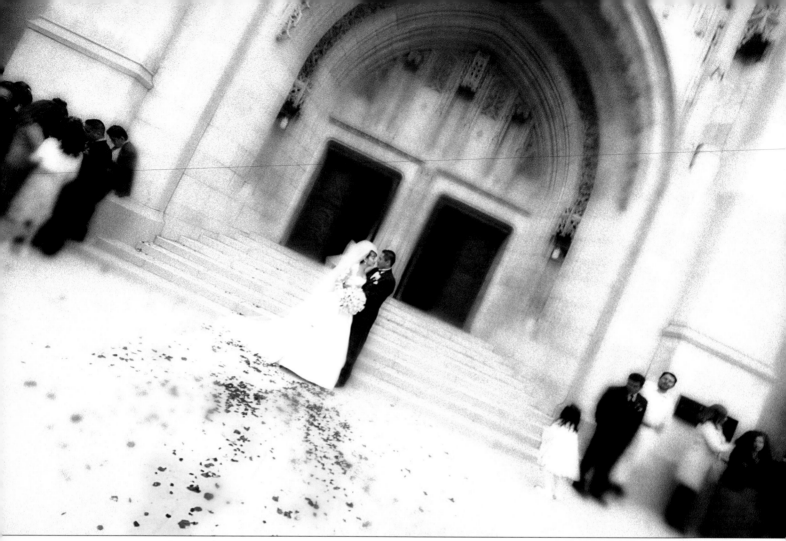

ABOVE—Tilting the camera is an often-overused technique, but here Jerry D carries it off to perfection. The image is heavily manipulated in Photoshop with filters. LEFT—Malcolm Mathieson created a panoramic of his bride and groom that stretches across the horizon line with the Sidney Opera House in the background. The bride and groom are positioned between trees, and backlit by the sun on the water.

that with the Coolpix 950, long exposures are required, meaning a tripod-mounted camera and bright sunlight—which, oddly enough, does not produce excessive contrast in the final images.

Hand Coloring. Another special effect is hand coloring prints, either with Kodak Retouching Colors or Prismacolor pencils. Often, prints to be hand colored are printed in black & white or with one predominant

color visible. The remainder of the print is hand colored. When complete, the image may be scanned (for a digital album), or used as is (for a conventional album). Both styles require patience to perfect.

Double-Trucks and Panoramic Pages. Regardless of which album type you use, adding panoramic format images can add great visual interest—particularly if using the bleed-mount digital or library-type albums.

Panoramics should not be done as an afterthought, since the degree of enlargement can be extreme. When shooting panoramics, be sure to offset the bride and groom so that they don't fall in the gutter of a two-page spread.

Tilting the Camera. A very popular (and sometimes overused) technique with wedding photojournalists is tilting the camera. This can be especially effective when used for wide-

angle shots—so much so, in fact, that with certain shots it cannot be determined whether the photo is truly a vertical or a horizontal image. Tilting the camera helps improve page dynamics, providing a built-in diagonal line within the composition. You will see lots of tilted shots on digital album pages as "guideposts" leading you to other places within the layout.

● FINE PRINTING

Robert Cavalli is a master printer in every sense of the word. He has an intuitive sense for improving an image and has worked with some of the finest photographers in the world to realize their visions, creating collaborative works of fine art.

Cavalli uses printing techniques that vary from simple approaches to elaborate techniques that might include darkroom vignetting, heavy diffusion, split contrast (areas of the print with differing contrasts), masking to reveal hidden detail in a negative, texture screens, flashing (exposing part of the print to raw light), soft borders, and a myriad of other self-conceived techniques.

Cavalli is a master in the conventional darkroom, but has also been combining traditional and electronic means of improving an image. Of the fusion, he says, "One approach I've used involves scanning a print and then using the computer for efficient digital manipulation to enhance the final outcome. At this point either a computer-generated print can be produced or a second 4x5-inch negative is made to create a silver-based image. Combining mediums yields the best that chemistry can achieve, while taking advantage of computer technology. Regardless of the techniques used, the ultimate worth of a print is in the lasting impact it has on the viewer."

Cavalli is so well respected that WPPI's 2003 print exhibit, which featured only prints that earned an

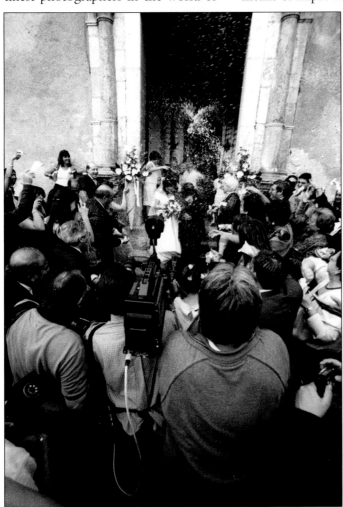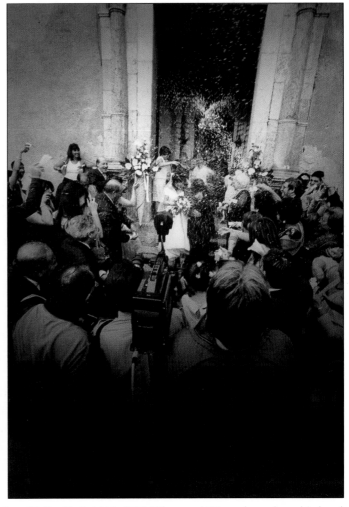

RIGHT—By luck Robert Cavalli happened on this wedding in Taramina, Sicily. He held his N90 Nikon and 17mm lens above his head and the framing was, fortunately, just right. Foreground photographers were videotaping the wedding. In this before-and-after set of images, you can see the difference a fine printer makes to the life of an image. In the black & white image, you can see all of the distracting elements in the foreground. In the sepia version, Cavalli subdued the newsmen, the white walls, and all the other distractions with consummate skill and subtlety. The final print is a masterpiece of storytelling.

ABOVE—Here is a Joe Buissink image for which master printer Robert Cavalli pulled out all the stops. Photographers believe Robert's skill helps them achieve fine-art status among their peers and clients. RIGHT—Gigi Clark is one of the finest photographic artists in America. Her imagination has no boundaries. Here she combines "transparent steel" and a vision of a wedding dress in negative form on display in a dress shop. To say the two images are incongruous is an understatement. It is an image that keeps you thinking about its meaning long after you've stopped looking at it.

Honorable Mention or above, included dozens of Cavalli's prints—he lost count at seventy-five!

● DIGITAL PRINT FINISHING

Martin Schembri's albums are all digital—design, page layout, and output. Schembri, whose albums include sixty to one hundred images, says that between scanning, retouching, page design, print output, and album assembly, each album takes between three and four weeks to create. Therefore, the time he spends reworking images in Photoshop is kept to a bare minimum. He averages roughly half an hour per page, including scanning, cleaning up, and finishing. Keeping it simple is his bottom line. He will only spend two to three full eight-hour days of his own time per album. Aside from resizing and color correction and the occasional change from color to black & white, Schembri will occasionally burn and dodge an image to get it just right. The only Photoshop filters he uses with any frequency are Gaussian Blur, Diffuse Glow, Unsharp Mask, and Noise.

Composition and Design

Good composition is little more than proper subject placement within the frame. Good design is a logical and pleasing arrangement of the elements within the photograph. The combination of good composition and design is crucial for creating vivid, dynamic images and album-page layouts.

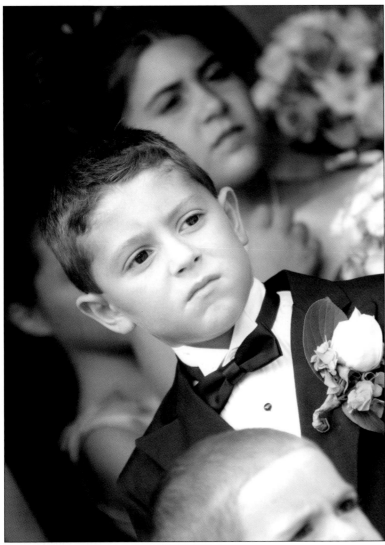

Good composition is often helped by referencing the rule of thirds, which divides the viewfinder frame into nine equal zones. In this wedding image by Michele Celentano, the center of interest, the boy, is off-center, the frame is tilted, implying direction, and the boy's eyes are very close to one of the centers of prime visual interest.

● THE RULE OF THIRDS

Many accomplished photographers don't really know where to place the subject within the frame, leaving it to be a consequence of good timing and observation. As a result, subjects can often end up

dead-center in the picture. This is the least dynamic subject placement you can produce.

The easiest way to improve your compositions is to use the rule of thirds. To apply this rule, mentally divide the rectangular area of the viewfinder into nine separate zones using a tic-tac-toe grid. Where any two lines intersect is an area of dynamic visual interest. The intersecting points are ideal spots to position your main point of interest. Many professional camera systems offer interchangeable viewfinder screens. One such screen is a grid screen, which cuts the frame into thirds, vertically and horizontally, and greatly facilitates off-center positioning of the subject. The main point of interest does not necessarily have to fall at an intersection of two lines. It could also be placed anywhere along one of the dividing lines.

● **DIRECTION**

Sometimes, you will find that if you place the main point of interest on a dividing line or at an intersecting point, there is too much space on one

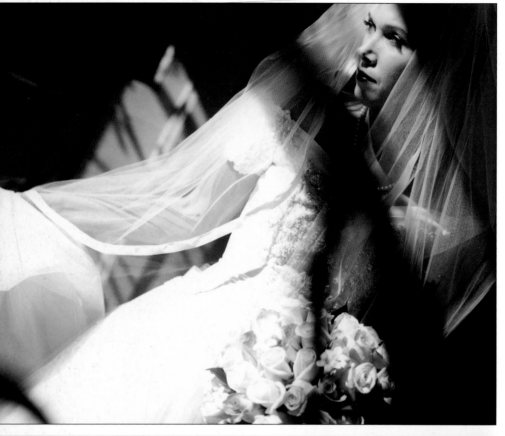

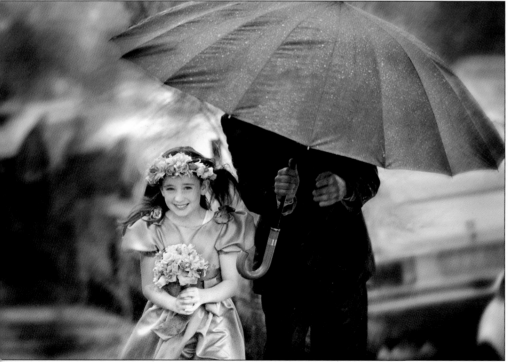

TOP—Tony Florez created this bridal formal in direct window light. His composition uses the sweeping lines of the bride's arm and body to lead you to her face, which is elegantly lit in the George Hurrell-style of the '30s. Sunlight is creating a "butterfly" type lighting pattern, which was often used on starlets for the effect it had on cheekbones and long eyelashes. **BOTTOM**—This image has an overpowering sense of direction. First, the diagonal line of out-of-focus cars establishes a right-to-left direction. Second, you have the stoic young girl braving the downpour in her flower girl's dress, her bouquet held firmly, her smile fixed. She seems to be fighting her way upstream. Lastly, you have the brave protector (her uncle, brother, chauffeur—we're not quite sure) providing a sort-of leading diagonal line as if propelling the young girl. Photo by Mercury Megaloudis. **FACING PAGE**—In this marvelous Kevin Kubota image you'll find a combination of powerful visual shapes. First there's the bride's triumphant, arms-raised, victory pose—the perfect "V". Next you have two beautiful "S" shapes, found in the gown's train blowing in the wind, and the more prominent "S" shape of the bride herself walking toward the wedding party. Kevin never set this image up; it happened spontaneously right after the wedding ceremony.

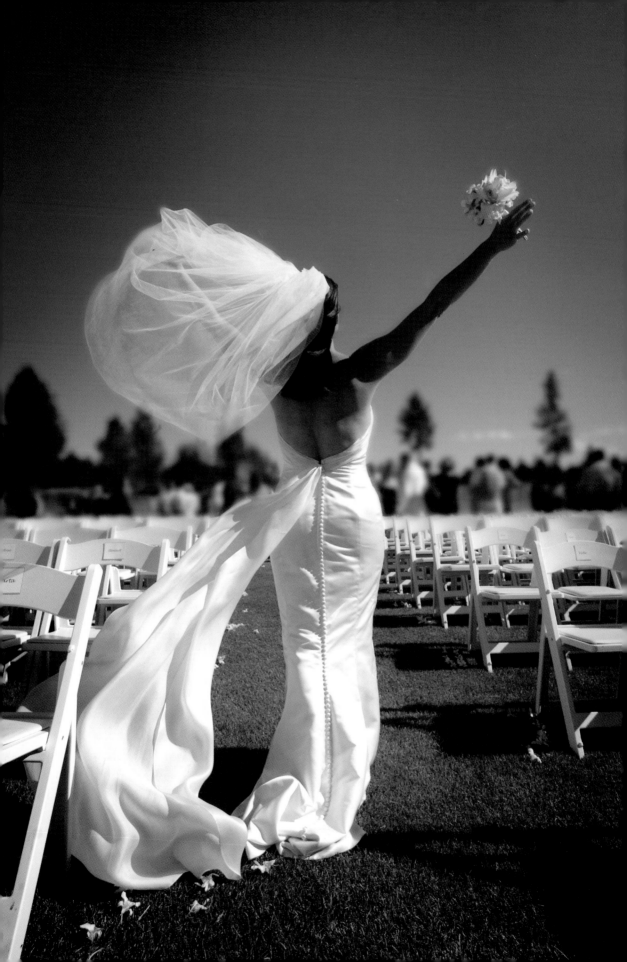

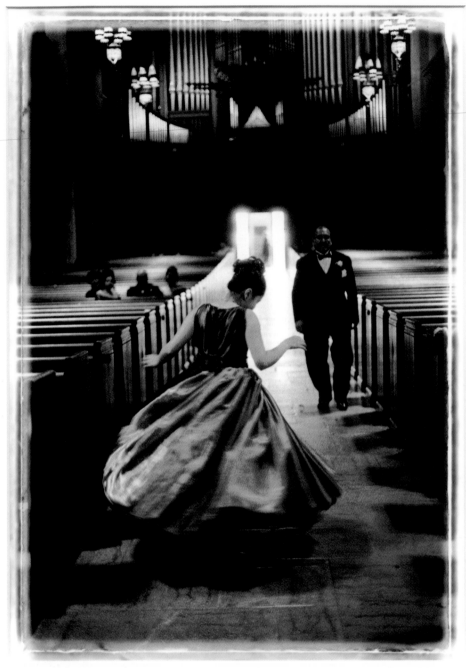

I've seen this image by Carrillo dozens of times and it never fails to amaze me. Is it a bridesmaid dancing down the aisle? Is she floating in midair? I've had ample opportunity to ask the photographer, but I guess I just don't want to know. One of the reasons the image is so compelling is that you have opposites at work in the formal circular pattern of the church chandeliers vs. the free-floating shape of the young woman. You have the disapproving group to the left, and the bemused usher to the right. There are so many wonderful things going on in this image that it is almost too perfect.

side of the subject, and not enough on the other. Obviously, you would then frame the subject so that he or she is closer to the center of the frame.

It is important, however, that the person not be dead center. Regardless of which direction the subject is facing in the photograph, there should be slightly more room in front of the person. For instance, if the person is looking to the right as you look at the scene through the viewfinder, then there should be slightly more space to the right side of the subject than to the left of the subject in the frame. This gives a visual sense of direction.

Even if the composition is such that you want to position the person very close to the center of the frame, there should still be slightly more space on the side toward which the subject is turned. This principle still applies even when the subject is looking directly at the camera. He or she should not be centered in the frame, and there should be slightly more room on one side or the other to enhance the composition.

● **PLEASING COMPOSITIONAL FORMS**
The S-shaped composition is perhaps the most pleasing of all compositions. The center of interest will fall on or near a rule-of-thirds line, but the remainder of the composition forms a sloping "S" shape that leads the viewer's eye to the center of main interest. Another pleasing type of composition is the "L" shape or inverted "L" shape—a composition that is ideal for reclining or seated subjects.

These compositional forms, as well as the "Z" shape and "C" shape, are compositional formulas that are used not only in the design of individual photographs, but as explained in the last chapter, in the formation of cohesive and visually stimulating album-page layouts. Shapes in compositions provide visual motion. The viewer's eye follows the curves and angles and travels logically through the shape, and consequently, through the photograph.

Subject shapes can be contrasted or modified with additional shapes found either in the background or foreground of the image. The "lead-in line," for example, is like a visual

arrow, directing the viewer's attention toward the subject.

● SUBJECT TONE

The viewer's eye is always drawn to the lightest part of a photograph. The rule of thumb is that light tones advance visually, while dark tones retreat. Therefore, elements in the picture that are lighter in tone than the subject will be distracting. Bright areas, particularly at the edges of the photograph, should be darkened either in printing, in Photoshop, or in the camera (by vignetting) so that the viewer's eye is not led away from the main subject.

Of course, there are portraits where the subject is the darkest part of the scene, such as in a high-key portrait with a white background. This is really the same principle at work as above, because the eye will go to the region of greatest contrast in a field of white or on a light-colored background. Regardless of whether the subject is light or dark, it should dominate the rest of the photograph either by brightness or by contrast.

● IN FOCUS, OUT OF FOCUS

Whether an area is in focus or out of focus greatly impacts the amount of visual emphasis it receives. For instance, a subject may be framed in green foliage, yet part of the sky is visible in the scene. The eye would ordinarily go to the sky first. But if the sky

The overtones are sentimental and emotional in this Joe Buissink image. As the bride feeds her horse for the last time as a single woman, the strain is almost unbearable. Dark tones push down on the lighter clouds as if an oppressive emotion is present. The composition is elegant and dynamic and beautiful.

is soft and out of focus, the eye will revert back to the area of greatest contrast—hopefully the face. The same is true of foreground areas. Although it is a good idea to make them darker than your subject, sometimes you can't. If the foreground is out of focus, however, it will detract less from a sharp subject.

Similarly, rendering various portions of the face in and out of focus

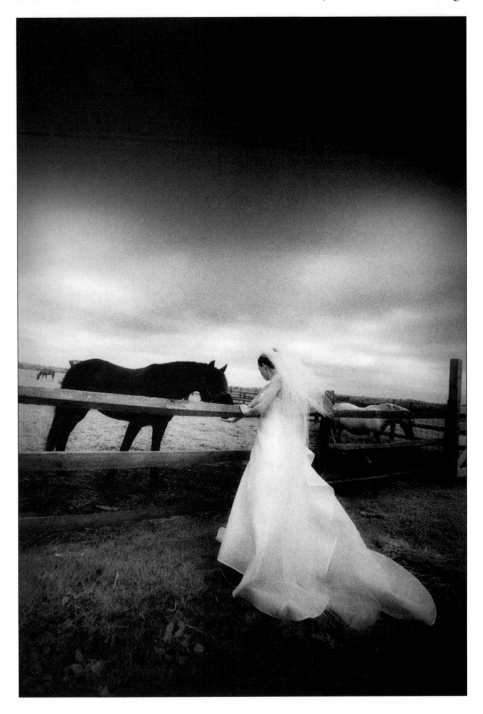

can present a visual treat. Photographers will often shoot with the fastest lens they own (f/1.2 or f/1.4) at close distances to create startlingly thin bands of focus. Additionally, the ability to create defocused areas of a scene in Photoshop has added to the popularity of selective focus.

In the days before Photoshop, photographers would shoot with a view camera, with its inherent swings

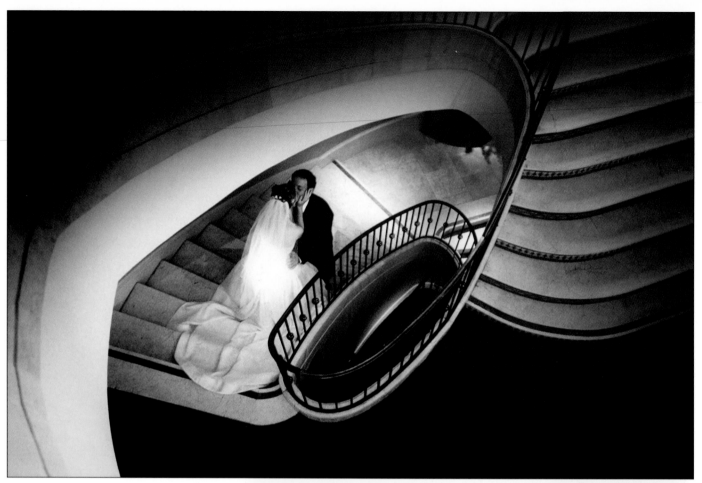

ABOVE—The perspective is skewed in this great image by Joe Buissink. Robert Cavalli gave this image a once-over, toning down the staircase above and below in printing to focus your attention on the kiss. Circular shapes, one of the most compelling forms in all of art, are repeated throughout the frame. **RIGHT**—Gigi Clark posed her bride between two wind-formed Cypress trees against a neutral-colored wall. Yet the image looks like the bride is dancing with the trees, her shape mimicking that of the trees. These are the artistic elements that separate the great wedding images from the so-so ones.

and tilts, which are capable of distorting the lens's plane of focus. With this type of camera, you can drastically distort the plane of focus by tilting the front lens board, for example, so that only a crucial area of an image is sharp—usually the eyes.

Creative control of focus is a way of riveting attention on a singular trait of your subject. Whether it is done conventionally or in Photoshop, it can be quite effective.

● LINE

To effectively master the fundamentals of composition, the photographer must be fluent in all the elements of artistic creation, including both real

LEFT—David Beckstead captured this elegant image of a bride strolling down the shore. What makes this such an interesting image is the parallel "S" curves—the shoreline is the larger "S," and the bride, elegant and beautiful, is the prominent "S." David shot this image with a Fuji Finepix S2 Pro at $^1/_{90}$ second at f/22. The reason he used such a small aperture is that he wanted to keep the far shoreline sharp. You can trace a line between the bride's eyes and the house on the horizon—an effective storytelling technique. **BELOW**—Pure shape, pure magic. This is an image by Martin Schembri that he used as a detail in a wedding album, yet it has compelling force as a single image and is incredible all on its own.

and implied lines within the photograph. A real line is one that is obvious—a horizon line, for example. An implied line is one that is not as obvious, like the curve of the wrist or the bend of an arm. Further, an implied line may jump from shape to shape, spurred by the imagination to take the leap.

Real lines should not intersect the photograph in halves. This splits the composition into two separate photos. It is better to locate real lines at a point one-third into the photograph. This creates a pleasing imbalance—

the photo is "weighted" top or bottom, left or right.

Lines, real or implied, that meet the edge of the photograph should lead the eye into the scene and not out of it, and they should also lead

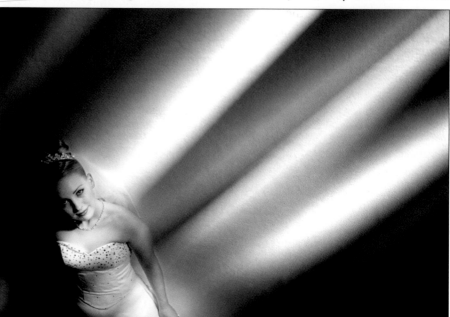

RIGHT—Martin Schembri's sense of composition and visual tension and dynamics is incredible. Here, a bride is focused in the light of her own personal sunbeams. The balance between the rays of focused light and the bride create a perfect balance of composition. **BELOW**—In *Anticipation,* by Kevin Kubota, you can see the flower girl being held back by dark tones, wanting to proceed to the light. It's basic symbolism, but it conveys universal storytelling truths. The line that leads from out to in also conveys a sense of travel and a message of transition.

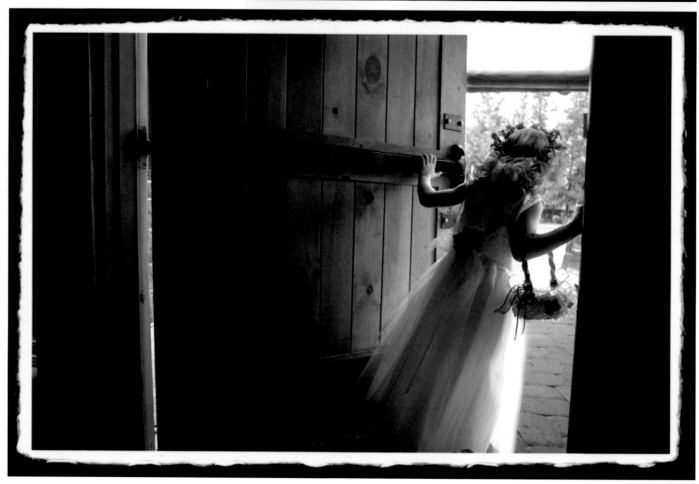

toward the subject. A good example of this is the country road that is widest in the foreground and narrows to a vanishing point on the horizon, where the subject is walking. These lines lead the eye straight to the subject, and in fact resemble the pyramid, one of the most compelling of all visual shapes.

● SHAPE

Shape is nothing more than a basic geometric form found within a composition. Shapes are often made up of implied and/or real lines. For example, a classic way of posing three people is in a triangle or pyramid shape. In any good portrait, the lines and positioning of the body, specifically the elbows and arms, create a triangle base to the composition. Shapes, while more dominant than lines, can be used similarly in unifying and balancing a composition.

Shapes often come into play in composing group portraits, in which small numbers of people are composed to form a unified portrait. Sometimes, in these instances, shapes may be linked, having a common element in both groups. For example, two groups of three people in pyramid shapes can be linked by a person in between—a common technique in arranging groups of people.

The number of possibilities is infinite, involving shapes and linked shapes and even implied shapes, but the point of this discussion is to be aware that shapes and lines are prevalent in well composed images, and that they are vital tools in creating strong visual interest within an image. Many photographers have told me that they were unaware of contrasting or complementary shapes within the

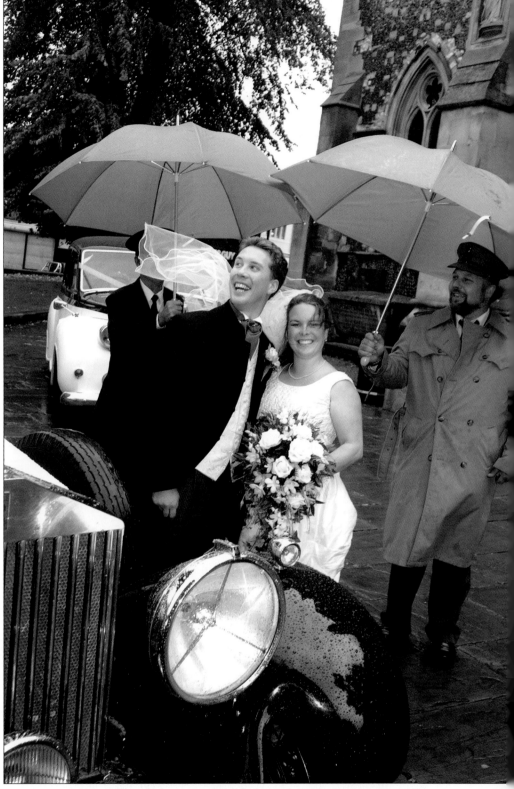

The line of Rolls Royces produced a decidedly left-to-right line. The line of the umbrellas and the groom's and chauffeur's gaze contradict these lines. The bride, however, is facing the camera, smiling as hard as she can. The result is a dynamic, charming portrait. And yes, it's raining in England, yet again. Photograph by Dennis Orchard.

design of a photograph. While this is not a psychoanalytical profile, suffice to say that when photographers who are fluent in the language of design

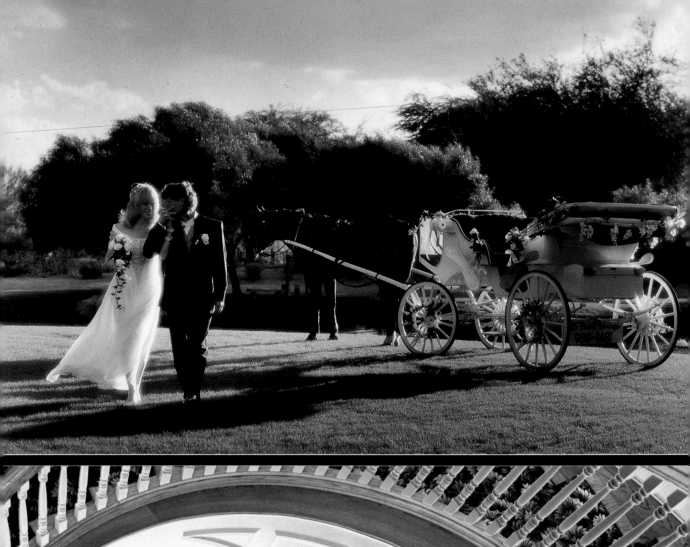
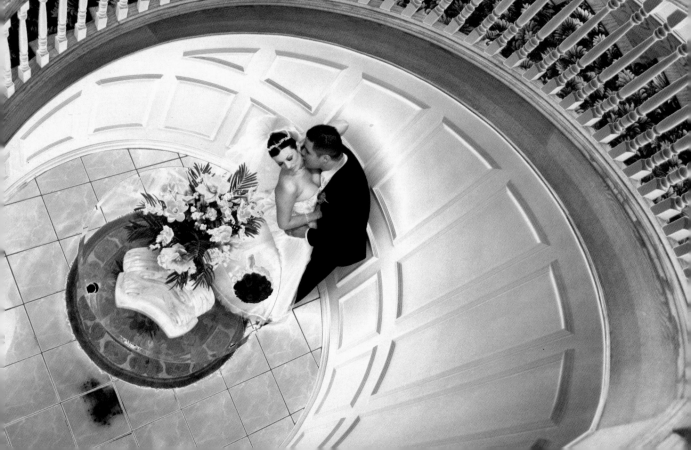

FACING PAGE (TOP)—Ken Sklute created this elegant image. The static horse and carriage, although much larger, are in perfect balance with the couple walking away, even though the physical size of the horse and carriage is much larger than the people. The vertical nature and expressions of the couple make them more important, visually, than the horse and carriage. **FACING PAGE (BOTTOM)**—The bride and groom in an embrace are trapped within concentric circles. The design and image are by photographer Jerry D. While the bride and groom are normal, the rest of the image is solarized (positive images are partially reversed to negatives) creating a natural tension that is resolved by the dynamic shapes of the bride and groom. **RIGHT**—Joe Buissink photographed this delightful scene of a flower girl at the center of attention. It's as if all the spotlights from the stage are focused on her—and with good reason!

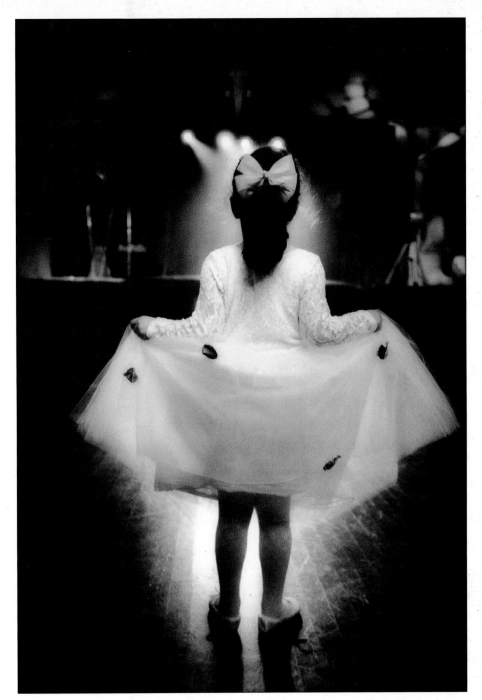

find and successfully integrate design elements, it can literally be an unrecognized aspect of their photography.

● **TENSION AND BALANCE**

Just as real and implied lines and real and implied shapes are vital parts of an effectively designed image, so are the "rules" that govern them—the concepts of tension and balance. Tension is a state of imbalance in an image—a big sky and a small subject, for example, is a situation having visual tension. Balance is where two items, which may be dissimilar in shape, create a harmony in the photograph because they have more or less equal visual strength.

Although tension does not have to be "resolved" within an image, it works side by side with the concept of balance so that, in any given image, there are elements that produce visual tension and elements that produce visual balance. This is a vital combination of artistic elements because it

creates a sense of heightened visual interest. Think of it as a musical piece with varying degrees of harmony and discord coming together to create a pleasing experience.

Tension can be referred to as visual contrast. For example, a group of four children on one side of an image and a pony on the other side of the image would seemingly produce visual tension. They contrast each other because they are different sizes

and they are not at all similar in shape. But the photograph may still be in a state of perfect visual balance. For instance, these two different groups could be "resolved" visually if the larger group (the children) was wearing bright clothes and the pony was dark colored. The eye then sees the two units as equal—one demanding attention by virtue of size, the other demanding attention by virtue of brightness.

Glossary

Angle of incidence. The original axis on which light travels. The angle of reflection is the secondary angle light takes when reflected off of some surface. The angle of incidence is equal to the angle of reflection.

Balance. A state of visual symmetry among elements in a photograph.

Barebulb flash. Portable flash unit with a vertical tube that fires the flash illumination 360 degrees.

Barn doors. Black, metal folding doors that attach to a light's reflector; used to control the width of the beam of light.

Bleed. A page in a book or album in which the photograph extends to the edges of the page.

Bounce flash. Bouncing the light of a studio or portable flash off a surface such as a ceiling or wall to produce indirect, shadowless lighting.

Box light. A diffused light source housed in a box-shaped reflector. The bottom of the box is translucent material; the side pieces of the box are opaque, but they are coated with a reflective material such as foil on the inside to optimize light output.

Broad lighting. One of two basic types of portrait lighting in which the key light illuminates the side of the subject's face that is turned toward the camera.

Burning-in. A darkroom or computer printing technique in which specific areas of the image are given additional exposure in order to darken them.

Butterfly lighting. One of the basic portrait lighting patterns, characterized by a high-key light placed directly in line with the line of the subject's nose. This lighting produces a butterfly-like shadow under the nose. Also called Paramount lighting.

Catchlight. The specular highlights that appear in the iris or pupil of the subject's eyes reflected from the portrait lights.

CC filters. Color-compensating filters that come in gel or glass form and are used to correct the color balance of a scene.

Chromogenic films. Dye-based black & white films capable of being processed in C-41 color negative chemistry. Prints may be made on conventional black & white paper or on color paper for prints that exhibit a slight sepia tint.

Color temperature. The degrees Kelvin of a light source or film sensitivity. Color films are balanced for 5500°K (daylight), or 3200°K (tungsten) or 3400°K (photoflood).

Cross-lighting. Lighting that comes from the side of the subject, skimming facial surfaces to reveal the maximum texture in the skin. Also called side-lighting.

Cross processing. Developing color negative film in color transparency chemistry or developing transparency film in color negative chemistry.

Cross shadows. Shadows created by lighting a group with two light sources from either side of the camera. These should be eliminated to restore the "one-light" look.

Depth of field. The distance that is sharp beyond and in front of the focus point at a given f-stop.

Depth of focus. The amount of sharpness that extends in front of and behind the focus point. Some lenses' depth of focus extends 50 percent in front of and 50 percent behind the focus point. Other lenses may vary.

Diffusion flat. Portable, translucent diffuser that can be positioned in a window frame or near the subject to diffuse the light striking the subject.

Dodging. Darkroom printing technique in which specific areas of the print are given less print exposure by blocking the light to those areas of the print, making those areas lighter.

Double truck. Two facing bleed pages. Usually, a panoramic or long horizontal image is used across the two pages.

Dragging the shutter. Using a shutter speed slower than the X-sync speed in order to capture the ambient light in a scene.

E.I. Otherwise known as exposure index. The term refers to a film speed other than the rated ISO of the film.

Feathering. Deliberately misdirecting the light so that the subject is illuminated by the edge of the beam of light.

Fill card. A white or silver foil-covered card used to reflect light back into the shadow areas of the subject.

Fill light. Secondary light source used to fill in the shadows created by the key light.

Flash-fill. Flash technique that uses electronic flash to fill in the shadows created by the main light source.

Flashing. A darkroom technique used in printing to darken an area of the print by exposing it to raw light.

Flash key. Flash technique in which the flash becomes the main light source and the ambient light in the scene fills the shadows created by the flash.

Flashmeter. A handheld incident meter measures both the ambient light of a scene and, when connected to the main flash, will read flash only or a combination of flash and ambient light. They are invaluable for determining outdoor flash exposures and lighting ratios.

Focusing an umbrella. Adjusting the length of the exposed shaft of an umbrella in a light housing to optimize light output.

Foreshortening. A distortion of the normal perspective caused by close proximity of the camera/lens to the subject. Foreshortening exaggerates subject features—noses appear elongated, chins jut out, and the backs of heads may appear smaller than normal.

45-degree lighting. A portrait lighting pattern characterized by a triangular highlight on the shadow side of the face. Also known as Rembrandt lighting.

Full-length portrait. A pose that includes the full figure of the model. Full-length portraits can show the subject standing, seated, or reclining.

FTP. Stands for File Transfer Protocol. It is a means of opening a portal on a web site for direct transfer of large files or folders to or from a web site.

Gatefold. A double-sided foldout page in an album that is hinged or folded so that it can be opened out to reveal a single- or double-page panoramic format.

Gaussian blur. A Photoshop filter that diffuses a digital image.

Gobo. Light-blocking card that is supported on a stand or boom and positioned between the light source and subject to selectively block light from portions of the scene. Also known as a black flag.

Gutter. The inside center of a book or album.

Head-and-shoulders axis. Imaginary lines running through shoulders (shoulder axis) and down the ridge of the nose (head axis). Head-and-shoulders axes should never be perpendicular to the line of the lens axis.

High-key lighting. Type of lighting characterized by a low lighting ratio and a predominance of light tones.

Highlight brilliance. Refers to the specularity of highlights on the skin. A negative with good highlight brilliance shows specular highlights (paper base white) within a major highlight area. This is achieved through good lighting and exposure techniques.

Hot spots. Area of the negative that is overexposed and without detail. Sometimes such areas are etched down to a printable density.

Incident light meter. A hand-held light meter that measures the amount of light falling on its light-sensitive cell.

Key light. The main light in portraiture used to establish the lighting pattern and define the facial features of the subject.

Kicker. A backlight (a light coming from behind the subject) that highlights the hair or contour of the body.

Lead-in line. In composition, a pleasing line in the scene that leads the viewer's eye toward the main subject.

Lens circle. The circle of coverage; the area of focused light rays falling on the film plane or digital imaging chip.

Lighting ratio. The difference in intensity between the highlight side of the face and the shadow side of the face. A 3:1 ratio implies that the highlight side is three times brighter than the shadow side of the face.

Low-key lighting. Type of lighting characterized by a highlighting ratio and strong scene contrast as well as a predominance of dark tones.

Main light. Synonymous with key light.

Matte box. A front-lens accessory with retractable bellows that holds filters, masks, and vignettes for modifying the image.

Modeling light. A secondary light mounted in the center of a studio flash head that gives a close approximation of the lighting that the flash tube will produce. These are usually high intensity, low-heat output quartz bulbs.

Overlighting. Main light is either too close to the subject, or too intense and oversaturates the skin with light, making it impossible to record detail in highlighted areas. Best corrected by feathering the light or moving it back.

Parabolic reflector. Oval-shaped polished dish that houses a light and directs its beam outward in an evenly controlled manner.

Perspective. The appearance of objects in a scene as determined by their relative distance and position.

Point light source. A sharp-edged light source like the sun, which produces sharp-edged shadows without diffusion.

Prime lenses. Fixed focal-length lenses as opposed to zooms (variable focal length lenses).

Push-processing. Extended development of film, sometimes in a special developer, that increases the effective speed of the film.

Reflected light meter. A meter that measures the amount of light reflected from a surface/scene. All in-camera meters are of the reflected type.

Reflector. This is the same as a fill card. Also the term for a housing on a light that reflects the light outward in a controlled beam.

Rule of thirds. Format for composition that divides the image area into thirds, horizontally and vertically. The intersection of two lines is a dynamic point where the subject should be placed for the most visual impact.

Scrim. A panel used to diffuse sunlight. Scrims can be mounted in panels and set in windows, used on stands, or they can be suspended in front of a light source to diffuse the light.

Seven-eighths view. Facial pose that shows approximately seven-eighths of the face. Almost a full-face view as seen from the camera.

Short lighting. One of two basic types of portrait lighting in which the key light illuminates the side of the face turned away from the camera.

Slave. A remote triggering device used to fire auxiliary flash units. These may be optical- or radio-controlled.

Soft-focus lens. Special lens that uses spherical or chromatic aberration in its design to diffuse the image points.

Specular highlights. Sharp, dense image points on the negative. Specular highlights are very small and usually appear on pores in the skin.

Split lighting. Type of portrait lighting that splits the face into two distinct areas: shadow side and highlight side. The key light is placed far to the side of the subject and slightly higher than the subject's head height.

Straight flash. The light of an on-camera flash unit that is used without diffusion; i.e., straight.

Subtractive fill-in. This is a lighting technique that uses a black card to subtract light out of a subject area in order to create a better defined lighting ratio. The term also refers to the placement of a black card over the subject in outdoor portraiture to make the light more frontal and less overhead.

Tension. A state of visual imbalance within a photograph.

Three-quarter-length pose. A pose that includes all but the lower portion of the subject's anatomy. Can be from above knees and up, or below knees and up.

Three-quarter view. Facial pose that allows the camera to see three-quarters of the facial area. Subject's face usually turned 45 degrees away

from the lens so that the far ear disappears from camera view.

Tooth. Refers to a negative that has a built-in retouching surface that will accept retouching leads.

TTL-balanced fill flash. Flash exposure systems that read the flash exposure through the lens and adjust flash output to compensate for flash and ambient light exposures, producing a balanced exposure.

Two-thirds view. A view of the face that is between three-quarter view and seven-eighths view. Many photographers do not recognize these distinctions—anything not a head-on facial view or a profile is a two-thirds view.

Umbrella lighting. Type of soft, casual lighting that uses one or more photographic umbrellas to diffuse the light source(s).

Unsharp mask. A sharpening tool in Adobe Photoshop that is usually the last step in preparing an image for printing.

Vignette. A semicircular, soft-edged border around the main subject. Vignettes can be either light or dark in tone and can be included at the time of shooting, or added later in printing.

Watt-seconds. Numerical system used to rate the power output of electronic flash units. Primarily used to rate studio strobe systems.

Wraparound lighting. Soft type of light, produced by umbrellas, that wraps around the subject producing a low lighting ratio and open, well-illuminated highlight areas.

X sync. The shutter speed at which focal-plane shutters synchronize with electronic flash.

Zebra. A term used to describe reflectors or umbrellas having alternating reflecting materials such as silver and white cloth.

Index

Select Books by Bill Hurter . . .

MASTER LIGHTING GUIDE
FOR WEDDING PHOTOGRAPHERS

Capture perfect lighting quickly and easily at the ceremony and reception—indoors and out. Includes tips from the pros for lighting individuals, couples, and groups. $34.95 list, 8.5x11, 128p, 200 color photos, index, order no. 1852.

THE BEST OF
ADOBE® PHOTOSHOP®

Rangefinder editor Bill Hurter calls on the industry's top photographers to share their strategies for using Photoshop to intensify and sculpt their images. $34.95 list, 8.5x11, 128p, 170 color photos, 10 screen shots, index, order no. 1818.

THE PORTRAIT PHOTOGRAPHER'S
GUIDE TO POSING

Posing can make or break an image. Now you can get the posing tips and techniques that have propelled the finest portrait photographers in the industry to the top. $34.95 list, 8.5x11, 128p, 200 color photos, index, order no. 1779.

RANGEFINDER'S
PROFESSIONAL
PHOTOGRAPHY

edited by Bill Hurter

Editor Bill Hurter shares over one hundred "recipes" from *Rangefinder's* popular cookbook series, showing you how to shoot, pose, light, and edit fabulous images. $34.95 list, 8.5x11, 128p, 150 color photos, index, order no. 1828.

POSING FOR PORTRAIT
PHOTOGRAPHY
A HEAD-TO-TOE GUIDE

Jeff Smith

Author Jeff Smith teaches surefire techniques for fine-tuning every aspect of the pose for the most flattering results. $34.95 list, 8.5x11, 128p, 150 color photos, index, order no. 1786.

PROFESSIONAL
MODEL PORTFOLIOS
A STEP-BY-STEP GUIDE FOR PHOTOGRAPHERS

Billy Pegram

Learn to create portfolios that will get your clients noticed—and hired! $34.95 list, 8.5x11, 128p, 100 color images, index, order no. 1789.

PROFESSIONAL POSING
TECHNIQUES FOR WEDDING AND
PORTRAIT PHOTOGRAPHERS

Norman Phillips

Master the techniques you need to pose subjects successfully—whether you are working with men, women, children, or groups. $34.95 list, 8.5x11, 128p, 260 color photos, index, order no. 1810.

BLACK & WHITE
PHOTOGRAPHY
TECHNIQUES WITH ADOBE® PHOTOSHOP®

Maurice Hamilton

Become a master of the black & white digital darkroom! Covers all the skills required to perfect your black & white images and produce dazzling fine-art prints. $34.95 list, 8.5x11, 128p, 150 color/b&w images, index, order no. 1813.

NIGHT AND LOW-LIGHT
TECHNIQUES FOR DIGITAL PHOTOGRAPHY

Peter Cope

With even simple point-and-shoot digital cameras, you can create dazzling nighttime photos. Get started quickly with this step-by-step guide. $34.95 list, 8.5x11, 128p, 100 color photos, index, order no. 1814.

PROFESSIONAL MARKETING
& SELLING TECHNIQUES FOR
DIGITAL WEDDING PHOTOGRAPHERS
2nd Ed.

Jeff Hawkins and Kathleen Hawkins

Taking great photos isn't enough to ensure success! Become a master marketer and salesperson with these easy techniques. $34.95 list, 8.5x11, 128p, 150 color photos, index, order no. 1815.

MASTER COMPOSITION
GUIDE FOR DIGITAL PHOTOGRAPHERS

Ernst Wildi

Composition can truly make or break an image. Master photographer Ernst Wildi shows you how to analyze your scene or subject and produce the best-possible image. $34.95 list, 8.5x11, 128p, 150 color photos, index, order no. 1817.

HOW TO CREATE A HIGH PROFIT PHOTOGRAPHY BUSINESS
IN ANY MARKET

James Williams

Whether your studio is in a rural or urban area, you'll learn to identify your ideal client, create the images they want, and watch your financial and artistic dreams spring to life! $34.95 list, 8.5x11, 128p, 200 color photos, index, order no. 1819.

MASTER LIGHTING TECHNIQUES
FOR OUTDOOR AND LOCATION DIGITAL PORTRAIT PHOTOGRAPHY

Stephen A. Dantzig

Use natural light alone or with flash fill, barebulb, and strobes to shoot perfect portraits all day long. $34.95 list, 8.5x11, 128p, 175 color photos, diagrams, index, order no. 1821.

BEGINNER'S GUIDE TO ADOBE® PHOTOSHOP®, 3rd Ed.

Michelle Perkins

Enhance your photos or add unique effects to any image. Short, easy-to-digest lessons will boost your confidence and ensure outstanding images. $34.95 list, 8.5x11, 128p, 80 color images, 120 screen shots, order no. 1823.

PROFESSIONAL PORTRAIT LIGHTING
TECHNIQUES AND IMAGES FROM MASTER PHOTOGRAPHERS

Michelle Perkins

Get a behind-the-scenes look at the lighting techniques employed by the world's top portrait photographers. $34.95 list, 8.5x11, 128p, 200 color photos, index, order no. 2000.

MASTER POSING GUIDE
FOR CHILDREN'S PORTRAIT PHOTOGRAPHY

Norman Phillips

Create perfect portraits of infants, tots, kids, and teens. Includes techniques for standing, sitting, and floor poses for boys and girls, individuals, and groups. $34.95 list, 8.5x11, 128p, 305 color images, order no. 1826.

LEGAL HANDBOOK FOR PHOTOGRAPHERS, 2nd Ed.

Bert P. Krages, Esq.

Learn what you can and cannot photograph, how to handle conflicts should they arise, how to protect your rights to your images in the digital age, and more. $34.95 list, 8.5x11, 128p, 80 b&w photos, index, order no. 1829.

MASTER GUIDE
FOR PROFESSIONAL PHOTOGRAPHERS

Patrick Rice

Turn your hobby into a thriving profession. This book covers equipment essentials, capture strategies, lighting, posing, digital effects, and more, providing a solid footing for a successful career. $34.95 list, 8.5x11, 128p, 200 color images, order no. 1830.

PROFESSIONAL FILTER TECHNIQUES
FOR DIGITAL PHOTOGRAPHERS

Stan Sholik

Select the best filter options for your photographic style and discover how their use will affect your images. $34.95 list, 8.5x11, 128p, 150 color images, index, order no. 1831.

MASTER'S GUIDE TO WEDDING PHOTOGRAPHY
CAPTURING UNFORGETTABLE MOMENTS AND LASTING IMPRESSIONS

Marcus Bell

Learn to capture the unique energy and mood of each wedding and build a lifelong client relationship. $34.95 list, 8.5x11, 128p, 200 color photos, index, order no. 1832.

MASTER LIGHTING GUIDE
FOR COMMERCIAL PHOTOGRAPHERS

Robert Morrissey

Use the tools and techniques pros rely on to land corporate clients. Includes diagrams, images, and techniques for a failsafe approach for shots that sell. $34.95 list, 8.5x11, 128p, 110 color photos, 125 diagrams, index, order no. 1833.

HOW TO TAKE GREAT DIGITAL PHOTOS
OF YOUR FRIEND'S WEDDING

Patrick Rice

Learn the skills you need to supplement the photos taken by the hired photographer and round out the coverage of your friend's wedding day. $17.95 list, 8.5x11, 80p, 80 color photos, index, order no. 1834.

DIGITAL CAPTURE AND WORKFLOW
FOR PROFESSIONAL PHOTOGRAPHERS

Tom Lee

Cut your image-processing time by fine-tuning your workflow. Includes tips for working with Photoshop and Adobe Bridge, plus framing, matting, and more. $34.95 list, 8.5x11, 128p, 150 color images, index, order no. 1835.

THE PHOTOGRAPHER'S GUIDE TO COLOR MANAGEMENT
PROFESSIONAL TECHNIQUES FOR CONSISTENT RESULTS

Phil Nelson

Learn how to keep color consistent from device to device, ensuring greater efficiency and more accurate results. $34.95 list, 8.5x11, 128p, 175 color photos, index, order no. 1838.

SOFTBOX LIGHTING TECHNIQUES
FOR PROFESSIONAL PHOTOGRAPHERS

Stephen A. Dantzig

Learn to use one of photography's most popular lighting devices to produce soft and flawless effects for portraits, product shots, and more. $34.95 list, 8.5x11, 128p, 260 color images, index, order no. 1839.

JEFF SMITH'S LIGHTING FOR OUTDOOR AND LOCATION PORTRAIT PHOTOGRAPHY

Learn how to use light throughout the day—indoors and out—and make location portraits a highly profitable venture for your studio. $34.95 list, 8.5x11, 128p, 170 color images, index, order no. 1841.

PROFESSIONAL CHILDREN'S PORTRAIT PHOTOGRAPHY

Lou Jacobs Jr.

Fifteen top photographers reveal their most successful techniques—from working with un-cooperative kids, to lighting, to marketing your studio. $34.95 list, 8.5x11, 128p, 200 color photos, index, order no. 2001.

CHILDREN'S PORTRAIT PHOTOGRAPHY
A PHOTOJOURNALISTIC APPROACH

Kevin Newsome

Learn how to capture spirited images that reflect your young subject's unique personality and developmental stage. $34.95 list, 8.5x11, 128p, 150 color images, index, order no. 1843.

PROFESSIONAL PORTRAIT POSING
TECHNIQUES AND IMAGES FROM MASTER PHOTOGRAPHERS

Michelle Perkins

Learn how master photographers pose subjects to create unforgettable images. $34.95 list, 8.5x11, 128p, 175 color images, index, order no. 2002.

STUDIO PORTRAIT PHOTOGRAPHY OF CHILDREN AND BABIES, 3rd Ed.

Marilyn Sholin

Work with the youngest portrait clients to create cherished images. Includes techniques for working with kids at every developmental stage, from infant to preschooler. $34.95 list, 8.5x11, 128p, 140 color photos, order no. 1845.

MONTE ZUCKER'S
PORTRAIT PHOTOGRAPHY HANDBOOK

Acclaimed portrait photographer Monte Zucker takes you behind the scenes and shows you how to create a "Monte Portrait." Covers techniques for both studio and location shoots. $34.95 list, 8.5x11, 128p, 200 color photos, index, order no. 1846.

DIGITAL PHOTOGRAPHY FOR CHILDREN'S AND FAMILY PORTRAITURE, 2nd Ed.

Kathleen Hawkins

Learn how staying on top of advances in digital photography can boost your sales and improve your artistry and workflow. $34.95 list, 8.5x11, 128p, 195 color images, index, order no. 1847.

LIGHTING AND POSING TECHNIQUES FOR PHOTOGRAPHING WOMEN

Norman Phillips

Make every female client look her very best. This book features tips from top pros and diagrams that will facilitate learning. $34.95 list, 8.5x11, 128p, 200 color images, index, order no. 1848.

JEFF SMITH'S POSING TECHNIQUES FOR LOCATION PORTRAIT PHOTOGRAPHY

Use architectural and natural elements to support the pose, maximize the flow of the session, and create refined, artful poses for individual subjects and groups—indoors or out. $34.95 list, 8.5x11, 128p, 150 color photos, index, order no. 1851.

WEDDING PHOTOGRAPHY
CREATIVE TECHNIQUES FOR LIGHTING, POSING, AND MARKETING, 3rd Ed.

Rick Ferro

Creative techniques for lighting and posing wedding portraits that will set your work apart from the competition. Covers every phase of wedding photography. $34.95 list, 8.5x11, 128p, 125 color photos, index, order no. 1649.

LIGHTING TECHNIQUES FOR FASHION AND GLAMOUR PHOTOGRAPHY

Stephen A. Dantzig, PsyD.

In fashion and glamour photography, light is the key to producing images with impact. With these techniques, you'll be primed for success! $29.95 list, 8.5x11, 128p, over 200 color images, index, order no. 1795.

WEDDING AND PORTRAIT PHOTOGRAPHERS' LEGAL HANDBOOK

N. Phillips and C. Nudo, Esq.

Don't leave yourself exposed! Sample forms and practical discussions help you protect yourself and your business. $29.95 list, 8.5x11, 128p, 25 sample forms, index, order no. 1796.

PHOTOGRAPHING CHILDREN WITH SPECIAL NEEDS

Karen Dórame

This book explains the symptoms of spina bifida, autism, cerebral palsy, and more, teaching photographers how to safely and effectively work with clients to capture the unique personalities of these children. $29.95 list, 8.5x11, 128p, 100 color photos, order no. 1749.

MARKETING & SELLING TECHNIQUES
FOR DIGITAL PORTRAIT PHOTOGRAPHY

Kathleen Hawkins

Great portraits aren't enough to ensure the success of your business! Learn how to attract clients and boost your sales. $34.95 list, 8.5x11, 128p, 150 color photos, index, order no. 1804.

POSING TECHNIQUES FOR PHOTOGRAPHING MODEL PORTFOLIOS

Billy Pegram

Learn to evaluate your model and create flattering poses for fashion photos, catalog and editorial images, and more. $34.95 list, 8.5x11, 128p, 200 color images, index, order no. 1848.

THE ART OF PREGNANCY PHOTOGRAPHY

Jennifer George

Learn the essential posing, lighting, composition, business, and marketing skills you need to create stunning pregnancy portraits your clientele can't do without! $34.95 list, 8.5x11, 128p, 150 color photos, index, order no. 1855.

BIG BUCKS SELLING YOUR PHOTOGRAPHY, 4th Ed.

Cliff Hollenbeck

Build a new business or revitalize an existing one with the comprehensive tips in this popular book. Includes twenty forms you can use for invoicing clients, collections, follow-ups, and more. $34.95 list, 8.5x11, 144p, resources, business forms, order no. 1856.

ILLUSTRATED DICTIONARY OF PHOTOGRAPHY

Barbara A. Lynch-Johnt & Michelle Perkins

Gain insight into camera and lighting equipment, accessories, technological advances, film and historic processes, famous photographers, artistic movements, and more with the concise descriptions in this illustrated book. $34.95 list, 8.5x11, 144p, 150 color images, index, order no. 1857.